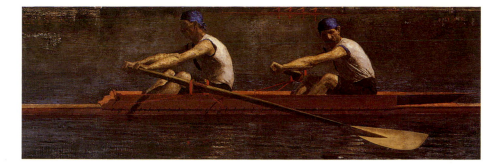

Rowing—the noblest, manliest, and approaching to the scientific,
of any game, or sport, or play, in any nation, clime or country.

ROBERT B. JOHNSON
A History of Rowing in America, 1871

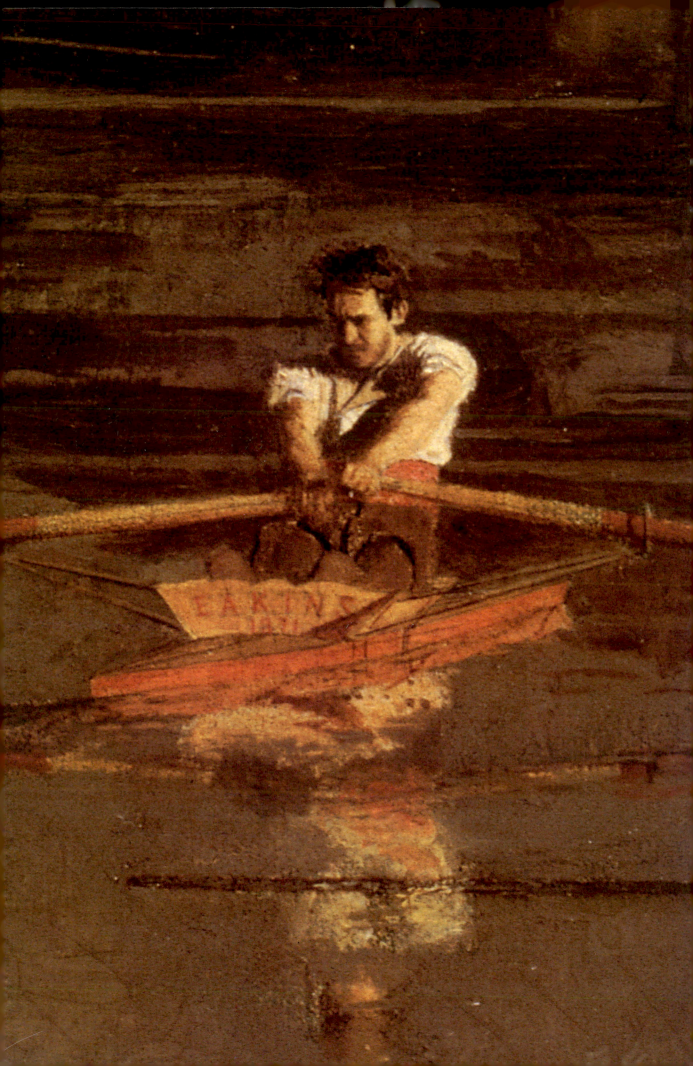

Thomas Eakins *The Rowing Pictures*

HELEN A. COOPER

with contributions by

MARTIN A. BERGER

CHRISTINA CURRIE

AMY B. WERBEL

Yale University Art Gallery

Yale University Press · New Haven and London

This book is published
on the occasion of the exhibition
Thomas Eakins: The Rowing Pictures,
organized by the Yale University Art Gallery, New Haven.
The exhibition and catalogue have been made possible in part
by The Henry Luce Foundation, Inc.,
and the National Endowment for the Arts, a federal agency.
Additional support has been provided
by the Virginia and Leonard Marx Publication Fund,
The Andrew Mellon Foundation,
Mr. and Mrs. Holcombe T. Green, Jr.,
and Jan and Frederick Mayer.

EXHIBITION DATES

National Gallery of Art, Washington, D.C.
 June 23–September 29, 1996
Yale University Art Gallery, New Haven
 October 11, 1996–January 14, 1997
The Cleveland Museum of Art
 February 19–May 15, 1997

Library of Congress Cataloging-in-Publication Data
Cooper, Helen A.
 Thomas Eakins: the rowing pictures / Helen A. Cooper; with
 contributions by Martin A. Berger, Christina Currie, and Amy B. Werbel.
 p. cm.
 ISBN 0-300-06939-1 (cloth).—ISBN 0-89467-076-X (pbk.)
 1. Eakins, Thomas, 1844–1916—Exhibitions. 2. Rowing in art—
 Exhibitions. 3. Eakins, Thomas, 1844–1916—Criticism and
 interpretation. I. Berger, Martin A. II. Currie, Christina.
 III. Werbel, Amy B. IV. Title.
 ND237.E15C66 1996
 759.13—dc20 96-15716
 CIP

COVER/JACKET ILLUSTRATION
John Biglin in a Single Scull, 1874, detail of fig. 34.

HALF TITLE ILLUSTRATION
The Biglin Brothers Racing, 1872, detail of fig. 22.

FRONTISPIECE
Self-portrait of Thomas Eakins, detail of fig. 4, *The Champion Single Sculls,* 1871.

182750 - 001

PRINTED IN THE UNITED STATES OF AMERICA

Contents

Lenders to the Exhibition

The Cleveland Museum of Art

Hirshhorn Museum and Sculpture Garden, Smithsonian Institution, Washington, D.C.

Paul Mellon Collection, Upperville, Virginia

The Metropolitan Museum of Art, New York

Museum of Fine Arts, Boston

National Gallery of Art, Washington, D.C.

Pennsylvania Academy of the Fine Arts, Philadelphia

Philadelphia Museum of Art

Portland Museum of Art, Oregon

Yale University Art Gallery, New Haven

Private collection

Foreword

We are pleased to present *Thomas Eakins: The Rowing Pictures*, the first exhibition to survey this extraordinary group of paintings, watercolors, and drawings by one of America's greatest artists at the beginning of his career. Although other exhibitions have included some of the rowing pictures, never before have all the extant works been brought together. Viewers will have an unprecedented opportunity to witness firsthand the creative process itself. We watch the artist as he works and reworks his theme, adding, subtracting, and turning the elements about. As Eakins' ideas unfolded, he created some of the most widely recognized and acclaimed images in American art.

This project has received crucial and most generous support from The Henry Luce Foundation, Inc., and from the National Endowment for the Arts, a federal agency, for which we express our sincere thanks. We are also grateful to the Virginia and Leonard Marx Publication Fund, The Andrew Mellon Fund, Mr. and Mrs. Holcombe T. Green, Jr., and Jan and Frederick Mayer, whose support ensured the high quality of the exhibition and book.

The exhibition has been organized by Helen A. Cooper, The Holcombe T. Green Curator of American Paintings and Sculpture. We owe special thanks to her, and to the other scholars whose essays form this book: Martin A. Berger, Christina Currie, and Amy B. Werbel. In her acknowledgments, Helen Cooper thanks the many colleagues who have been instrumental in the organization of the exhibition, and I can only underscore our appreciation for their contributions.

We are proud to share *Thomas Eakins: The Rowing Pictures* with two of America's greatest museums. Earl A. Powell III, director, National Gallery of Art, and Robert P. Bergman, director, The Cleveland Museum of Art, were enthusiastic partners from the beginning.

Above all we are most indebted to our lenders, and are gratified that every loan request found a positive response. Through their generosity, Thomas Eakins' rowing paintings, watercolors, and drawings have been brought together in an exhibition that will surely surprise and move even those long familiar with the artist's achievements.

SUSAN M. VOGEL
The Henry J. Heinz II Director

Acknowledgments

No major project is ever the result of a single individual's efforts. My first thanks must go to the enlightened and generous financial support of The Henry Luce Foundation, Inc. I would especially like to acknowledge John Cook and Ellen Holtzman and, for his encouragement, H. Christopher Luce. I am deeply grateful for the support of the National Endowment for the Arts, the Virginia and Leonard Marx Publication Fund, and The Andrew Mellon Foundation. Nancy and Holcombe T. Green, Jr., and Jan and Frederick Mayer generously came forward to make certain that the exhibition would be produced without compromise.

This book and exhibition build on the contributions of scholars who have written with perception on Eakins, many of whom are cited in the essays published here. Beginning in 1933 with the pioneering critical biography of Eakins by Lloyd Goodrich—the earliest comprehensive biography of any American artist—and revised by Goodrich almost fifty years later, scholars have continued to add to our understanding of Eakins' life and art. In more recent times, the contributions of Kathleen A. Foster, Michael Fried, Elizabeth Johns, Elizabeth Milroy, Darrel Sewell, and John Wilmerding have opened new paths to

this complex artist. I am particularly indebted to Johns' discussion of the meaning of rowing in Eakins' work, and to Foster's interpretations of the subject in her forthcoming book.

The reader of the present volume will find that the rowing paintings, like all great works of art, lend themselves to multiple interpretations and approaches. I am grateful for the opportunity to acknowledge here the contributions of my fellow essayists: Martin A. Berger, visiting assistant professor of art history, University of North Carolina, Chapel Hill; Christina Currie, independent paintings conservator; and Amy B. Werbel, assistant professor of fine arts, St. Michael's College. Their rigorous analyses both celebrate and cast new light on Eakins' achievement.

Working on this project not only introduced me to the beauty of rowing, but led me to the extraordinary community of rowers, many of whom contributed significantly to my understanding of this strange and wonderful sport. My sincerest thanks to Thomas E. Weil, Jr., the foremost collector of rowing prints, whose enthusiasm and love for rowing are contagious, and whose generosity of spirit, depth of knowledge, and unfailing courtesy in answering any rowing question, no matter how trivial, saved me from egregious errors.

I am deeply indebted to William Lanouette, the author of a forthcoming biography of the champion oarsmen John and Barney Biglin, for graciously sharing his information with me, and for never once showing the slightest irritation at being interrupted at his own work to clarify a point. David H. Vogel, head coach of the Yale University men's heavyweight crew, helped me see Eakins' pictures through the eyes of a rower. Peter Sutton, Linda Thomas, and Edward S. Cooke led me to books about the rowing experience. Strangers became instant colleagues: while walking along the banks of the Schuylkill River one spring day I had the good fortune to meet Ted A. Nash, Olympic coach of the Penn Athletic Club, who, with Joseph A. Sweeney, communications operation manager of the City of Philadelphia, helped me identify the specific locations depicted in each of the paintings.

Many people offered crucial assistance at important junctures. Stuart Feld of Hirschl and Adler Galleries, New York, was instrumental in helping us secure a critical loan. Sylvia Yount, curator of collections at the Pennsylvania Academy of the Fine Arts, was most generous and supportive of our requests. At the Philadelphia Museum of Art, Darrel Sewell, curator of American art, offered every assistance and courtesy. I am grateful to him for putting us in touch with Mr. and Mrs. Daniel Dietrich II, who kindly allowed us to reproduce their original photographs of Eakins and Max Schmitt. Mike Hammer was most helpful during our research visits. W. Douglass Paschall was of invaluable assistance in compiling a comprehensive list of the exhibitions to which Eakins contributed rowing works. Tom Loughlan graciously undertook the tedious task of checking every inscription. Thanks

also to Phyllis Rosenzweig, associate curator, Hirshhorn Museum and Sculpture Garden, and Annette McConnell, McCord Museum of Canadian History. Graeme King of King Boatworks kindly arranged the loan of the actual sculls in the exhibition.

Our sister venues for this exhibition were ideal partners. At the National Gallery, Earl A. Powell III, director, enthusiastically supported the idea of the exhibition from the beginning. I had the pleasure of working with Nicolai Cikovsky, Jr., and Franklin Kelly, the curators of American and British paintings, Dodge Thompson, chief of exhibitions, and Nancy Breuer and Naomi Remes in the exhibitions office; and Frances Smyth, senior editor. The Cleveland Museum of Art offered every support, and I thank Robert P. Bergman, director, William Talbot, deputy director, and David Steinberg, assistant curator of paintings, for their generous participation.

I am deeply indebted to my colleagues at the Yale University Art Gallery. The project was initiated under Mary Gardner Neill, now director of the Seattle Art Museum. Her successor, Susan M. Vogel, The Henry J. Heinz II Director, has been supportive in every way. I greatly appreciate the efforts of Louisa Cunningham, business manager; registrar Susan Frankenbach and associate registrar Carolyn Padwa; conservator Mark Aronson; Daphne Deeds, curator of exhibitions and programs; and Janet Saleh Dickson and Mary Kordak, curator and associate curator of education, respectively. Anna DiFonzo, administrative assistant, typed innumerable drafts of the manuscript and attended to myriad details associated with loan requests and photographs with amazing efficiency. Dana Goodyear, bursary assistant, cheerfully ran

errands and helped in every way. Suzanne Warner handled photography orders with her usual efficiency. Joseph Szaszfai and Carl Kaufman responded graciously to photograph requests. Patricia Kane and Lisa Newman offered computer expertise at moments of crisis. I thank Richard Moore and his expert installation crew, Burrus Harlow, Maishe Dickman, and Nancy Valley. I particularly appreciate Marie Weltzien's seamless coordination of press coverage and public events, all executed with her usual flair and wit.

During the course of this project, I was fortunate to have the research assistance of two graduate students, and I warmly thank Jessica Smith and Liena Vayzman for their important contributions.

Mark Aronson, Nancy Cooper, Robin Jaffee Frank, William Lanouette, Thomas E. Weil, Jr., Marie Weltzien, and Marlene Worhach kindly read various drafts of the manuscript, making suggestions that greatly clarified the final text. For allowing Eakins' rowing pictures to speak for themselves, I thank Sarah Buie, for her evocative and elegant exhibition design at Yale.

Beyond this supportive community, I would single out several individuals without whom the book could not have taken shape. Robin Jaffee Frank, assistant curator of American paintings and sculpture at Yale, has my warmest appreciation for the critical role she played in the realization of the book; her perspicacity and tact, joined to limitless energy, kept us moving forward. My gratitude to Sheila Schwartz for her exemplary and sensitive editing, and her sense of humor; this book has benefited immeasurably from her guidance. In checking the endnotes, Elise K. Kenney was tireless in her pursuit of accuracy. It has been a pleasure to work again with Judy Metro at the Yale University Press. Special thanks must go to Greer Allen and Ken Scaglia, whose responsiveness to and respect for Eakins' art illuminate the design of these pages; that they created this beautiful book under extreme deadline pressures is proof that exceptionally talented individuals have magical powers.

Finally, my deepest thanks to my husband, Jack Cooper. It was he, after all, with his unfaltering patience, who helped me keep my craft on course.

HELEN A. COOPER
*The Holcombe T. Green Curator
of American Paintings and Sculpture*

Preface

Considered one of the greatest artists America has produced and the foremost realist of his time, Thomas Eakins (1844–1916) enjoys a well-established place in the history of art; equally well-established are the facts of his turbulent career. Painter, sculptor, and photographer, he was also an influential and inspiring teacher at the Pennsylvania Academy of the Fine Arts, beginning in 1876. But his emphasis on the thorough study of the nude, particularly his insistence on the completely nude male model, scandalized the more proper women students and conservative Victorian society in Philadelphia and ultimately forced his resignation in 1886. For further indiscretions in his teaching practices, he lost his position at the Drexel Institute in 1895. Widely acknowledged as an important, though unorthodox contemporary artist, he could no longer earn his living as a teacher.

As Eakins grew older, he was increasingly disinterested in genre and outdoor subjects, and portrait commissions were rare. Almost all his sitters were friends and students, or individuals who interested him because of their intellectual and creative achievements. His portraits—uncompromisingly acute in their observations and psychological insights—did not make for flattery or financial success. In a letter of 1894, Eakins voiced bitterness about his rejection as a teacher and an artist: "My honors are misunderstanding, persecution & neglect, enhanced because unsought." Recognition of his importance as a major figure in American art began to grow only near the end of his life. It needed the memorial exhibitions in New York and Philadelphia in 1917, the year after his death, to finally accord him his just reputation.

This book and the exhibition it accompanies focus on the most ambitious project of Eakins' early career, when the artist was full of optimism and success appeared within his grasp. The rowing pictures, created over a period of less than four years, are crucial to an understanding of Eakins' creative process. In no subsequent series is the tension between the intellect and the senses, between the scientific and the artistic, and between observed reality and abstract composition so evident. The rowing theme presented the young artist with the perfect metaphor for his belief in the interrelatedness of physical, mental, and moral discipline. Like almost all the art he would create throughout his life, these pictures are, at heart, about the strivings of the human spirit.

HELEN A. COOPER

Eakins' Early Years: An Introduction

HELEN A. COOPER

On Independence Day, 1870, Thomas Cowperthwait Eakins (1844–1916) returned to his native Philadelphia after three and a half years of rigorous artistic training in Europe (fig. 1). The date was auspicious: bristling with ambition, fearless and passionate, the twenty-six-year-old was eager to begin life as a professional artist in his own land.

It was the career for which he had been preparing since adolescence. The eldest child and only son of Benjamin, a successful writing master and teacher of penmanship, and Caroline Cowperthwait Eakins, who encouraged his ambitions, Eakins had, from the time he was a boy, shown an exceptional enthusiasm for knowledge and precision. Whether it was a manual activity, the study of languages, mathematics, or the natural sciences, he embarked on any project with eagerness and disciplined thoroughness. This schoolboy curiosity and penchant for exactitude would never leave him.

Guided by his father's ambitions, Eakins undertook the training necessary to become a professional artist with single-minded determination. At Central High School in Philadelphia from 1857 to 1861, he worked his way through a curriculum of geometry, explorations of line and form, and mechanical and perspective drawing. The emphasis was on accurate calculation and developing a faculty for correct observation. In 1862 he registered at the Pennsylvania Academy of the Fine Arts, the oldest art institution in the United States and the foremost art school in Philadelphia. Despite its prominence, the Academy, like the few other art schools of the time, offered little in the way of training. There was no organized curriculum or standing faculty; students turned to older and more experienced classmates for advice and criticism. The only organized activity was drawing from the cast collections or from hired models. Instruction in painting or sculpture had to be obtained elsewhere—usually from established artists who gave private lessons.[1] The system of instruction was patterned after that of the École des Beaux-Arts in Paris. Beginners were required to work from casts of antique sculptures, and only after an approved period of study could they graduate to a thrice-weekly life class (for men only) to draw from the nude model.

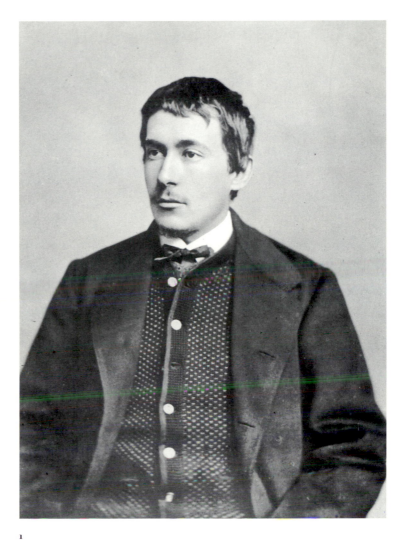

1

Frederick Gutekunst, *Thomas Eakins*, c. 1871. Gelatin silver print, 3 ⁹/₁₆ x 2 ⅜ in. (9 x 6 cm). Collection of Mr. and Mrs. Daniel Dietrich II, Philadelphia.

By 1864, Eakins was looking beyond the Academy for professional training. He wanted a greater scientific understanding of the human figure, its form, postures, and movements. Many European and American art schools urged their students to supplement their life drawing studies by attending medical school lectures in gross anatomy.[2] Eakins enrolled in the anatomy class of the well-known surgeon Dr. Joseph Pancoast at Jefferson Medical College in Philadelphia. Sitting alongside medical students, the young artist learned at firsthand the structure and actions of the human body. With characteristic enthusiasm and thoroughness, he studied until his anatomical knowledge was "as great as that of most physicians, and considerably greater than that of most artists."[3] A commitment to both art and science would continue to characterize Eakins' career.

Many of Eakins' contemporaries had been to European art schools or were planning to go abroad. They not only sought more professional training, but they wanted the cachet of the European experience because American patrons were more often attracted to fashionable Continental artists than to native-trained Americans. Moreover, a sojourn in a European city, especially Paris, would give an artist added self-confidence and status.

Benjamin Eakins believed that the kind of professional instruction his son now needed could only be had from the superior curriculum and faculty of the École des Beaux-Arts.[4] Immediately upon arriving in the French capital in October 1866, the twenty-two-year-old Philadelphian set out to win admission to the École, the official and most distinguished French art school of the time, and the one which offered the most complete artistic training in the Western world.[5] No foreign students had been admitted to the school for a year, and a number of American artists had already been waiting for six months to enroll. Armed with letters of introduction to notables in the French artistic community from the influential Philadelphia engraver and art impresario John Sartain, who was a good friend of his father, Eakins tirelessly pursued every lead. Thanks to his ignorance of the admission procedures for foreign students and his stubborn determination not to be defeated by the French bureaucracy, within weeks of his arrival he gained admission. "I am in, at last," wrote Eakins exultantly to his father. "I have certainly to regret that to get what I wanted I had sometimes to descend to petty deceptions but the end has justified the means. . . ."[6] His admittance also opened the way for the other Americans.[7]

Except for one three-month visit home (December 1868–March 1869), Eakins remained in Europe until June 1870. His letters to Philadelphia during these years form an intimate chronicle of the artistic development of an intelligent, self-confident, and ambitious young American who was eagerly adopting the life of a Parisian art student.[8] With a respectable allowance from his father and a working knowledge of French, he made many friends among his French colleagues and the expatriate American artists, visiting museums and exhibitions, attending the opera, and frequenting "the city's notorious dance halls and cafés-concerts."[9] He

was not much concerned with vanguard aesthetic developments, his preferences being almost exclusively for conservative artists. In letters and notes, he referred approvingly to the painters Isabey, Troyon, Jacques, Couture, Meissonier, Fortuny, Régnault, Robert-Fleury, and the sculptor Carpeaux. In a letter to his father concerning the Universal Exposition of 1867, he said nothing about the furor over Courbet and Manet (artists whom he later admired)—nothing about the organizers' refusal to let them exhibit or their defiant act of exhibiting their work in a shed outside the grounds. Rather, most of Eakins' letter was given over to describing the machinery at the show, and he proudly declared his nationality by stating that America's great locomotive was "by far the finest there."[10]

Eakins was also proud that he had been admitted into the atelier of Jean-Léon Gérôme, one of the École's most celebrated teachers.[11] Gérôme's paintings were well known to virtually every American art student through the wide distribution of photogravures after his works and through exhibitions of many of the actual paintings in America.[12] Eakins' admiration for the cosmopolitan Gérôme would last until the French artist's death in 1904. Gérôme in turn found the thoughtful, somewhat raw young American a rewarding student. The leading exponent of Beaux-Arts principles, Gérôme was an outstanding figure in the conservative establishment. His sophisticated, erudite interpretations of the Near East, ancient Greece and Rome, and seventeenth-century France were exceedingly popular. Meticulously crafted tableaux, they were admired for their truth of character and the accuracy of their archaeological and scientific detail, all precisely rendered with minuscule and invisible brushstrokes. Among the most celebrated of his works—Eakins would certainly have seen it at the Universal Exposition—was *The Prisoner* (fig. 2), a typically exotic image in which a handcuffed prisoner is being transported across the Nile by two muscular, bare-chested rowers in a boat. As Kathleen Foster has noted, it was a painting that Eakins would later remember in his American rowing pictures.[13]

Gérôme's academic literalism, concern with objective description, and almost photographic finish reflected the mid-nineteenth century's immense faith in the capacity of science to unravel the secrets of the universe. It was a period obsessed with cataloguing and analyzing the natural world. At the École, Eakins was also exposed to the positivist theories of Hippolyte Taine, professor of aesthetics and the history of art. Much admired by the École students, Taine believed that the scientific method should be extended to every form of human activity, including art; that the artist was both a product of his environment and an interpreter, but must not be a mindless imitator; and that great works of art, by definition, reflected the essential qualities of their period and represented its characteristic types. Taine popularized and developed further the English philosopher Herbert Spencer's concept of human cultural development as the survival of the fittest, the individual who stood out from the group.[14] Eakins was already familiar with the general principles of Spencer's determinist philosophy, for the Englishman's essays and books were influential in American art circles by the mid-1860s.[15]

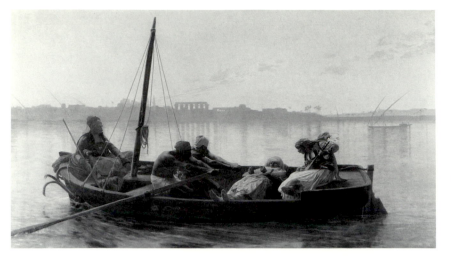

2
Jean-Léon Gérôme,
The Prisoner, 1861. Oil on panel,
18 ⅞ x 30 ¾ in. (47.9 x 78.1 cm).
Musée des Beaux-Arts, Nantes.

Eakins' French masters simply reaffirmed what he already believed: artistic truth required the most exact method. Eakins never sought to emulate Gérôme's jewel-like finish, but his teacher's thorough research into his subject and his archaeological precision served as models of artistic integrity that Eakins absorbed and applied to his own art.

For Gérôme, the basis of a painting was meticulous drawing, and the essential element in all art was line. The scrupulous study of nature, especially of the anatomy of the nude, was paramount and could be attained only through intensified perception rather than through artificial mannerisms or tricks of technique.[16] The academic method of working out a major composition—careful preparation of sequential sketches and studies—also reinforced Eakins' scientific and rational leanings, particularly his view that figure painting depended upon a mastery of anatomy acquired through dissection.[17] He attended classes at the nearby medical school and undoubtedly was among the art students who flocked to the lectures on the physiology of motion given by its brilliant discoverer, neurologist Dr. G.B. Duchenne.

Gérôme's standards for draftsmen were exacting, and they had to be met before he permitted his students to touch brush to canvas.[18] After what were to him five long months, Eakins was able to report to his father that "Gérôme has at last told me I might get to painting."[19] Up to this time he had never worked in oil on a regular basis. Despite his considerable experience in life drawing, he found controlling color when painting from life a much greater challenge.

In his usual stubborn way, Eakins chose to solve the problem for himself. He decided that his difficulties in mastering painting could be resolved by avoiding the life class and working on his own, away from Gérôme's atelier. He rented a studio where he could hire models and work

at composition and color by painting from inanimate objects until he felt more comfortable in handling the oil medium.[20] "I remember many a trouble that I have got into from trying to play my tunes before I tuned my fiddle up."[21] He soon was able to report: "Color is becoming a little less of a mystery than it was & more of a study in proportion. When it ceases altogether to be a mystery and it must be very simple at the bottom, I trust I will soon be making pictures. One consolation is that I am composing. It was hard to begin. . . ."[22]

For a few months in the spring of 1868, Eakins also studied under the conservative sculptor Augustin Alexandre Dumont, not to master the medium itself but to gain from modeling in clay a greater understanding of form and structure.[23] In the summer of 1869, while Gérôme was away, Eakins also worked for a month in the atelier of Léon Bonnat, a rising young portrait painter whose emphasis on broad handling of paint was in distinct contrast to Gérôme's preference for contour, line, and precise draftsmanship.[24]

Eakins' confidence in his technical ability was growing at the same time that his unwavering belief in the primacy of clear observation of the physical world was being reinforced by what he saw in the work of the greatest artists. In a now-famous letter to his father, he outlined his philosophy: "The big artist does not sit down monkey like & copy a coal scuttle or an ugly old woman like some Dutch painters have done nor a dungpile, but he keeps a sharp eye on Nature & steals her tools. He learns what she does with light the big tool & then color then form and appropriates them to his own use."[25]

Eakins believed that centuries of tradition had meaning only insofar as they taught one something about the present. While one could learn from the work of other artists, past and present, the "big" artist did not imitate but instead chose subjects that were part of his personal experience.

I love sunlight & children & beautiful women & men their heads & hands & most everything I see & someday I expect to paint them as I see them and even paint some that I remember or imagine from old memories of love & light & warmth, . . . but if I went to Greece to live there twenty years I could not paint a Greek subject for ~~I would~~ my head would be full of classics the nasty besmeared wooden hard gloomy tragic figures of ~~this~~ the great French school of the last few centuries & Ingres & the Greek letters I learned at the High School . . . & my mud marks of the antique statues.[26]

After three years of studying with Gérôme and the others, it was time to move on. "I am as strong as any of Gérôme's pupils and I have nothing now to gain by remaining. What I have learned I could not have learned at home, for beginning Paris is the best place. My attention to the living model even when I am doing my worst work has benefitted me and improved my standard of beauty. It is bad to stay at school after being advanced as far as I am now."[27]

Eakins was sure of the kind of art he wanted to make. He despised most English art and all of Rubens' paintings ("nastiest most vulgar painter"), and anything that tasted of "vanity & affectation & show politeness & useless knowledge & parrot talking."[28] "I am certain now of one thing that is to paint what I can see before me better than the namby pamby fashion painters. Whether or not I will afterwards find poetical subjects & compositions like Raphael remains to be seen. . . . But with or without that I will paint well enough to earn a good living & become even rich."[29]

In November 1869, Eakins left Paris, the strain of hard work and the gloom of the city's damp winter weather having had their effect. "The French know no more about comfort than the man in the moon," he complained. "I am going to Spain. . . straight to Madrid, stay a few days to see the pictures, & then go to Seville."[30] In Madrid he quickly revived, all traces of the cold and dysentery that had plagued him in Paris now gone.

At the Prado, Eakins discovered Spanish painting. The impact of Velázquez on him was immediate and profound. "I have seen big painting here," he wrote to his father, and went on to describe how different was his reaction to these paintings.

When I had looked at all the paintings by all the masters I had known [before] I could not help saying to myself all the time, its very pretty but its not all yet. It ought to be better, but now I have seen what I always thought ought to have been done & what did not seem to me impossible. . . Spanish work [is] so good so strong so reasonable so free from every affectation. It stands out like nature itself. . . . It has given me more courage than anything else ever could."[31]

Eakins continued on to Seville, where he remained for five months, working very hard on a number of portraits and genre scenes.

By late May 1870, Eakins knew it was time to go home. His studies in Paris, his visits to museums in Switzerland, Italy, Germany, and Belgium, and his months in Spain had taught him many things, but none more important than a belief in the truth of his own vision and a confidence in his identity as an American. Unlike many young artists who returned from study abroad in the 1860s and 1870s and thought the American scene uncivilized, crude, and hard to assimilate into art, Eakins was deeply proud of his native land and determined to work from American subjects. He reentered his environment as if he had never been away, renewing relationships with old friends and resuming an active outdoor life—hunting, sailing, swimming, and rowing on his beloved Schuylkill River. He never again set foot in Europe.

Eakins took up his brush at once, working in a studio that his father had prepared for him on the top floor of the family home at 1729 Mount Vernon Street, a few blocks from the Schuylkill. His first paintings were largely private subjects—family and friends depicted in shadowy interiors reading, playing a musical instrument, or attending to children (fig. 3). Modest in size and informal, they have a kind of sober poetry, infused with an authenticity

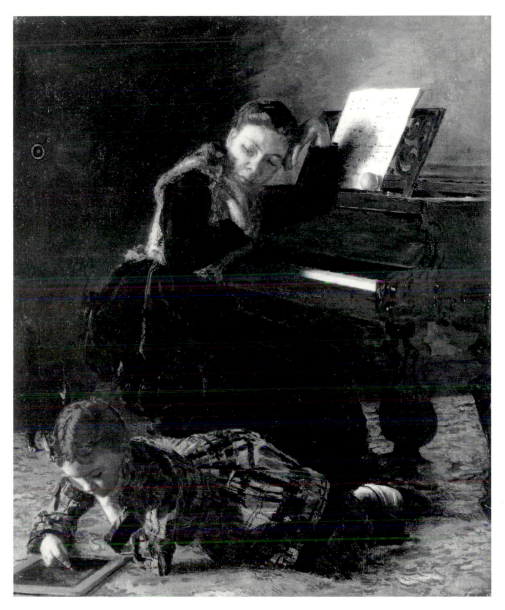

3
Thomas Eakins, *Home Scene*, c. 1870–71. Oil on canvas, 21 ¹¹⁄₁₆ x 18 ¹⁄₁₆ in.
(55.1 x 45.9 cm). The Brooklyn Museum, New York; Gift of George A. Hearn,
Frederick Loeser Art Fund, Dick S. Ramsay Fund, Gift of Charles A. Schieren.

4

The Champion Single Sculls, 1871
Oil on canvas
32 ¼ x 46 ¼ in. (81.9 x 117.5 cm)
The Metropolitan Museum of Art,
New York; Purchase, The Alfred N. Punnett
Endowment Fund and George D. Pratt Gift, 1934

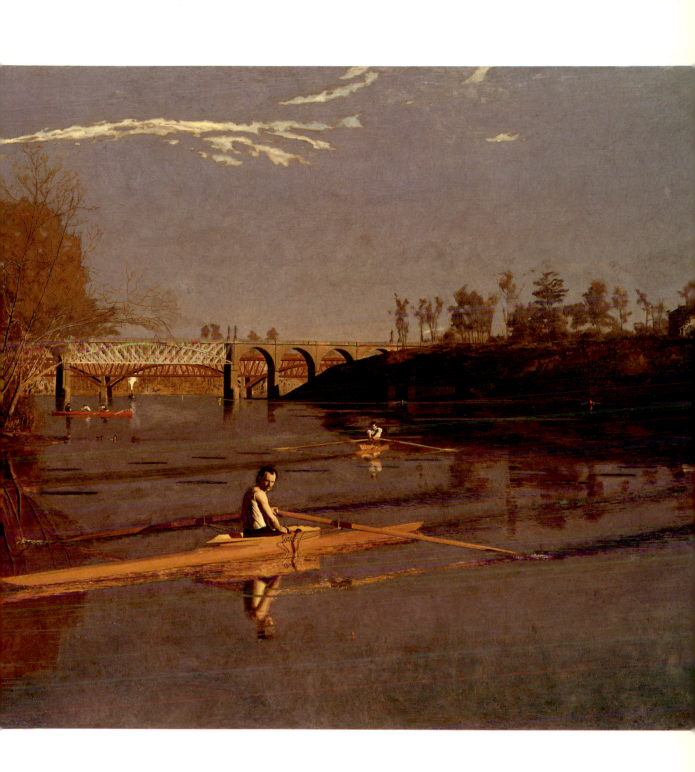

and depth of feeling that separates them from most other American genre images of the time. With their subdued tones, breadth, and painterly handling, these early works rest well within European canons of subject and style, reflecting in particular Eakins' exposure to the paintings of Velázquez and Ribera which, together with those of Rembrandt, he considered free from aesthetic affectation.

Despite the clear stylistic impact of these European masters, Eakins chose, for his professional debut, to show a work that was unlike anything he—or anyone else—had done before. In April 1871, nine months after returning to America, he sent to his first public exhibition the major painting that would declare his independence, *The Champion Single Sculls*, long known as *Max Schmitt in a Single Scull* (fig. 4).[32] In Eakins' rendering, Gérôme's tableau of oarsmen on the Nile (fig. 2), with its light, smooth surfaces, meticulous arrangements of forms, and detailed observation of the human figure had become a painting of a contemporary rower on the Schuylkill.[33] For the next three years, the theme of rowers and rowing would hold Eakins in a kind of imaginative possession. It was an intensity of focus that he would never repeat with any other subject.

5 *John Biglin in a Single Scull,* detail of fig. 34

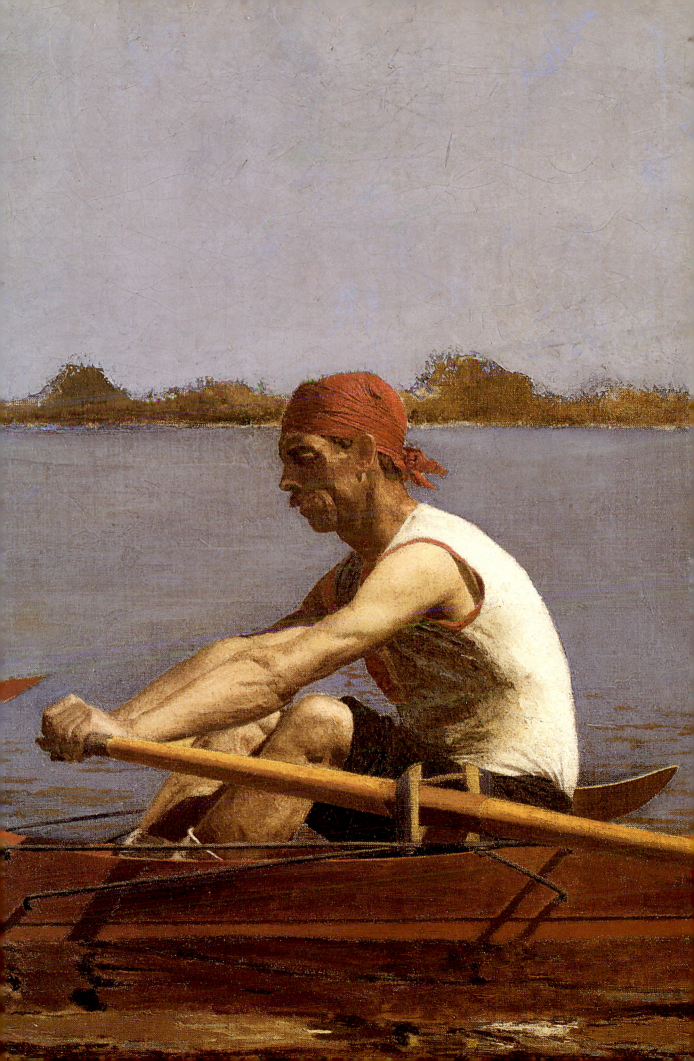

Rowing in the Art and Life of Thomas Eakins

HELEN A. COOPER

The Sport of Rowing

"I hope you have been boating," Eakins wrote to his sister Caroline from Paris, "Our Schuyl-kill is so beautiful at this season."[1] Eakins loved rowing. He had learned to row long before he went to Europe and was an enthusiastic and knowledgeable oarsman. In his letters from Paris he mentioned rowing to his three sisters on a number of occasions, perhaps because the presence of the Seine running through the city reminded him of his beloved Schuylkill.[2]

Rowing has been called the first modern sport. Before the eighteenth century, organized popular sports did not exist in forms that would be recognizable today. The few professional athletes were individual performers in events with no universally accepted rules, regulatory bodies, settled locations, schedules of competition, uniforms, leagues, or established followings.[3]

Annual boat races began in 1716 on the Thames in London when Thomas Doggett, an Irish playwright and actor, established an annual regatta for professional watermen.[4] Boat racing in America was launched less than fifty years later in the waters around New York City by professional ferry- and bargemen, who began to race at the urging of their passengers. Following their English counterparts, American amateurs organized boat clubs in Boston, New York, and Philadelphia in the 1830s, and the first college boat club was formed at Yale in 1843. Rowing as a sport gradually spread from the East Coast to rivers and lakes across the country, and regattas became popular and much-anticipated events. Following the Industrial Revolution, as ever greater numbers of people moved from the country to the cities, public recreational facilities became essential elements of urban life and culture. With more leisure and money at their disposal, an emerging middle class turned increasingly to public entertainments for amusement. Rowing became more accessible to more people, offering an escape from an increasingly sedentary urban life, and the number of participants as well as spectators grew rapidly.

In 1858, nine of the Philadelphia boat clubs founded the Schuylkill Navy in order to promote, regulate, and supervise amateur rowing competition on the river. By the end of the 1860s,

6

The College Regatta—The Finish. Wood engraving from sketches by Theodore R. Davis. *Harper's Weekly,* August 1, 1874, p. 632. Collection of Thomas E. Weil, Jr.

rowing had achieved unprecedented popularity, its growth having been only temporarily interrupted by the Civil War.[5] It was the ideal egalitarian and therefore American sport. The Amateur Rowing Association would never have tolerated the elitism and insularity that was associated with club membership in England, where rowing was a sport of "gentlemen"—no mechanic, artisan, or laborer could join. In America, if a man's hands were calloused from honest labor, so much the better; he would have no blisters when he rowed. In Philadelphia, students, doctors, lawyers (like Max Schmitt, the subject of *The Champion Single Sculls*), clerks, mechanics, and artisans formed rowing clubs and began to hold races and regattas. Club membership made expensive equipment available to those who could not afford to purchase their own. Sponsored championships on the Schuylkill River, based on English models, attracted thousands of spectators. Rowing provided some of the earliest mass spectator events in modern sporting history (fig. 6). The railroad and the telegraph combined to make it a regional, and even national sport, bringing competitors and crowds together, broadcasting the results, and producing a half-dozen sporting weeklies to stimulate rivalry and delight fans. Daily newspapers and weekly news magazines devoted hundreds of inches of column space to accounts of professional and amateur racing.

Nor was rowing confined to the male sex (fig. 7). Women rowed in their own regattas during these years, but they did not compete as frequently as men, and consequently were unable to achieve equivalent "prowess." The first independently chartered American women's club, ZLAC (an acronym of the initials of the founders), was formed in 1891 in San Diego, although it was preceded by rowing programs at some women's colleges, such as Smith and Wellesley. Periodicals that catered to sportsmen regularly reported on women's rowing matches, noting the positive impact of female participation in "masculine" activities. "The mere presence of a woman is refining," wrote one reporter, "when she smiles on sport the smile is potent. Muscular games have a tendency to lead us into barbarism, therefore it is important to throw around them the restraining influence of society." Rowing especially was recommended as a

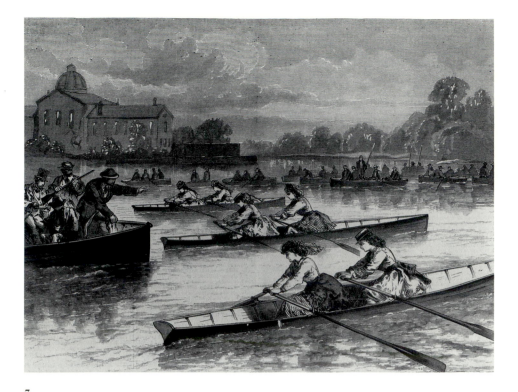

7
Regatta of Empire City Rowing Club at Harlem—The Ladies' Double-Scull Race. Wood engraving,
Frank Leslie's Illustrated Newspaper, October 14, 1871, p. 69. Collection of Thomas E. Weil, Jr.

corrective to the perceived idleness of affluent women; the benefits included not only better health but an irresistible way to attract male attention.[6]

By 1860 there was a growing sense that Philadelphia was lagging behind other cities in developing its rowing potential. In 1867 the commodore of the Schuylkill Navy announced that the city, with its flat, gently curving Schuylkill River ideally suited to sculling, was going to become the supreme boating city in America.

A three-day regatta opened on June 10, 1867; among the events was the race for the first single-scull championship of the Schuylkill. Eakins' boyhood friend Max Schmitt was one of the oarsmen who entered the contest. At Fairmount Park, the site of the racecourse, there were huge crowds—"a surging mass of anxious humanity, men, women, and children"—who covered every inch of the river-banks, shores, and bridges, while the river itself was "dotted. . . with innumerable craft gaily decorated with flags and streamers."[7] Schmitt won the championship, rowing against his fellow Pennsylvania Barge Club member Austin Street. Eakins heard of Schmitt's victory while still in Paris. "I have got an account of Max's triumph," he wrote to his sister Caroline. "Congratulate Max for me enough to last till I can write him a letter, I am very glad he has beaten Street so."[8]

8

James Hammill and Walter Brown, in their Great Five Mile Rowing Match for $4000 and The Championship of America, 1867. Lithograph by Currier & Ives. Collection of Thomas E. Weil, Jr.

The Champion Single Sculls

It was fitting, then, that Eakins' career as an artist was launched with a rowing portrait of his old friend. *The Champion Single Sculls* was Eakins' first homage to an athlete and expressed unequivocally his commitment to contemporary subjects. Exhibited for three days in April 1871 at the Union League of Philadelphia, the painting had no precedent in fine art. (The few earlier American paintings of scullers that exist are largely naive renderings.) Most European boating pictures routinely depicted gentlemen in yachting uniforms and holiday rowers at leisure. By portraying the rower in the act of his chosen sport, Eakins not only rejected European tradition but appropriated a subject of popular journalism and culture. With the growing popularity of rowing as a spectator sport in the 1860s, rowing images proliferated. Lithographs and wood engravings of courting couples, regattas, and boating parties appeared in magazines, sheet music covers, and newspapers (figs. 9–11). The first print (other than newspaper and magazine illustrations) of American professional rowers was issued in 1867 by Currier & Ives, in honor of James Hammill and Walter Brown (fig. 8). Champion rowers had now become celebrated sports heroes, their images purchased and framed for display on the walls of private homes.

The Champion Single Sculls is a landmark in the history of American realism. It shares with Whitman's poetry a "determination to break down esthetic barriers to the acceptance of raw-

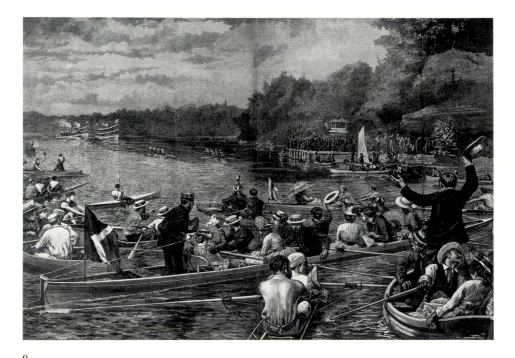

9
A College Regatta. Wood engraving from a drawing by A.B. Frost.
Harper's Weekly, July 17, 1880, pp. 456–57. Collection of Thomas E. Weil, Jr.

boned, athletic Americans as emblematic of the best qualities of the nation's citizens."[9] Eakins' paintings, like Whitman's poetry, and the era itself, celebrated the value of the strenuous life. In 1868, an observer of American culture noted:

No recreation, no method of exercise, no out-door or in-door sport, offers less temptations and more advantages than rowing. In truth, excellence as an oarsman is wholly inconsistent with dissipation or excess of any nature. Regular habits, constant exercise, open-air life, and plain food, are essential to every man who aspires to endurance, skill, and rowing fame. There is no more certain way of fitting the mind and heart for vigorous labor and the reception of careful culture than by putting the body in perfect condition. Let this work of physical culture go on until every American shall deem it as important to educate the body as to train and improve the mind.[10]

Eakins' portrayal of Schmitt, the democratic hero who excels at a demanding, competitive task, coincided with the popular perception of rowing as an antidote to the excesses of the Gilded Age. Complex and ambitious, *The Champion Single Sculls* was at once a summary of all the lessons that had shaped Eakins and an extraordinary assertion of self and place. It projected a new kind of vision: objective recording based on close observation, without reference to rhetoric or sentiment.

This truly modern work embodies the theory of art Eakins had formulated during his study in Europe: "In a big picture you can see what o'clock it is afternoon or morning," he had written his father,

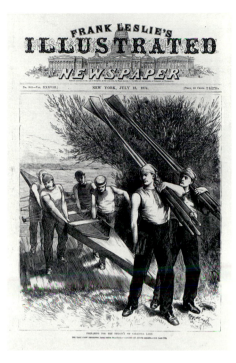

10 Sheet music cover for a duet, "Light May the Boat Row," originally published in 1836. Lithograph, published in New York.

11 *Preparing for the Regatta on Saratoga Lake, The Yale Crew Returning from Their Practice.* Wood engraving from a sketch by Joseph Becker. *Frank Leslie's Illustrated Newspaper,* July 18, 1874, cover. Collection of Thomas E. Weil, Jr.

if its hot or cold winter or summer & what kind of people are there & what they are doing & why they are doing it.. . . . If a man makes a hot day he makes it like a hot day he once saw or is seeing if a sweet face a face he once saw or which he imagines from old memories or parts of memories & his knowledge & he combines & combines never creates but at the very first combination no man & less of all himself could ever disentangle the feelings that animated him just then & refer each one to its right place.[11]

The Champion Single Sculls is just such a palimpsest. On one level, it is about a kind of extreme (and alleged) realism; on another, much is contrived; and on a third, the work is highly personal. Informed by Eakins' own experience as an accomplished oarsman, it is simultaneously a depiction of a famous sculler, a sporting subject and, on a subtler level, a revealing self-portrait.

The Champion Single Sculls commemorates the victory of the great amateur oarsman Max Schmitt (fig. 13) in the three-mile race for the single-scull championship of the Schuylkill Navy Regatta in Philadelphia on October 5, 1870.[12] This race generated greater interest than any race to date, for it drew four competitors, the first time since the single-scull championship was inaugurated in 1867 that more than two competitors were entered. The three-mile

course on the Schuylkill River ran from Turtle Rock to Columbia Railroad Bridge and back (fig. 12). Eakins was present as Schmitt won easily, finishing with the impressively fast time of twenty minutes.[13]

Eakins chose to memorialize Schmitt not at the moment of the rower's greatest triumph, however, but at practice on the Schuylkill one still, clear autumn afternoon. As Schmitt straightens out from a turn and glides left, his oars are almost horizontal, or feathered, the blades lying on the water's surface and trailing as the scull continues the momentum of its run at the finish of a stroke. Schmitt holds the ends of the handles of each oar together in his left hand, while his right hand rests on his thigh in a moment of partial relaxation. His face is turned toward the spectator and he seems to exist in a space virtually continuous with our own. The strong late afternoon sun that illuminates his face, arm, and shirt also strikes the stocky figure of Eakins, who has taken the aesthetic liberty of embedding himself in the scene, in a scull, rowing into the right middle distance. In a nod to his master Gérôme, who had signed and dated *The Prisoner* on the boat, Eakins inscribed his name and the date on the stern end of the washbox (see frontispiece). The two friends have met and passed each other, Schmitt now momentarily at ease, Eakins hard at work. The earth-colored austerity of the riverbanks and trees is relieved by the thickly painted blue sky, enlivened by a few thin clouds and punctuated with scattered touches of red—in the bridge in the distance, the boat at the left, the artist's belt, and the inscription "Josie" (for his sister) on Schmitt's scull.

Signs of cultural change resonate throughout the scene. In the far distance, a puff of white identifies a steamboat, a technological contrast to the manual exertions of the scullers; near the left shore, a heavy, red old-style boat with two rowers and a coxswain in old-fashioned Quaker garb play off against the bare-headed and sleeveless-shirted Schmitt in his sleek contemporary shell (fig. 66). The eighteenth-century stone house at lower right is a counterpoint to the mid-nineteenth-century mansion "Sweetbriar," seen above it on the brow of the hill in Fairmount Park. Similarly, the historic Girard Avenue Bridge in the distance is countered by the Connection Bridge, with a train puffing across from the right.

As Eakins' own title makes clear, Schmitt has *already* won. The painting is a wholly contrived studio production—informed, as Elizabeth Johns was the first to note, by details that recreate the time and setting of the championship race. The late afternoon light restates the 5 p.m. start of the contest; the leafless trees along the left bank and the autumn-tinged landscape retell the early October season of the event; the houses and double bridges mark the particular three-mile amateur course that Schmitt rowed in the very scull depicted. The passage of time, the invocation of past action and achievement, becomes a potent element in this multilayered scene.

Although *The Champion Single Sculls* is primarily a portrait of Schmitt and secondarily a sporting picture, it may also be read as a self-portrait and a metaphor of artistic struggle. In a

THE ROWING COURSES USED ON THE SCHUYLKILL RIVER.

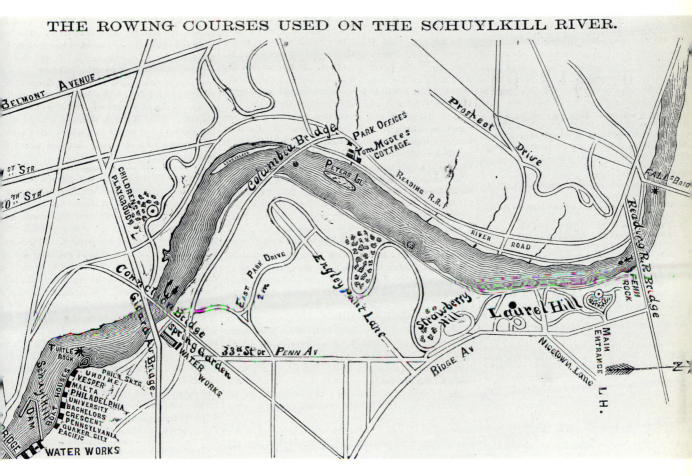

12
"The Rowing Courses Used
on the Schuylkill River."
Turf, Field and Farm, June 14, 1872.

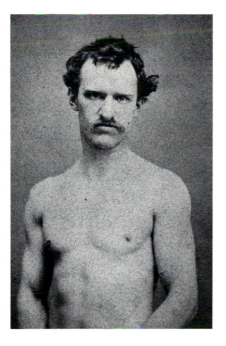

13
Schreiber and Son, *Max Schmitt,*
c. 1871. Albumen print, 4 ³⁄₁₆ x 2 ½ in.
(10.6 x 6.4 cm). Collection of
Mr. and Mrs. Daniel Dietrich II,
Philadelphia.

letter to his father from Paris in 1868, Eakins had described the "big" artist as one who navigates a vessel by himself:

[H]e's got a canoe of his own smaller than Nature's but big enough for every purpose. . . . With this canoe he can sail parallel to Nature's sailing. He will soon be sailing only where he wants to selecting nice little coves & shady shores or storms to his own liking, but if ever he thinks he can sail another fashion from Nature or make a better shaped boat he'll capsize. . . .[14]

Eakins is describing the artist's freedom to invent, within the boundaries of nature. At the same time, he believes that the great artist, like the champion rower, controls his own destiny through skill and knowledge, experience and memory. Schmitt, in the center of the composition as champion, controls the scene; having already achieved his goal, he can now rest on his oars. By contrast, Eakins, a recreational rower, is nearing the end of a stroke, rowing with some pressure, the effort evinced by the strain on his arms and back. Unlike Schmitt, who is relaxed enough to turn from his practice to acknowledge the viewer (and the artist), Eakins is completely absorbed in his task. About to take another stroke, Eakins the sculler is at the point of maximum kinetic energy just as Eakins the artist is similarly poised at the threshold of maximum artistic achievement.

That Eakins chose rowing as the theme of his first major work is not surprising. Although he believed that the most profound artistic truths were best expressed through the human figure, American social attitudes discouraged nude subjects. The seminude, muscular rower allowed him to demonstrate his Paris-trained skills. Rowing also embodied all that he admired—rigorous discipline and the harmony of mind and body, head and hand. Both the single sculler and the artist test limits: one physical, the other visual. The single scull, like the canvas, is uncompromising, for the slightest awkward movement of the rower affects the stability of the boat.[15] In the contest represented by the painting—by the object itself no less than the subject— artist and rower are victorious. Schmitt is completely relaxed, resting confidently and comfortably in his craft. At first glance the painting, too, seems as effortless and spontaneous as Schmitt's athletic ease. But the apparent directness and simplicity of the moment captured are deceptive. A muscular subject is here laboriously painted, the artist's work hidden behind extraordinary preparation, attention to detail, and largely invisible brushwork. Just as rowing, a sport of rhythmic fluid beauty, is built on precision rather than instinct, on arduous practice and rigorous mental and physical discipline, so the painting itself was constructed from intensive observation and preparation.

The Champion Single Sculls is a tightly reasoned, premeditated work whose refinements of position and proportion suggest the employment of extensive preliminary studies. Eakins, however, invested his working drawings with little artistic importance, usually discarding them after they had served his purpose. Only two preparatory drawings for *The Champion Single Sculls* survive: the charcoal study of the Girard Avenue Bridge and the sketch of an oar

14
Sketch of Girard Avenue Bridge, c. 1871
Pencil on paper
4 ⅛ x 6 ⅞ in. (10.5 x 17.5 cm)
Hirshhorn Museum and Sculpture Garden, Smithsonian Institution,
Washington, D.C.; Gift of Joseph H. Hirshhorn, 1966
(photo: Lee Stalsworth)

15
Sketch of an oar, verso of fig. 14

16
Thomas Eakins, *Kathrin (Girl with a Cat)*, 1872. Oil on canvas,
62 ¾ x 48 ¼ in. (159.4 x 122.6 cm). Yale University Art Gallery,
New Haven; Bequest of Stephen Carlton Clark, B.A. 1903.

on the verso (figs. 14, 15). Since there exist elaborate perspective drawings for the later rowing paintings, it is reasonable to assume that Eakins followed the same procedure for *The Champion*—executing precise pencil and wash drawings of perspective, reflections, and waves, as well as quick plein-air sketches in charcoal and broadly painted studies in oil to record basic forms in light and dark.

The Champion is distinguished by linearity and classical composition. Eakins conveys Schmitt's stability and mastery through the largely horizontal composition in which the sculler, placed in the exact vertical center of the picture, controls everything around him. The stable position of his body, scull, and oars is further strengthened by the reiteration of the forms as reflections in the water. The portrayal of Schmitt is exquisitely rendered with invisible brushwork, and the bridges are executed with the precision of a master draftsman. Although Eakins would later urge his students to draw with a brush, traces of pencil outlines are still visible in the bridges and Schmitt's scull. In contrast to the precision of these elements, the foliage in the left foreground and right distance is rendered with soft strokes of opaque color, applied irregularly and without articulation. The composition also has a strong geometric character. By positioning Schmitt on the central axis of the composition and having him directly confront the viewer, Eakins makes the champion both the focal point of the scene and its agent of symmetry and balance. Just as Eakins' self-portrait can be read as a trope for his career potential, so Schmitt is a symbol of those traits of command and independent tenacity that Eakins would most admire and depict throughout his life.

With *The Champion Single Sculls* Eakins announced that he was an artist to be noticed. The reviews of his debut, however, were mixed. The *Philadelphia Evening Bulletin* noted that the artist "lately returned from Europe and the influence of Gérôme, has . . . a picture entitled *The Champion Single Sculls*, which, though peculiar, has more than ordinary interest. The artist, in dealing so boldly and broadly with the commonplace in nature, is working upon well-supported theories, and, despite somewhat scattered effect, gives promise of a conspicuous future." The critic added: "A walnut frame would greatly improve the present work."[16]

The *Philadelphia Inquirer* was somewhat less encouraging: "Thomas Eakins shows . . . a river scene entitled 'The Champion Sculls.' While manifesting marked ability, especially in the painting of the rower in the foreground, the whole effect is scarcely satisfactory. The light on the water, on the rower, and on the trees lining the bank indicate that the sun is blazing fiercely, but on looking upward one perceives a curiously dull leaden sky."[17]

Eakins was undeterred. Over the next three years, in an extraordinary creative burst, he completed close to sixty paintings, drawings, and watercolors, roughly half of them about rowers and rowing. This prolificacy, however, came at an emotionally difficult time for him. Always close to and protective of his mother, he was anxious and sad about her deteriorating mental health. The exact nature of her condition is not clear, but she seems to have suffered from

some form of manic-depressive disorder, which had first struck a few months after Eakins' return from abroad. She died on June 4, 1872, age fifty-two, of what the death certificate recorded as "exhaustion from mania."[18] At a period when so much in his personal life seemed unsettled and out of control, the unambiguous, objective analysis of an artistic problem no doubt offered Eakins a certain comforting structure.

During these same years, Eakins continued to paint portraits of his family and friends. For these he employed the earthy palette and expressive brushwork that reflected his exposure to the seventeenth-century Spanish painters, especially Velázquez and Ribera, and to Rembrandt. His portrait of Kathrin Crowell, to whom he was engaged from 1872 until her death in 1879, is typical (fig. 16).

Eakins and the Biglin Brothers

The rowing images Eakins produced through 1874 survive in an exceptional series of perspective drawings, oil studies, watercolors, and finished oils.[19] In them he investigated all aspects of the sport he loved, portraying single rowers in sculls and pairs and fours in sweep shells, showing them at practice or in contest, close to the viewer or in the distance, on a wide expanse of river or sheltered by the pier of a bridge. But the most frequent model was no longer a close friend. Instead, Eakins was inspired by the performance of the Biglin brothers of New York in a historic rowing contest (fig. 17).

In January 1872, the celebrated professional oarsmen John and Bernard (Barney) Biglin had issued a challenge for any two men in England to row against them in a pair-oared race. The brothers had most often rowed together in four-oared shells, and in fifteen races they had been victorious in all but one.[20] Essentially, there are two types of rowing: "sculling," in which each rower (or "sculler"), singly, in doubles, or quads, pulls two oars (or "sculls"), one in each hand; and "sweep rowing," in which each rower, in a pair, four, or eight, pulls with both hands on one longer oar, either on the port or starboard side of the shell. Pair-oared racing was widely practiced in England but was almost unknown in America, and the Biglins hoped for an international contest for the first time upon American waters. When no English rowers responded to their call, Henry Coulter, the prominent rower from Pittsburgh, successfully argued that the match be extended to American competitors. He and Lewis Cavitt (who had never rowed a professional race) took up the challenge. The race, for a purse of $2,000, was set to take place on the Schuylkill River on Monday, May 20, 1872. The five-mile course ran from just above the Reading Railroad Bridge to Connection Bridge (a little north of the Girard Avenue Bridge), where the racers turned at two stake-boats anchored 25 yards apart, leaving only room enough at the stake for a free turn, and rowed back to Reading Bridge (fig. 18).[21]

Considered by many rowers to be the most difficult form of propelling a boat, pair-oared racing requires great skill and precision, and two oarsmen who are very evenly matched. Close in age

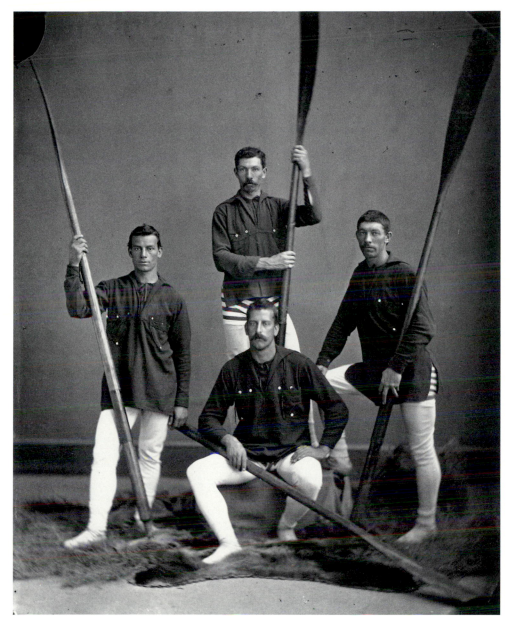

17
William Notman, *The Biglin Crew, International Regatta at Halifax,
Nova Scotia*, August 31, 1871. Notman Photographic Archives, McCord
Museum of Canadian History, Montreal. (Left to right: Joseph Kaye, Jr.,
Henry Coulter [seated], Barney Biglin, John Biglin).

18

The Schuylkill River Racecourse, Selected for the International Rowing Matches. Engraving.
Historical Register of the Centennial Exposition, 1876. Collection of Thomas E. Weil, Jr.

and size, the Biglins had been rowing together since the late 1850s.[22] "They are both dapper fellows, about the medium height, well formed, and with a very determined cast of countenance," reported the *Philadelphia Press*. "They are both in their prime, and have made the art of rowing a study most of their lives."[23] At the time of the race, Barney was thirty-one years old, 5 feet 9 ½ inches tall, 151 pounds, and he had great endurance; he held a position in the New York Customs House.[24] John was twenty-eight years old, 5 feet 9 ¾ inches tall, and weighed 161 pounds; he worked at different times as a fireman, mechanic, laborer, and boatman.[25]

From the early 1860s to the early 1870s, John Biglin dominated the sport as a single sculler, winning almost every race he entered; by about 1867 or 1868, there were few rowers willing to race him.[26] In 1872, when Eakins came to know him, he was single sculls champion of North America. John Biglin was often praised for having the ideal rower's physique: "[T]hough an admirer of a smooth, round face, body and limbs might be better pleased with [Henry] Coulter's appearance, *connoisseurs* would choose John Biglin for a model at once, as showing a general development hard to equal." Another admirer wrote: "As a single oar puller or sculler there are few among our oarsmen more to be depended on than he, as besides being skillful and experienced in the art, he is endowed with great strength, presenting in appearance the perfect picture of an athlete."[27]

As the first pair-oared contest in this country, the May 20, 1872 race on the Schuylkill attracted a great deal of attention. Almost three weeks before the race, the oarsmen came to Philadelphia to train on the actual course and to break in their shells, which were constructed of Spanish cedar and had sliding seats, the latest improvement in rowing technology.[28] The *Philadelphia Press* proudly reported that the Biglins were "delighted with our park and our magnificent river Schuylkill" (fig. 18).[29]

The Biglins were the Philadelphians' favorites. Crowds gathered daily to watch the brothers practice, and anticipation about the contest grew. "Their rowing since their arrival here has been much admired for the grace and ease manifested in every motion, and betting has been decidedly in their favor."[30] Eakins came to know the brothers during their weeks in Philadelphia, and was clearly impressed by them. Over the next two years, he would depict John and Barney Biglin together in three oils and one watercolor and John Biglin alone in one oil and four watercolors.

The Pair-Oared Shell

The first painting in the Biglin series was *The Pair-Oared Shell* (fig. 19).[31] Painted a year after *The Champion Single Sculls,* it is remarkably different in conception. In the earlier painting, the deep space of the view down the river and the focus on several separate elements at once—Schmitt, the bridge, the landscape, Eakins in his scull—make it difficult to resolve the

various parts into a pictorial whole. In *The Pair-Oared Shell*, the elements have been reduced to the essentials: shell, rowers, the pier of the bridge behind them, and the generalized line of trees on the opposite west bank of the river. The result is a bold composition of broad vertical and horizontal bands held in tension by the figures.

Eakins shows the brothers alone in a practice run on the Schuylkill just before sunset, about to pass beneath the massive stone pillars of the old Columbia Railroad Bridge. In the lengthening shadows of the dying afternoon, the mood is private and contemplative as the shell glides past us just inches off the water. John is in the stroke position, closer to the viewer; Barney occupies the bow seat. With their heads up and turned slightly toward the spectator, they are just past the midpoint of a light paddle stroke, their bodies and timing uniformly matched. The countless hours of arduous practice, the calloused hands and sore muscles, the short breath and burning arms and legs are all concealed by a sense of balance and harmony. Like the river itself, the stroke is flowing and continuous.

The sky is rendered in loose herringbone strokes of gray-blue, its painterly textured surface in contrast to the methodical, somewhat dryly painted foreground waves and reflections (which are constructed through small horizontal strokes in descending width toward the shell, allowing the darker underpainting to show through in places). Dressed in dark knee breeches and blue-trimmed shirts, their heads covered with dark blue scarves, the oarsmen are broadly treated, their muscular bodies built up with glazes and impasto strokes. A halo-shaped pentimento around the head of Barney, at left, reveals that Eakins altered the original pose to the present, more upright one. The highlights on the rowers' bodies and the shell receive the most detailed treatment—tactile, raised, and applied in bright yellow with a pointed brush, while the mellow light that suffuses the whole is achieved through a general brown tonality, the result of the final glazing.[32] Eakins' pupil, Charles Bregler, recalled that Eakins generally used permanent earth pigments and that brilliant colors were not part of his palette; the colors we see today, many of which are low key, are the colors he chose.[33]

The expressive character of *The Pair-Oared Shell* is built upon precision. To establish the composition exactly, Eakins made large, detailed perspective drawings, two of which survive. In one he fixed the position of the empty shell on the river (fig. 20); in the other he studied the pattern of reflections in the water (fig. 21). In their analytical intensity, Eakins' studies for his rowing series are unique in American art. He had a firm grounding in perspective drawing, and he delighted in the exactness which such a mathematical and conceptual approach afforded.[34] He would later tell his students: "A boat is the hardest thing I know of to put into perspective. It is so much like a human figure, there is something alive about it. It requires a heap of thinking and calculating to build a boat."[35]

The first drawing is so precise in its recording of the dimensions of the Biglin shell, its location on the river, the distance of the boat from the spectator, and the position of the sun that

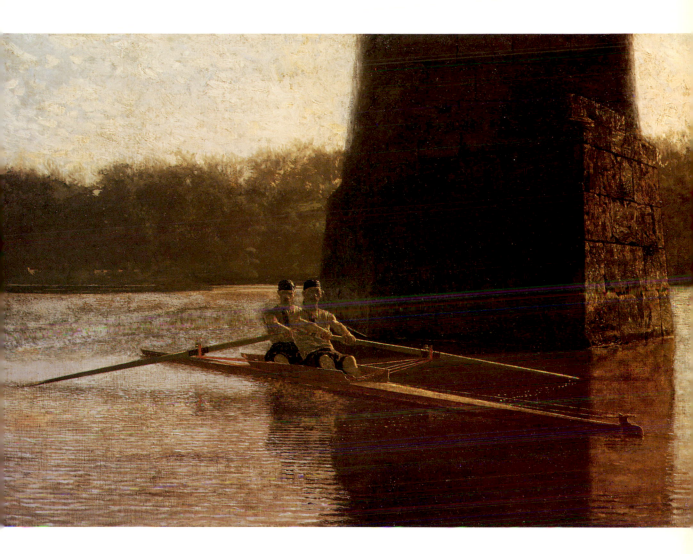

19

The Pair-Oared Shell, 1872
Oil on canvas
24 x 36 in. (61 x 91.4 cm)
Philadelphia Museum of Art; Gift of Mrs. Thomas Eakins
and Miss Mary Adeline Williams

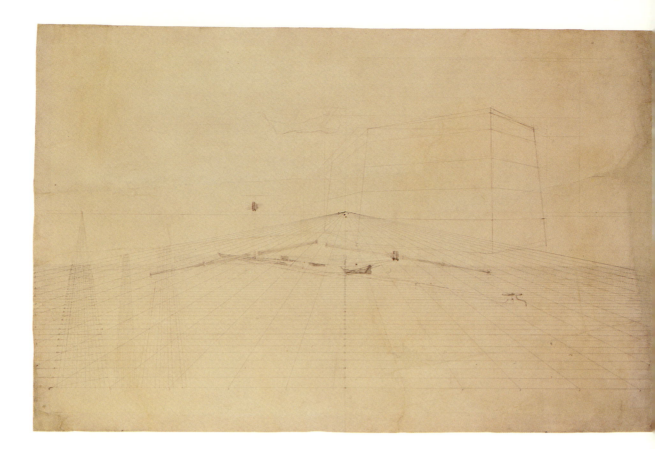

20

Perspective Drawing for The Pair-Oared Shell, c. 1872
Pencil, ink, and wash on paper
31 1/16 x 47 1/8 in. (78.9 x 119.7 cm)
Philadelphia Museum of Art; Purchased with the
Thomas Skelton Harrison Fund

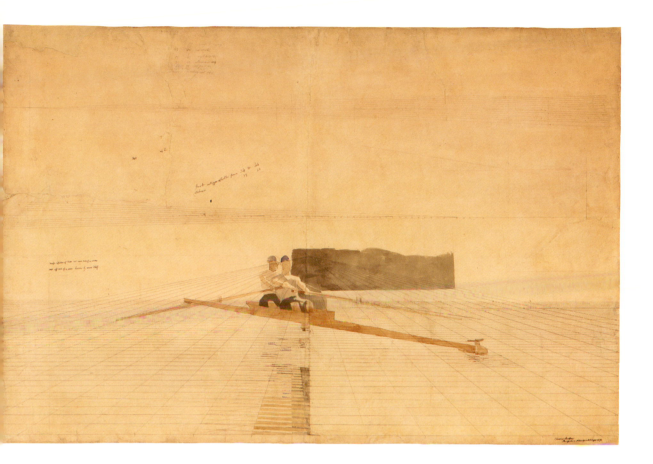

21

Perspective Drawing for The Pair-Oared Shell, c. 1872
Pencil, ink, and watercolor on paper
31 13/16 x 47 9/16 in. (80.8 x 120.8 cm)
Philadelphia Museum of Art; Purchased with the
Thomas Skelton Harrison Fund

Theodor Siegl was able to determine that the time depicted was shortly before 7:20 p.m. in early June or mid-July, 1872.[36] The second drawing exactly repeats the grid, pier, and boat of the first, but Eakins then added the rowers in broad strokes of pale, precise washes, their spare, secure rendering implying the use of individual figure studies (now lost). Eakins created his own system for representing reflections in the water. As Darrel Sewell points out, the artist "broke the water's surface into tilted planes containing fragments of color from the boat, the pier, and the clothing of the rowers, and made notations on the drawing as to where a reflection might fall. . . ."[37] "There is so much beauty in the reflections," Eakins wrote, "that it is generally worth while to try to get them right."[38] And he did, for one of the most striking features in all the rowing paintings is the convincing treatment of reflections in the water.

The Pair-Oared Shell was not known to a wider public until seven years after it was completed, when it was shown in 1879 at the National Academy of Design in New York; in 1881, it was exhibited at the Pennsylvania Academy of the Fine Arts. The reviews echoed the ambivalence many viewers still had toward a depiction of athletic prowess as an appropriate subject for art. The painting came as "a shock to the artistic conventionalities of Philadelphia," wrote Eakins' friend and pupil William J. Clark, Jr., in the *Philadelphia Evening Telegraph.* The *New York Herald* dismissed it as "decidedly photographic," and *The American Art Review* described it as a "scientific statement of form, rather than as embodiment of movement and color." It remained for *The New York Time*s to recognize the painting's merits:

Scant justice has been done a genre picture by Thomas Eakins, of Philadelphia, which hangs in the West Room. . . . [I]t will be found remarkable for good drawing, natural and quiet composition, and a pleasant feeling in the color. . . . In a less technical sense, it is also an entrance into a sphere of human activity where one might have expected artists would have sought for subjects long ago. . . . If it were possible to conceive that an artist who paints like Mr. Eakins had a poetic impression, we would like to think that in this composition he had tried to express the peculiar charm that every one has experienced when rowing out of the sunlight into the shadow of a great bridge.[39]

The Biglin Brothers Racing

Having shown the Biglins at practice, Eakins portrayed them in the race itself in the next two paintings in the series, *The Biglin Brothers Racing* and *The Biglin Brothers Turning the Stake* (figs. 22, 26). On the day of the contest an estimated 30,000 people crowded the shores of the river, gathering anywhere that afforded a good view of the course. Carriages and other vehicles occupied the brow of every hill. The river itself bobbed with handsome barges and shells of the clubs of the Schuylkill Navy, steamboats, pleasure yachts, and scores of small craft, many gaily decked with colorful bunting, which added to the air of excitement. Just before the race was called, a drenching rain began to fall, the stormy gusts and high winds roiling the

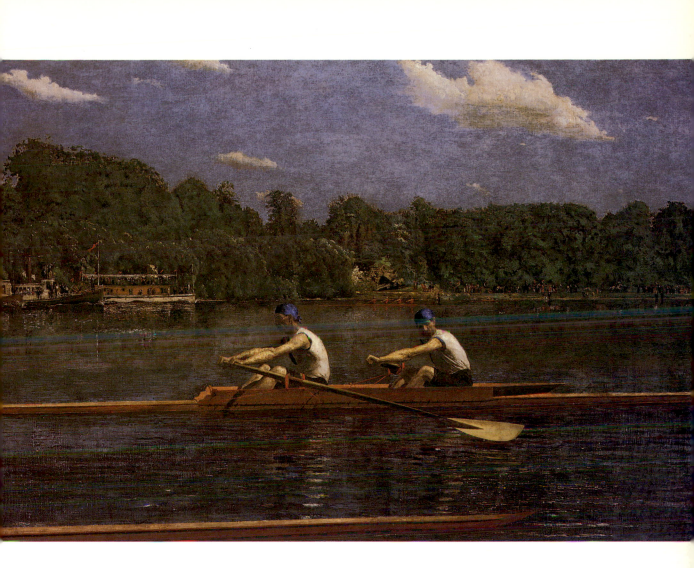

22
The Biglin Brothers Racing, 1872
Oil on canvas
24 ⅛ x 36 ⅛ in. (61.3 x 91.8 cm)
National Gallery of Art, Washington, D.C.; Gift of Mr.
and Mrs. Cornelius Vanderbilt Whitney, 1953

OVERLEAF
23
The Biglin Brothers Racing,
detail of fig. 22

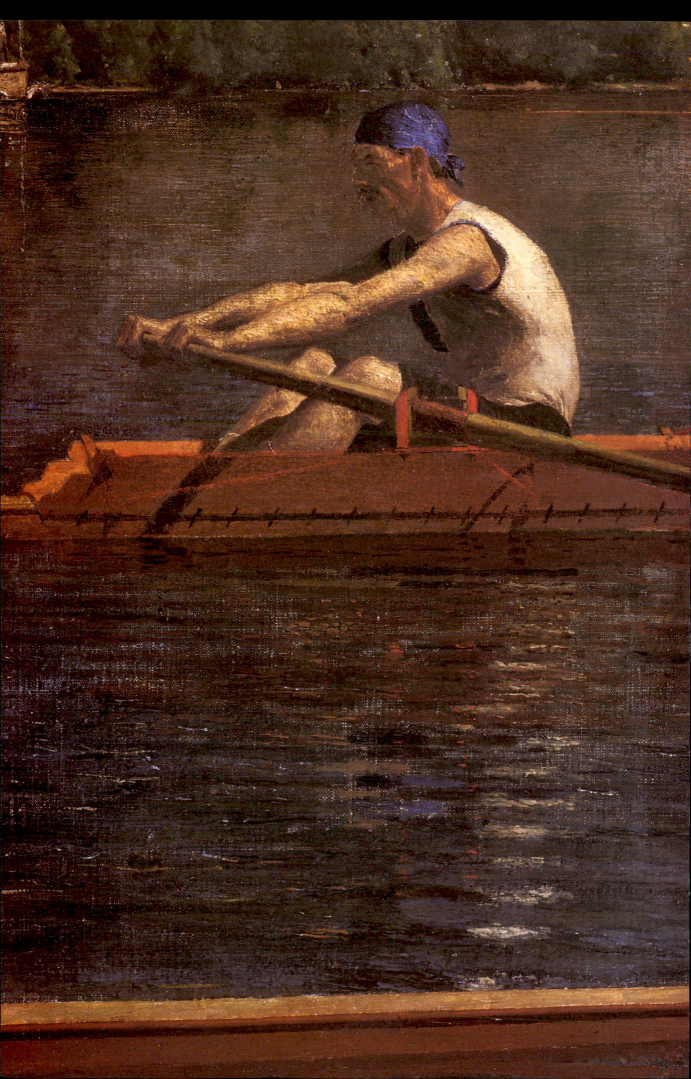

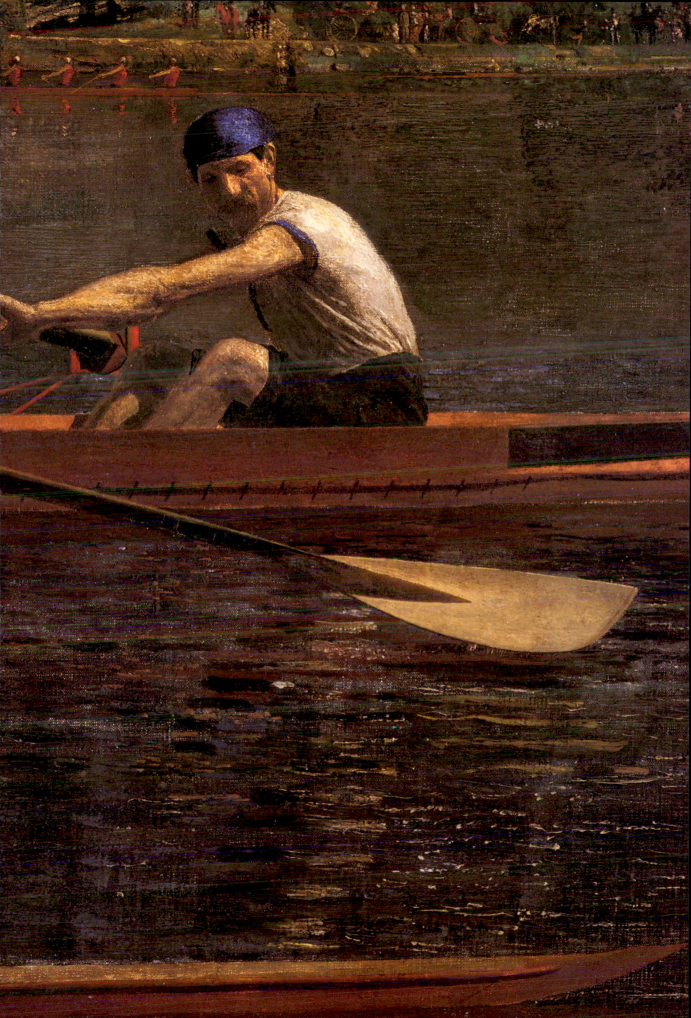

normally quiet Schuylkill. Coulter and Cavitt refused to row until the wind and water calmed down. The great crowds remained, determined to witness the outcome of America's first professional pair-oared race.[40]

About 4 o'clock the Biglins made their appearance in their boat, the Judge Elliott—a beautiful model, 35 feet long, 15 inches wide, and 6 inches deep amidships, and weighing 40 pounds; built by Charles B. Elliott, of Greenpoint [now Brooklyn], in whose compliment she was named. The occupants of the boat were dressed in blue flannel half-breeches, close fitting armless shirts, and wore a blue silk handkerchief about the head. They rowed around for awhile, and elicited the admiration of those on shore by the manner in which they handled the oar.

Shortly after 6 o'clock the wind lessened materially, the Schuylkill's surface becoming quite smooth, so that the referee . . . called the boats into line. This brought out the Coulter crew, in the Twin City, which boat was built by Coulters. She is 36 feet long, 15 inches wide amidships, and 7 deep, 5 ½ inches deep at the stem and 4 ½ inches at the stern. She weighs 50 pounds, and no rudder is used in steering her. [The Biglins used a rudder.] Coulter and Cavitt wore red half-breeches, and were bare to the waist, including the head, the hair of which was closely shaven.[41]

Another reporter gave a detailed account of the surprising turn of events:

The Biglins won the toss for choice of position, and . . . selected the inside, nearest the shore, . . . Coulter and Cavitt starting from the judges' boat; at 6:40 P.M. the referee . . . fired the pistol, . . . the signal for the start. Coulter and Cavitt got away handsomely, gaining half a length, as the Biglins seemed to be taken by surprise and were slow to start, and then unsteady. Coulter and Cavitt . . . held a good course, rowing handsomely at 41 strokes [per minute] . . . until Peter's Island was reached . . . and they went abroad, pulling off to the west bank, the Biglins passing them rowing 40 strokes, the latter keeping a splendid straight course to the second arch of Columbia street bridge, passing their opponents, who lost more distance by taking the third arch of the bridge, making a gap of about eight lengths between them.

The Biglins reached their turning-stake boat in 15 minutes, and were straightening out on the home course, when Coulter and partner, making a bad approach to their stake-boat crossed their bow; on the way back both crews settled down to 38 strokes and despite a heavy rain rowed finely, Coulter and partner trying hard to close the gap, but without avail.

The Biglins crossed the score in 32.01, beating their opponents by about 50 seconds.

The mass of people on shore, as well as those afloat, shouted and hurrahed until they were hoarse, and for fifteen minutes nothing could be heard but Biglins, hurrahs and tigers.[42]

The Biglins were now world champions.

The Biglin Brothers Racing shows the rowers from a viewpoint on the western shore of the river near the old Columbia Railroad Bridge.[43] Eakins evokes the immediacy of the moment,

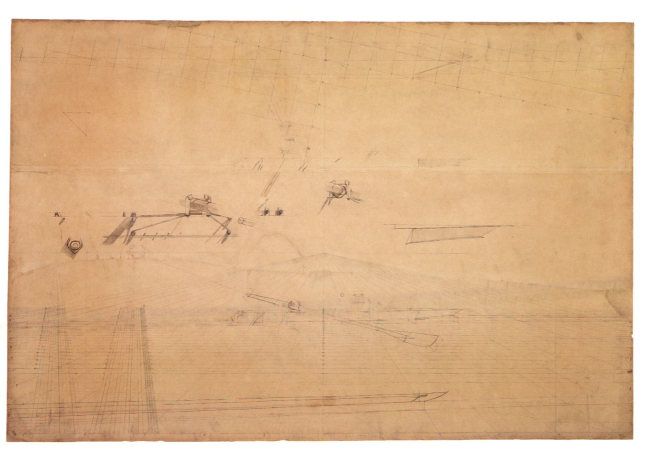

25

Perspective Drawing for The Biglin Brothers Racing, 1872
Ink, colored ink, pencil, and watercolor wash on paper
31 ⅞ x 47 ⅝ in. (81 x 121 cm)
Hirshhorn Museum and Sculpture Garden, Smithsonian
Institution, Washington, D.C.; Gift of Joseph H. Hirshhorn, 1966
(photo: Lee Stalsworth)

24

Bridge Study, c. 1872
Pencil on paper
8 1/16 x 5 15/16 in. (20.5 x 15.1 cm)
Pennsylvania Academy of the Fine Arts, Philadelphia;
Charles Bregler's Thomas Eakins Collection,
Purchased with the partial support of the Pew Memorial
Trust and the John S. Phillips Fund

not through brushwork (which is non-expressive here), but through composition. Placing the Biglins close to the foreground, he indicates the closeness of the race by showing the bow of the Coulter shell in the foreground, just feet from the brothers' craft. We see the Biglins as if we too are on the water, directly opposite them but out of sight. Although the actual race took place at 6:40 p.m., Eakins evidently believed the light of mid-afternoon better served his artistic purposes, and he set the scene under a clear blue sky punctuated with a few scudding clouds, on a calm river that shows no trace of the afternoon's storm.

The sense of quiet inwardness and private pleasure that permeates *The Pair-Oared Shell* has been replaced in *The Biglin Brothers Racing* with a higher-keyed palette and the bright light of a public event. As the Biglins move forward in their shell, with its bright red oarlocks (the color reiterated in the shirts of the four oarsmen in the distance), their yellow blades are feathered and squaring up for the catch that begins the next stroke. Barney, in the bow seat, glances over at the bow of the competitors' shell to judge their position. John at stroke, body over the keel and eyes fixed astern, is completely absorbed in setting the timing for the Biglins' next stroke (fig. 23). With the arms and back curve of one rower's body an echo of the other's, the brothers present a moment of complete autonomy within a perfect union.[44]

The Biglins were especially admired for the steadiness of their stroke cadences, a characteristic Eakins recapitulates through the measured rhythm of the composition. Just as they dominated the sport in life, the Biglins here dominate the pictorial space, existing on and for the river. Like all the rowing pictures, *The Biglin Brothers Racing* was a studio work, preconceived and invented; nothing was spontaneous or improvised. Some years later, Eakins would tell his class: "When I came back from Paris I painted those rowing pictures. I made a little boat out of a cigar box and rag figures, with red and white shirts . . . blue ribbons around the head, and I put them out into the sunlight on the roof and painted them, and tried to get the true tones."[45] The canvas is divided vertically into thirds and horizontally into four bands, with every element in the scene situated precisely. The Biglins are placed in the center third of the composition, with the tip of John's right hand and the curve of Barney's back marking the outer limits of that space. The Biglins in their shell, which bisects the lower half of the canvas, are completely surrounded by water; at no point do they intersect with the land.

Given the precise nature of the rowers, shell, waves, and reflections in the water, as well as Eakins' academic, conceptual approach to all the rowing pictures, it is safe to assume that the artist executed a number of studies and perspective drawings for *The Biglin Brothers Racing*. However, only one perspective drawing, larger than the painting, survives (fig. 25). The center of the sheet shows detailed studies for the front and rear oarlocks, and below them, a perspective study of the positions of each oar. Eakins also made a small sketch showing what may be a section of the Reading Railroad Bridge, with its distinctive stone posts and voussoirs, just below the Falls of the Schuylkill (fig. 24), which he may have considered using as part of the

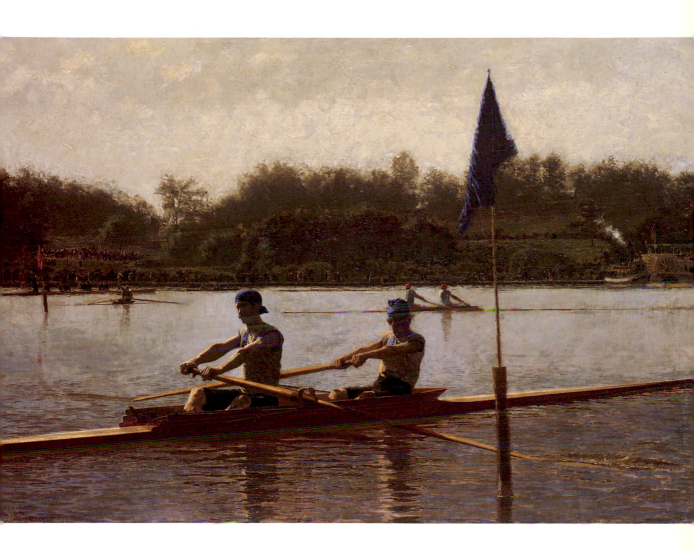

26
The Biglin Brothers Turning the Stake, 1873
Oil on canvas
40 x 59 ½ in. (101.6 x 151.1 cm)
The Cleveland Museum of Art;
Hinman B. Hurlbut Collection

background in the *The Biglin Brothers Racing*.[46] Even in so rough a sketch, he methodically recorded the distance between posts and the width of the bridge.

The Biglin Brothers Turning the Stake

The last picture to show the brothers together is *The Biglin Brothers Turning the Stake*, the largest and most complex painting in the series (fig. 26). "There is, perhaps, no artist in the country who can rival him for originality of conception, for adapting the matter-of-fact elements of our surroundings to artistic use, no one who imprints a sign-manual of individuality so strongly on everything he touches," wrote the critic Mariana Griswold van Rensselaer in 1880 on first seeing this work.[47]

Rendered from a vantage point on the eastern shore, the scene focuses on the delicate mechanics of the moment when the brothers had almost completed the complicated turn, with each oar at a slightly different angle in the water. John, in the stroke position, stares stoically over the stern, his blade buried in the water, while Barney, the bow oarsman who has been rowing the boat around, is just finishing a stroke that almost has the shell pointed properly back down the course to the finish.[48] Although accounts of the race described the Biglins as reaching their "turning-stake boat," Eakins chose to show only their blue-flagged stake in the water, probably to add a strong vertical form in an otherwise horizontal composition. To complete the turn, Barney will need to bring the boat around to starboard a bit more. He glances over at the stake to make sure that they are not too close to it. At this point in the race, the Biglins were three and a half lengths ahead. In the middle distance, their competitors, wearing red, are still at least one length from beginning the turn of their red-flagged stake.

Reports of the race consistently noted that Coulter and Cavitt were bare to the waist and that they wore no covering over their closely shaven heads (see p. 48 above). Rowing with half-nude bodies had become a minor *cause célèbre,* seen by some as a kind of youthful rebellion.[49] Eakins nevertheless chose to clothe Coulter and Cavitt in white shirts and red head scarves. This seems a curious display of modesty for someone as interested as Eakins was in depicting the nude body. But in the studio, observed reality took second place to aesthetic demands. Finding that the composition needed more red and white, he ignored what he had seen in order to create coloristic balance.

The banks of the river are crowded with spectators, some on horseback, others in carriages, and the river is alive with boats of every size and type. In the left distance, Eakins himself is seen in his single scull, signaling with raised arm (fig. 27). Whereas his presence in *The Champion Single Sculls* can be interpreted as a self-portrait of career "potential," in *Turning the Stake* he depicts himself as merely another excited spectator, his own identity as an artist by now having been recognized. The painting style is direct, emotionally exact. Lights and

27 *The Biglin Brothers Turning the Stake,* detail of fig. 26.

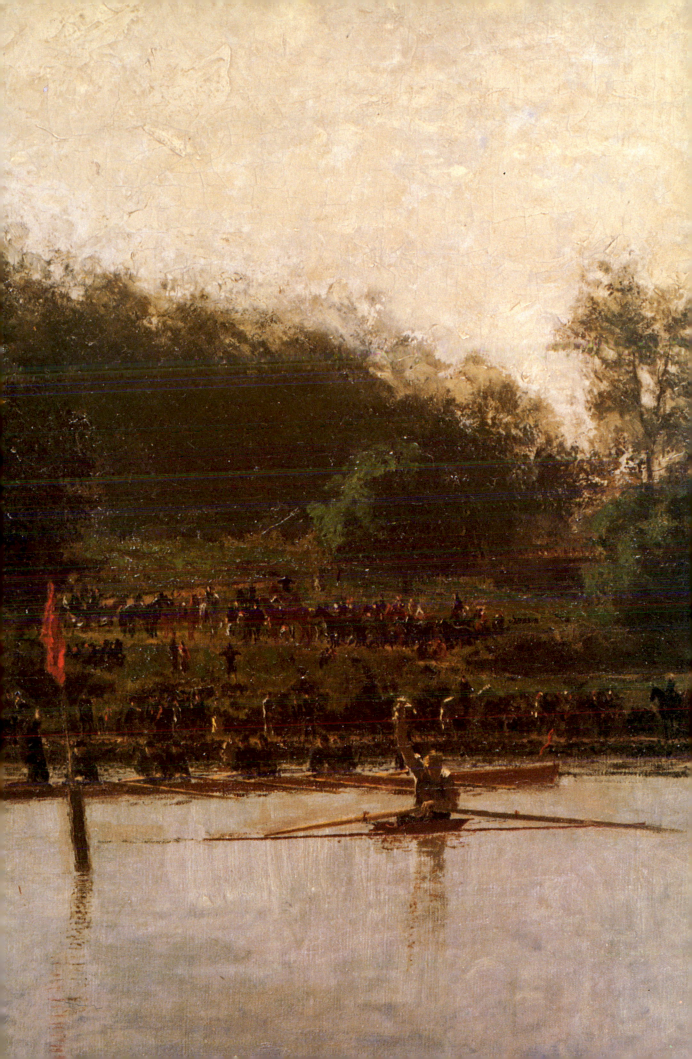

shadows are precisely defined and contrasted. The rowers stand out sharply against the sunlit water behind them, the unveiled light delineating their muscles and intensifying the sensation of physical energy.

One oil study and two perspective drawings for the painting survive. The oil study (fig. 28), which shows the Biglins passing beneath the pier, concentrates on the placement of the rowers' bodies in their shell and their position at oar. In all likelihood, it was painted outdoors, with quick, broad brushstrokes, as Eakins watched the brothers at practice. After the initial plein-air study, the work of picture making moved indoors to the studio, where the task of careful analysis began. "You can copy a thing to a certain limit," he told his students. "Then you must use intellect."[50]

In the larger of the two drawings (fig. 29), Eakins used blue ink to establish the main diagonals of the space and to describe the surface of the water. He then placed the two wood and metal stake flags to assess the space between them, added the shell and detailed renderings of the oars and oarlocks, and, in red ink, located the reflection of the rowers. The second drawing (fig. 30) is considerably smaller and defines the placement of the Biglins on the river in relation to the far shore and their reflections in the water.

Watercolors of the Biglin Brothers

Eakins had recently taken up watercolor, and even in this new medium the Biglins remained a favorite subject. In February 1874, he sent four watercolors to the Seventh Annual Exhibition of the American Society of Painters in Water Color at the National Academy of Design in New York. Three of the sheets were of rowers. Eakins' passion for objective analysis did not go unnoticed. In a review of the exhibition, Eakins' friend Earl Shinn, critic for *The Nation*, drew particular attention to the "remarkably original and studious boating scenes," noting that the artist wished to be known as "a realist, an anatomist and mathematician; that his perspectives, even of waves and ripples, are protracted according to strict science."[51] One of the sheets, now lost, was titled *The Pair-Oared Race—John and Barney Biglin Turning the Stake;* priced at $200, a high sum at the time, it was probably a large or complex work, and may have been the watercolor version of the painting. *The New York Tribune* praised it as "worthy of being closely looked at. It is full of spirit, and thoroughly right in intention; and while there are faults of detail plain to be seen, it is plain, too, that they are failures to get all the truth the artist is honestly striving for, and such failures add not only interest but value to any work. Mr. Eakins's drawings will be looked for with interest. It is not every year there is so prominent a first appearance."[52]

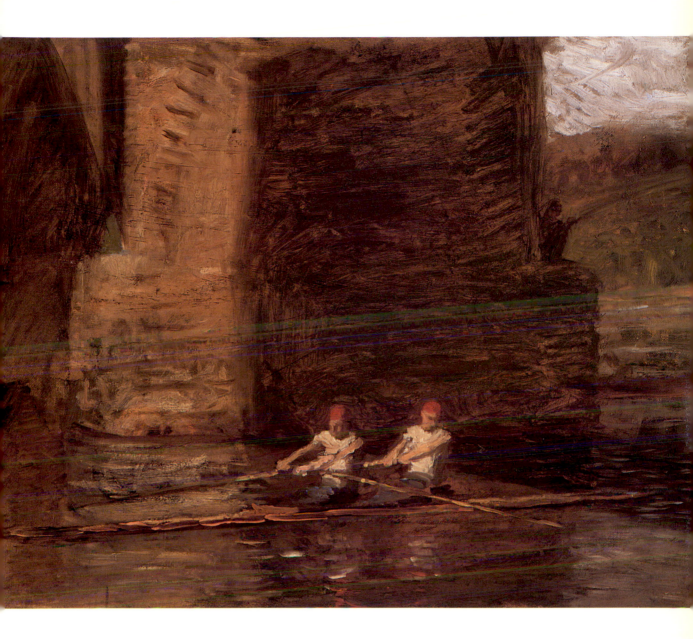

28

The Oarsmen, c. 1873
Oil on canvas
14 x 18 in. (35.6 x 45.7 cm)
Portland Art Museum, Oregon;
Mrs. Blanche Hersey Hogue Bequest

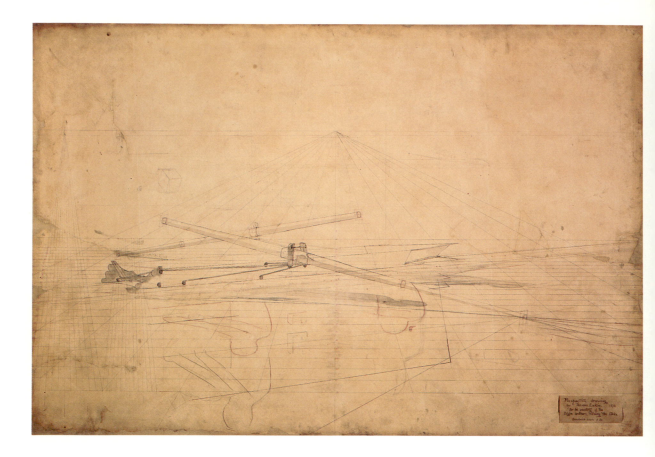

29

Perspective Drawing for The Biglin Brothers Turning the Stake, c. 1873
Pen and colored ink, pencil, and ink wash on paper
31 ⁷⁄₈ x 47 ¹¹⁄₁₆ in. (81 x 121.1 cm)
Hirshhorn Museum and Sculpture Garden, Smithsonian Institution,
Washington, D.C.; Gift of Joseph H. Hirshhorn, 1966
(photo: Lee Stalsworth)

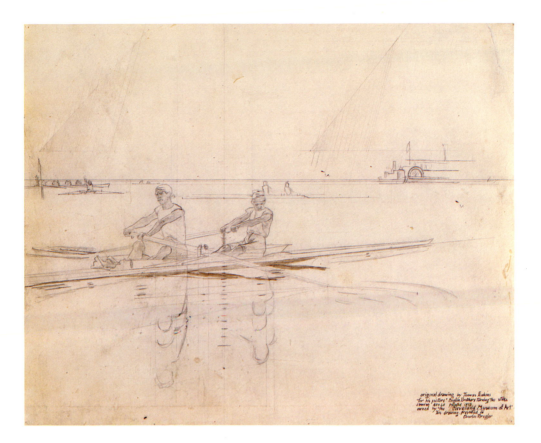

30
Perspective Drawing for The Biglin Brothers Turning the Stake, c. 1873
Pencil and brown wash on paper
13 ¹⁵⁄₁₆ x 17 in. (35.4 x 43.2 cm)
The Cleveland Museum of Art; Mr. and Mrs. William H. Marlatt Fund

The two other watercolors, *The Sculler* and *John Biglin of N.Y., the Sculler,* priced at $80 and $100, respectively, were described as

portraits of rowing and sculling celebrities in their boats, and set in landscapes that are as much to be enjoyed as the men, with their beautifully-ugly muscles, or the skeleton boats—the only exquisitely artistic production of the American, nineteenth century mind thus far. Repeating the old contest of the gods, Nature made a blood-horse as her masterpiece, and man a skeleton-boat as his. Nature, piqued, went one better, and put a soul into her beast, but man put a Biglin into his paper-shell, on which Nature sulked and smiled, and owned the odds were even. Mr. Eakins has struck out a new vein in these subjects, and, barring some slight exaggerations, and some signs of timidity, his work is very clever.[53]

John Biglin in a Single Scull

Eakins made John Biglin his most frequent rowing subject, portraying him alone in at least one oil (fig. 34) and four watercolors, of which two are known. The first watercolor among these single portraits was probably the one recorded in October 1872 as "water color of John in a single shell," hanging in the New York offices of *Turf, Field and Farm.*[54] This may have been the watercolor of a rower, now lost, that Eakins sent as a gift to his French master Gérôme early in 1873. Gérôme responded warmly, complimenting Eakins on his technique. He noted that the general tone of the sky was firm and light, and the water executed in a charming manner. But he criticized the rower's pose, which he thought lacked movement, and concluded, "What pleases me above all, and this in looking forward to the future, is the construction and the building up combined with the honesty which has presided over this work. . . ."[55] By the time he received Gérôme's reply in May 1873, Eakins had already produced *The Pair-Oared Shell, The Biglin Brothers Racing,* and *The Biglin Brothers Turning the Stake.*

In May 1874, after the exhibition of the American Society of Painters in Water Color closed, Eakins sent one of the exhibited watercolors, *John Biglin of N.Y., the Sculler,* to Gérôme. It was a "corrected" version of the watercolor he had sent in 1873. Gérôme replied that he found "very great progress" in Eakins' latest work, and he urged him to continue "in this serious path which assures you the future of a man of talent. The execution is very good, perhaps a little equal all over, a fault which it is necessary to avoid for it is only with the aid of certain sacrifices that one succeeds in giving interest to the principal parts of a picture. . . . Your water-color is entirely good and I am very pleased to have in the New World a pupil such as you who does me honor."[56]

The watercolor that Gérôme praised, now called *John Biglin in a Single Scull* (fig. 32), was based on a mathematically precise perspective study almost twice its size (fig. 31). The water-

color is a luminous work that utilizes the white of the paper and the transparency of the medium to create the impression of light bouncing off the water on a hot day. The sky is rendered in relatively free washes, but most of the sheet is constructed of small, parallel strokes, with the figure modeled in stippling and small patches of wash. Seen against the New Jersey shoreline of the Delaware River, Biglin is portrayed in a classic posture as he approaches the moment of the catch, with the boat running under him and his blade on the feather. The bow of a racing shell appears in the middle distance on a parallel course with Biglin, suggesting a race in progress. It is a well-caught image: Biglin has the concentrated gaze of an oarsman in competition. The shell mirrors the rower's austerity. Weighing less than forty pounds and strapped to the feet like shoes, it is more like apparel than a vehicle. The harmonic flexing of wood and muscle is almost palpable. In the distance, an eight-oared shell follows the race down the course, the crew's red shirts a refrain of Biglin's red headscarf. Before sending this watercolor to Gérôme, Eakins made a replica (the only time he repeated himself), without date or signature, that is slightly larger than the original, has a cooler, more silvery palette, and a more freely washed sky enlivened with prominent clouds (fig. 33).

The oil, *John Biglin in a Single Scull* (fig. 34), has long been thought to have been made in preparation for the watercolor that Eakins sent to Gérôme in 1874. The argument is largely based on the entry in Eakins' record book: "Sketch of Study of a man rowing (John Biglen [*sic*] for water/color)."[57] The unusual procedure of making an oil study for a watercolor expresses perfectly Eakins' meticulous preparation and premeditated approach. The slow-drying oil medium allowed corrections and changes not possible in watercolor, giving him maximum control of his subject before he rendered it in the more fluid medium.[58] Although the watercolor is signed and dated 1873, while the oil is signed and dated 1874 on the reverse, Eakins may have given the oil the later date because he reworked it. The sky shows signs of significant repaintings—the ground is built up of thick layers of dark and light blues, overlaid at the end with palette-knife applications of gray, perhaps a rethinking of the original brighter blue that can be seen at the edges of the stretcher.

The oil is more highly finished than Eakins' usual preparatory work. Biglin is powerfully modeled, his arms and shoulders sculptural in their roundness, like a figure in a relief. Every detail is rendered with Eakins' characteristic attention: the rower's facial features and light brown mustache; his red-trimmed white shirt and knotted red silk headscarf with its wrapped folds; the white rim of his sock; the highlights on his arms and oars; the white curve of his back silhouetted against the water; and even the slight wearing away of the wooden thole pin that acts as a fulcrum for the oar.

Eakins achieved a sense of monumentality and weight by orienting the canvas vertically, the only rowing picture conceived as an upright. The image is framed and cropped, perhaps influenced by his interest in photography. (After 1881, when he acquired his own equipment,

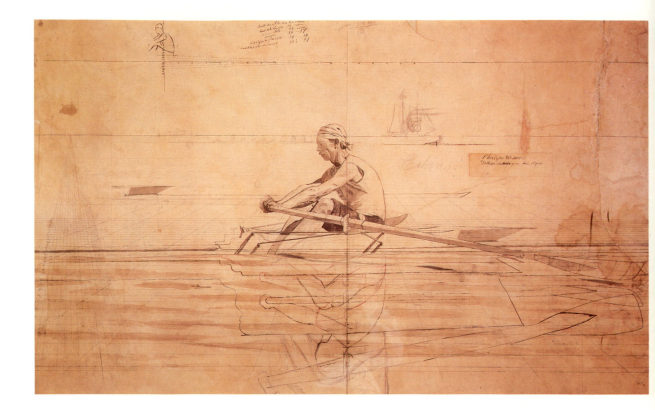

31

Perspective Studies for John Biglin in a Single Scull, c. 1873
Pencil, ink, and wash on two sheets of paper joined together
27 ⅜ x 45 ³⁄₁₆ in. (69.6 x 114.8 cm) (sight)
Museum of Fine Arts, Boston; Gift of Cornelius V. Whitney

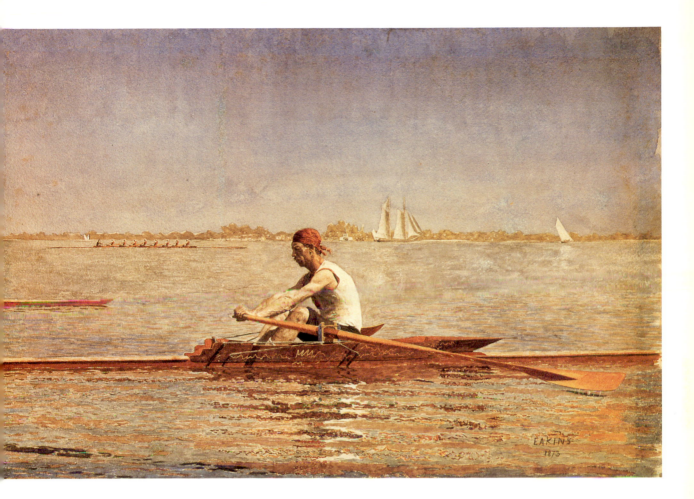

32
John Biglin in a Single Scull, 1873
Watercolor on paper
16 ⅞ x 23 ¹³⁄₁₆ in. (42.9 x 60.8 cm) irregular
Paul Mellon Collection, Upperville, Virginia

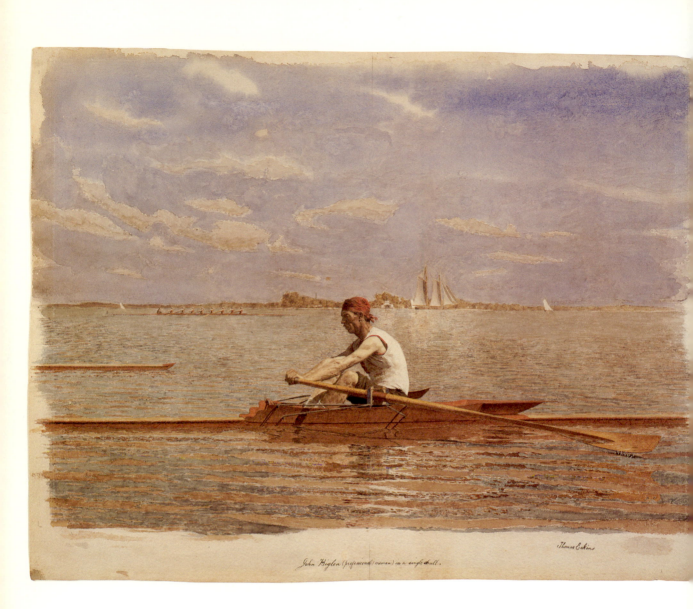

John Biglin (professional woman) in a single scull.

Thomas Eakins

33
John Biglin in a Single Scull, c. 1873
Watercolor on paper
19 ¹⁵⁄₁₆ x 24 ⅞ in. (50.6 x 63.2 cm)
The Metropolitan Museum of Art, New York;
Fletcher Fund, 1924

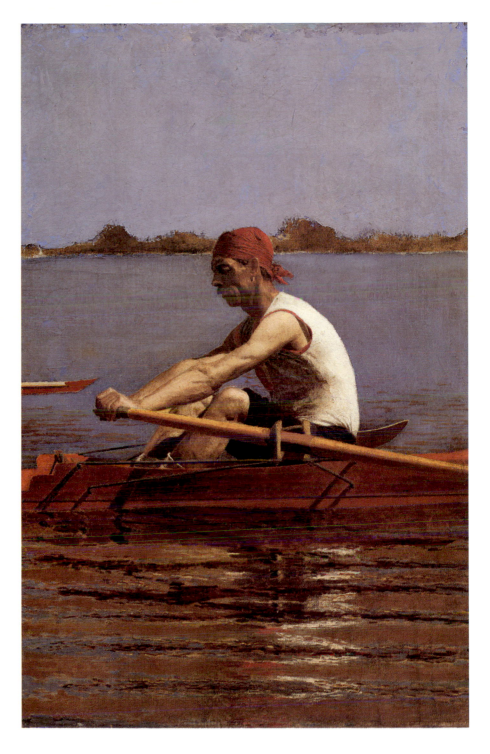

34
John Biglin in a Single Scull, 1874
Oil on canvas
24 ⅜ x 16 in. (61.9 x 40.6 cm)
Yale University Art Gallery, New Haven; Whitney
Collections of Sporting Art, given in memory of Harry
Payne Whitney, B.A. 1894, and Payne Whitney, B.A.
1898, by Francis P. Garvan, B.A. 1897, M.A. (Hon.) 1922

photography became an integral part of Eakins' preliminary approach to a subject.[59]) The close-up profile figure is detached from the viewer, iconic, its power given in the simplest terms. What may have started out as a working study became a unique and powerful painting on its own.

The Schreiber Brothers

Eakins was apparently dissatisfied with the Biglin oils. In a letter to Earl Shinn, he explained that he did not wish to exhibit "those Biglin ones" at the National Academy Annual in April 1875 because "[t]hey are clumsy & although pretty well drawn are wanting in distance & some other qualities. . . . " Instead, "I sent on my little picture. It is better than those Biglin ones."[60] The "little picture" was *The Schreiber Brothers* (figs. 35, 36).

The Schreiber brothers were not champion oarsmen like Max Schmitt and the Biglin brothers, but recreational rowers and friends of Eakins. Henry Schreiber was a professional photographer known for his animal portraits. The profession of his brother—perhaps named "Billy," the starboard oar, according to the annotations on one of the perspective drawings (fig. 39)—remains unknown.[61] The painting shows the rowers in a pair-oared shell set against a pier of the Columbia Railroad Bridge, the same pier seen in *The Pair-Oared Shell* (fig. 19). Behind them, moored under the bridge in the shadows, a rowboat holds five people fishing, including a man wearing a black-banded boater hat in the stern, a boy, and a dog (now darkened and blurred, but clearly visible in x-ray) poised alertly on the bow. A barge is near the shore at the left; farther left there is a small boat with two figures, one in red and one in white, the latter holding a parasol.

Wearing white shirts trimmed in magenta, long, dark-blue trunks, and magenta headscarves, the Schreibers have reached the end of the stroke. Unlike the Biglins, their technique is imperfect. They are rowing hard but not showing what was then considered to be good form: the bow oarsman is slightly twisted around to the left with the effort of pulling his port side blade through its arc, while the stroke oarsman, holding his right elbow low in front, which suggests a weak finish, is twisted somewhat to the right. And compared with the impassive features of Schmitt and the Biglins, the faces of the Schreibers (like that of the hard-rowing Eakins in the background of *The Champion Single Sculls*) reveal the effort of the action. Only a champion can make rowing look effortless.

Eakins was aware of the figures' awkwardness when he sent the painting to the National Academy for exhibition in 1875: "The picture don't please me altogether," he wrote to Shinn; "I had it too long about I guess. The drawing of the boats & the figures the construction of the thing & the peculiar swing of the figures rowing pair oared, the twist of the starboard oarsman to one the one side & the port to the other on account of the long sweeps are all better

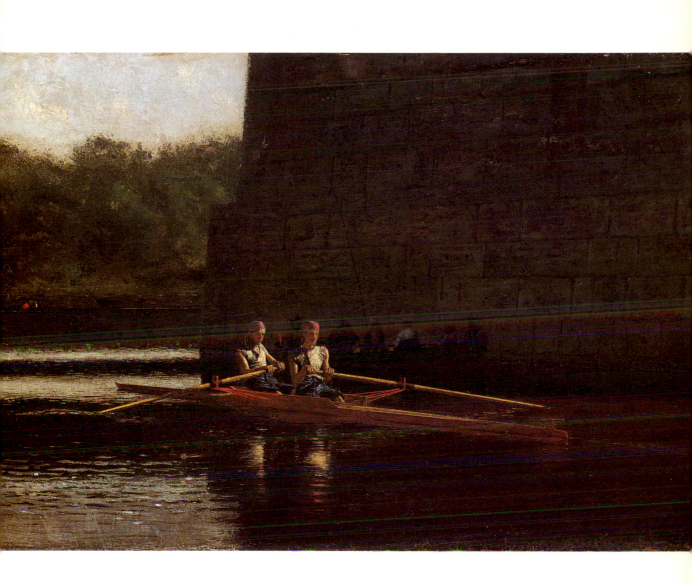

35

The Schreiber Brothers (The Oarsmen), 1874
Oil on canvas
15 x 22 in. (38.1 x 55.9 cm)
Yale University Art Gallery, New Haven;
John Hay Whitney, B.A. 1926, M.A. (Hon.) 1956, Collection

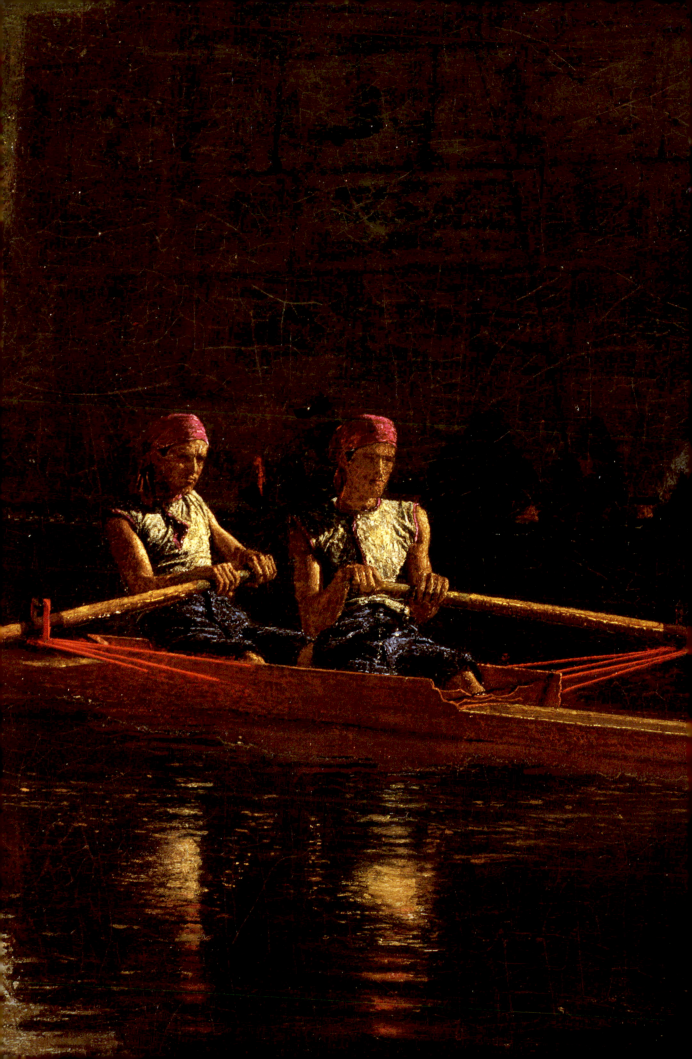

expressed than I see any New Yorkers doing—but anyhow I am tired of it. I hope it will sell and I'll never see it again."[62]

Despite Eakins' evident weariness with it, *The Schreiber Brothers* shows a deepening involvement with mood and color. Compared with *The Pair-Oared Shell*, the composition to which it bears the closest relationship, the Schreibers' shell is placed in subtly shallower space, which allows us to see the hands of both oarsmen. The pier now extends to the right edge of the canvas, blocking the view that was visible in *The Pair-Oared Shell*. Whereas the Biglins were placed partly against sunlit water, the Schreibers are set against the dark masonry of the pier, so that the sun strikes their figures and brilliantly defines them against the huge, shadowed stones. As Kathleen Foster has noted, "The airiness and abstract compositional energy of the larger painting are lost in these changes, but a more dramatic and particular sense of the figures and their motions has been gained."[63]

Three perspective drawings survive for *The Schreiber Brothers*. The first may have been *Perspective Study of Rowers* (fig. 37). Close in scale to the finished canvas, it varies only in having a much higher horizon line. Eakins' focus is on the wave pattern, the reflections, and the refraction of the oars as they pass under the water. He renders them with greater definition than in the painting, where the surface is broken up with lively brushwork. In the second Schreiber drawing, *Perspective and Plan* (fig. 39), the fundamentals of Eakins' perspective system are in evidence, as are further details for the final scene. In the upper right, he draws in the size and angle in space of the two boats in the painting. The left side of the sheet is in larger scale and is identical to the painting, except that it shows six figures; in the painting, Eakins reduced the number to five. Ruled vertical lines at the left and right of this section of the sheet mark the edges of the canvas. In a circular sketch at the bottom right of the paper, Eakins inscribed his name and the date, perhaps planning to inscribe both in perspective in the painting. In the final painting, however, he signed his name at the horizon line on the wall of the bridge pier.

The third study, *Perspective Study of Bridge Pier and Water* (fig. 38), devoid of details, is annotated in French, a vivid reminder of the continued influence of Gérôme and the École on the young American. The drawing shows pinholes throughout, which probably means that the major grid points and contours were transferred to the final canvas.[64] The number and width of the masonry courses are repeated in the painting, but the vertical lines that separate the blocks from one another are different in all three drawings, and much softened and diminished in the painting, making the wall less aggressive.

The smallest of all the rowing paintings, *The Schreiber Brothers*, has a poetic beauty and intimacy not found in the other pictures. The color—accents of magenta, red, and yellow set

56 *The Schreiber Brothers*, detail of fig. 35.

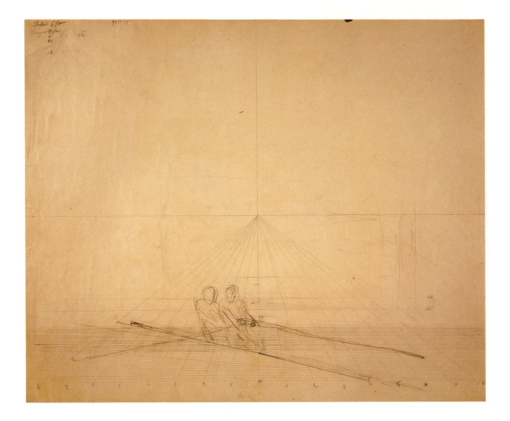

37

Perspective Study of Rowers for The Schreiber Brothers, c. 1874
Pencil on paper
14 ¹⁄₁₆ x 17 ¹⁄₁₆ in. (35.7 x 43.3 cm)
Pennsylvania Academy of the Fine Arts, Philadelphia; Charles Bregler's
Thomas Eakins Collection, Purchased with the partial support
of the Pew Memorial Trust and the John S. Phillips Fund

OPPOSITE, TOP
38

Perspective Study of Bridge Pier and Water for The Schreiber Brothers, c. 1874
Pencil on paper
13 ¹⁵⁄₁₆ x 17 in. (35.4 x 43.2 cm)
Pennsylvania Academy of the Fine Arts, Philadelphia; Charles Bregler's
Thomas Eakins Collection, Purchased with the partial support
of the Pew Memorial Trust and the John S. Phillips Fund

OPPOSITE, BOTTOM
39

Perspective and Plan for The Schreiber Brothers, 1874
Pen and black, red, and blue ink and pencil on paper
28 ¼ x 47 ⁵⁄₈ in. (71.8 x 121 cm)
Pennsylvania Academy of the Fine Arts, Philadelphia; Gift of Charles Bregler

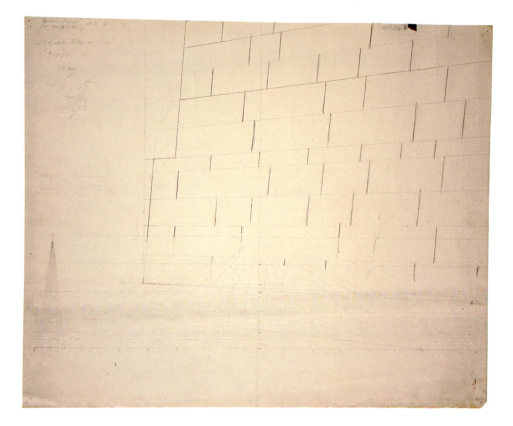

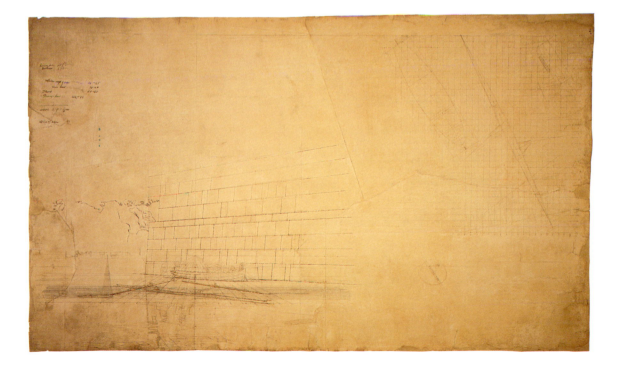

against the shadowed background—is immediate, even sensual. The exquisitely modulated deep tones of the pier and its dark reflection in the water form a resonant counterpoint to the rowers' brilliant purple-red headscarves and their faces and shirts, all caught in the slanting light of late afternoon. The sun-struck, yellow wooden oars, bright red outriggers and oar-locks, and the brown cedar shell enclose the rowers in a glowing grid of color. Eakins was so concerned about bringing the dark colors to full brilliance that he asked Shinn: "If you are in the neighborhood and want an excuse to go in [to the exhibition] you can rub a little linseed oil with your finger on any part of the shadows that are soaked in or on the whole of the picture except the light of the red handkerchiefs & the sky."[65]

For reasons that are not clear, *The Schreiber Brothers* was not accepted in the National Academy's exhibition and was returned to Eakins. He was indignant:

The reason my oil picture was not exhibited in New York I do not know. It was sent on in due time....

About 2 weeks since I got a polite circular from T. Addison Richards president [of the Academy] saying he dispatched my picture to my address.... I guess therefore my picture was simply refused.

It is a much better figure picture than any one in N.Y. can paint. I conclude that those who judged it were incapable of judging or jealous of my work, or that there was no judgement at all on merit, the works being hung up in the order received or by lottery.

Anyhow, I am mulcted in the price of frame, & double expressage & boxing.... [66]

In fact, Eakins was not represented in an exhibition at the National Academy until 1877.

Oarsmen on the Schuylkill

The last painting in the series, *Oarsmen on the Schuylkill* (fig. 40), is the only one in which a four-oared shell is the central subject. Perhaps Eakins was inspired by the victory of the Pennsylvania Barge Club "Four," which included his old friend Max Schmitt, competing against the Quaker City Rowing Club in the four-oared shell competition for the one-and-a-half mile straightaway race of the Schuylkill Navy Regatta on September 26, 1874.[67] Unlike *The Champion Single Sculls*, which memorializes the accomplishment of the individual amateur champion Max Schmitt, or the Biglin series, which presents iconic images of professional rowers, *Oarsmen on the Schuylkill* is a more generalized depiction.

Eakins shows the oarsmen at practice in late afternoon. Max Schmitt, with mustache and the beginnings of a beard, can easily be identified as the second man from the right.[68] Each of the other three rowers has been individualized to the same extent—John Lavens, Jr. (stroke), with mustache and muttonchops; Frank Henderson, with high forehead and mustache; and Oscar

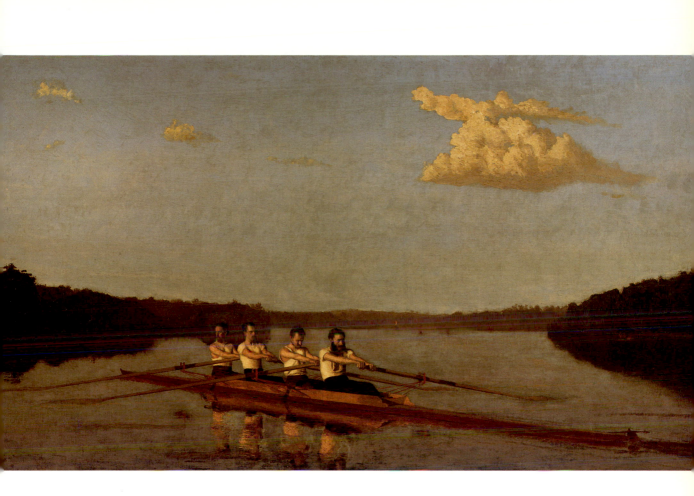

40
Oarsmen on the Schuylkill, c. 1874
Oil on canvas
27 ⅝ x 48 ¼ in. (70.2 x 122.6 cm)
Private collection; courtesy Hirschl and Adler Galleries, New York

OVERLEAF
41
Oarsmen on the Schuylkill, detail of fig. 40

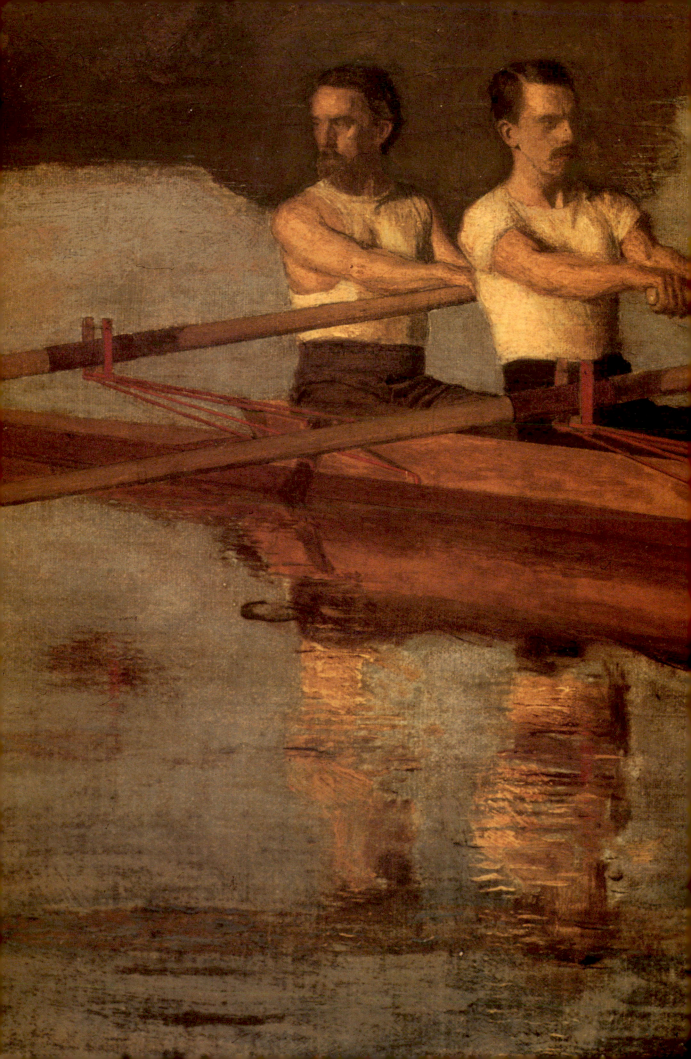

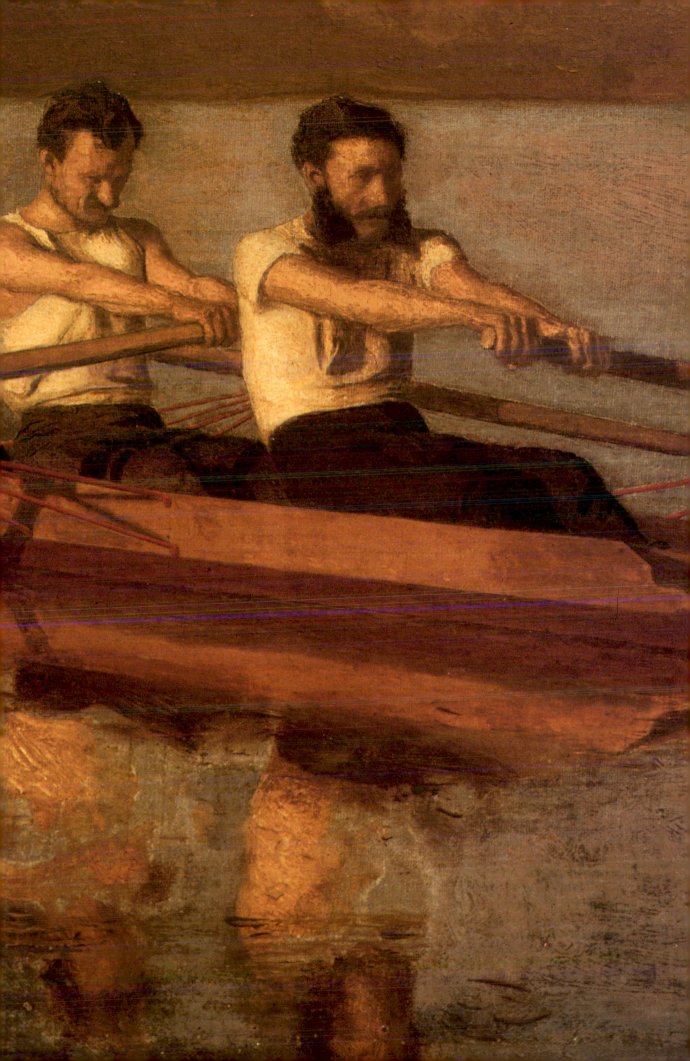

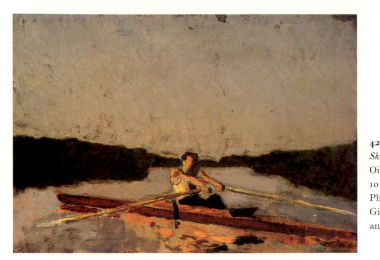

42
Sketch of Max Schmitt in a Single Scull, c. 1874
Oil on canvas
10 x 14 ½ in. (25.4 x 36.8 cm)
Philadelphia Museum of Art;
Gift of Mrs. Thomas Eakins
and Miss Mary Adeline Williams

West (bow), with light-colored beard and mustache (fig. 41). The different shirt each man wears further underscores his distinctness. The view is probably taken from the north tip of Peter Island, looking northeast along the western shore of the river above the dam at Fairmount. From this spot, the boathouses of the Schuylkill Navy would have been situated along the far shoreline, beyond the edge of the canvas at right. The landscape background is unarticulated, the calm water disturbed only by the wake of the shell and the faint puddles of the last stroke. The reflections of the men and shell are broadly painted, their mirror images affected by the ripples. The light, from low in the west, comes from behind and to the left, coloring the wide blue sky yellow at the horizon and bathing the white-shirted rowers and their cedar shell in gold.

As in the other sweep rowing pictures, Eakins here depicts the nineteenth-century's customary starboard stroke, not the more common portside stroke of today. The rowers are at, or just beyond, the midpoint of their strokes, their knees down, their bodies tilted back just past the perpendicular, their arms still straight before finishing off the stroke with a final pull. Their blades are in the water at the same time and angle—the rowing ideal. The bow oarsman glances to his right in order to steer (likely with a hinged foot stretcher that moved wires to control the rudder). Schmitt is looking down, a deviation from the standard model of all eyes straight ahead. This "off guard" moment gives the scene an engaging spontaneity, animating it in a subtle, unhurried way.

One oil sketch and two perspective drawings exist for *Oarsmen on the Schuylkill*. Eakins began with the oil *Sketch of Max Schmitt in a Single Scull*, painted out-of-doors on the Schuylkill (fig. 42). It lays out the general composition, landscape background, position of the shell, and overall palette of *The Oarsmen*. Drawn first in pencil, which is still visible in places, it was painted

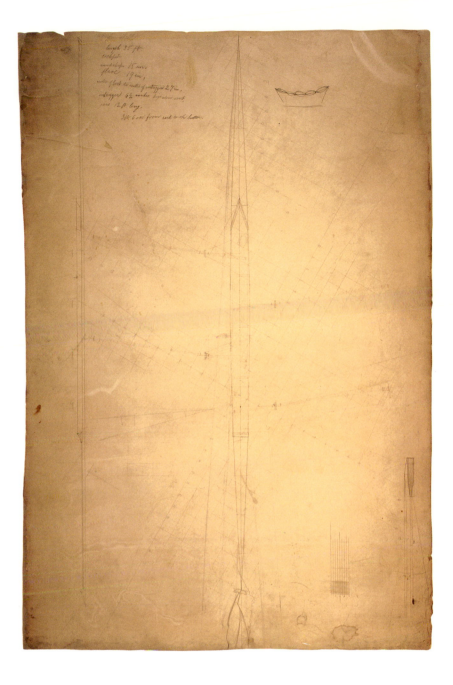

43

Plan and Cross-Section for Oarsmen on the Schuylkill, c. 1874
Pencil and ink on paper
47 ⅝ x 31 ⅝ in. (121 x 80.3 cm) irregular
Pennsylvania Academy of the Fine Arts, Philadelphia; Charles
Bregler's Thomas Eakins Collection, Purchased with the partial
support of the Pew Memorial Trust and the John S. Phillips Fund

in buttery strokes of apricots and blue-grays. The reflections in the water of the rower's dark red trunks and white shirt and the rust-brown shell are summarily suggested through broad, generalized brushstrokes. At some point, Eakins decided to develop this idea of a single rower into a composition with a four-oared shell. An analysis of the longer shell thus became the focus of two extremely detailed perspective drawings.

In *Plan and Cross-Section* (fig. 43), Eakins drew the shell onto a grid of 1 inch to 1 foot in real space. The shell therefore measures about 42 feet long and about 17 inches wide, which was very close to the dimensions of an actual standard four-oared shell. Eakins' notations in the upper left describing the "Biglin Shell," a shorter and narrower craft (35 feet long, 15 inches wide), refer to the kind of boat used in *The Pair-Oared Shell* and the other paintings of the Biglin brothers. The drawing is a remarkably accurate sketch of a top view looking down on a normally rigged, starboard stroked, four-without-coxswain racing shell. The three-bar outriggers are perfectly placed, and the last line of Eakins' notation at the upper right—"3 ft 6 oar from end to the button" (the wide collar on the leather sheath of the oar which keeps it from slipping through the oarlock)—reveals how concerned he was about the placement of the handle overlap in the final painting. He even shows the flow of the current around the large wooden rudder at the bottom of the sheet as it would occur if the shell were moving. In the painting, the movement of the boat is suggested by the rush of water off the rudder, the wake of the shell, and the puddles made by the oars.

In *Perspective Study* (fig. 44), Eakins clearly shows a pair-oared shell, yet the drawing is unquestionably a study for the four-oared shell in *Oarsmen on the Schuylkill*. The size and placement of the shell on the paper, even to the rudder running off the right edge of the sheet, are replicated exactly on the canvas. Also telling are the tiny pinholes around the oarlocks, on the outlines of the sculls and oars, and at the high points in the landscape, all of which indicate that this drawing was used to transfer the design to the *Oarsmen* canvas.

Although all the essential elements of the drawings have been incorporated into the painting, the intense, almost obsessive focus on detail that characterizes, for example, the Biglin racing scenes is absent. By 1874 the subject of rowing had assumed for Eakins a more general mantle. The earlier sense of enclosure in a self-contained world has been replaced in this last painting with a more outward-focused mood. While they are evidently at a practice session, the four rowers do not move as one body; the spell has been broken.

With *Oarsmen on the Schuylkill*, Eakins came to the end of the rowing pictures. He had captured the golden moment in American rowing. Within a few short years, betting and racing scandals would engulf the sport and rowing would fall from public favor. By the turn of the

44

Perspective Study for Oarsmen on the Schuylkill, c. 1874
Pencil, ink, and watercolor on paper
26 ¾ x 47 ⁹⁄₁₆ in. (67.9 x 120.8 cm)
Pennsylvania Academy of the Fine Arts, Philadelphia; Charles
Bregler's Thomas Eakins Collection, Purchased with the partial
support of the Pew Memorial Trust and the John S. Phillips Fund

century, professional rowing had disappeared from the American scene; the sport has been predominantly amateur ever since, relegating some of its champions to coaching at colleges and boat clubs. Never again would rowing attain anything close to the popularity and national recognition it had enjoyed when the subject held Eakins in such thrall. Just as the four rowers are moving away from us in pictorial space, by 1875 Eakins was moving to new projects, most notably *The Gross Clinic* (fig. 65).

As a subject, rowers had served the artist well. His three-and-a-half year engagement with the theme fulfilled a double purpose. In practical terms, the series allowed him to focus on a particular set of artistic challenges, changing the scale ratio of viewer-distance and figure-distance while solving the basic perspective problem of depicting a long, very narrow complex object in such a way that the character of the boat and the action of the men are clearly articulated.[69] Walt Whitman said, "I never knew of but one artist, and that's Tom Eakins, who could resist the temptation to see what they thought ought to be rather than what is."[70] The rowing pictures portray specific individuals at moments that can be tied to specific sporting events. In the subtlety with which Eakins depicts the muscular oarsman at the top of his stroke, or the broken reflections in the water, the paintings are convincing essays in naturalism.

But it would be wrong to view the rowing paintings so narrowly. For Eakins the rowing theme served a more profound purpose, one he had been working out slowly, sometimes painfully, from the raw material of his personality and talent. Ultimately, he came to see rowers—in their pursuit of excellence, their drive to break old boundaries, and their commitment to hard work—as symbols of a kind of democratic, American morality.

Rowers talk about "swing," the ideal moment of transcendence in which there is perfect harmony between them and their boat. Eakins' rowing pictures linger in the imagination for they too are about an ideal: they are a metaphor for a world in which rationality and self-discipline reign, society and self are held in balance, and the trained mind and body celebrate the perfect union. The rowing pictures reveal the artist's determination to understand, to uncover the secrets of the universe and, by reducing them to intellectual paradigms, to control them. For a young man on the threshold of his greatest achievements, it was a worthy ambition. One year later, Eakins completed the monumental painting, *The Gross Clinic*. This extraordinary work celebrates a different kind of human achievement—that of a great surgeon—but it too combines the best of head and hand. It owes much to the lessons of the rowers.

Perspective in Thomas Eakins' Rowing Pictures

A M Y B. W E R B E L

The ten perspective drawings Thomas Eakins made for his rowing paintings rank among the most remarkable works of his career. These drawings record the dimensions and positions of boats, rowers, and landscape elements with such precision that we can determine the time of day and orientation represented in each scene and fix Eakins' position as viewer.[1] This level of accuracy and detail is unmatched among nineteenth-century American painters and reflects Eakins' many years of specialized training in mathematics, linear perspective, and mechanical drawing.

Training in Linear Perspective and Mechanical Drawing

Eakins began his formal study of mathematics and drawing in 1857, at the time he entered Central High School in Philadelphia. Central's selective and rigorous program offered a curriculum heavily weighted in favor of sciences; nearly one-third of Eakins' courses were in mathematics alone, including algebra, trigonometry, geometry, and differential and integral calculus.[2] The drawing program at Central, which served as Eakins' introduction to art, was greatly influenced by the school's scientific orientation. Although Rembrandt Peale's general tome, *Graphics*, served as the introductory text for the drawing curriculum, the program soon moved on to drawing systems that combined advanced mathematics and art. Eakins' junior and senior years included rigorous study of the related sciences of perspective and mechanical drawing.[3]

Mechanical Drawing: Three Spirals (fig. 45) exemplifies the training Eakins received during these years. This study depicts three types of common screwthreads, each meticulously drawn in plan and elevation following an illustration in the class textbook, A. Cornu's *Course of Linear Drawing Applied to the Drawing of Machinery* (fig. 46).[4] This exercise served as a model of the type of work expected of mechanical draftsmen: both plan and elevation provide measured, accurate information that would assist in the manufacture of real objects. Eakins succinctly noted the advantages of this discipline in a treatise he wrote in 1882:

45

Thomas Eakins, *Mechanical Drawing: Three Spirals*, c. 1860. Pen, ink, and ink wash over
pencil on paper. 11 x 16 ⅜ in. (27.9 x 41.6 cm). Pennsylvania Academy of the Fine Arts,
Philadelphia; Charles Bregler's Thomas Eakins Collection, Purchased with the partial support
of the Pew Memorial Trust and the John S. Phillips Fund.

46

Delineation of Spirals, from A. Cornu,
*Course of Linear Drawing Applied to the
Drawing of Machinery*, 1842.

A perspective drawing of a thing gives a workman the best notion of the looks of the thing, but he could not measure from a perspective as from a mechanical drawing.[5]

Providing measurable information visually required facility not only in drawing but also in descriptive geometry, a system of orthographic projection invented by Gaspard Monge in the late eighteenth century. Monge's new system of representation implied an infinitely extended viewpoint, which permitted "the measured dimensions of the forms to remain constant in one, two or three planes, since perspectival diminution [was] eliminated in whole or in part."[6] Previous vanishing point systems had distorted dimensions and relationships in the course of foreshortening the scene. As Eakins remarked, traditional linear perspective gave a good idea of how things looked, but little assistance in actually building them.

Eakins' *Three Spirals* presents a simple example of mechanical drawing based on the principles of descriptive geometry. The ground plans at the bottom provide the measurements necessary for raising the elevations above. The inclusion of both these views is a hallmark of drawings using this system.

Monge's descriptive geometry was not only important for the engineers for whom it was originally intended. Monge himself adapted the system for Neoclassical artists, including Jacques-Louis David. Later, the first decades of the nineteenth century saw a proliferation of textbooks utilizing perspective systems requiring ground plans and elevations.[7] Eakins' training in Paris between 1866 and 1870 increased his familiarity with this most rigorous of perspective modes.[8] Although there is little evidence that Eakins specifically studied perspective in Paris, his professor, Jean-Léon Gérôme, seems to have utilized a method based on descriptive geometry in his own work, perhaps even receiving the assistance of professional draftsmen to complete his complex designs.[9]

Gérôme's *Hail Caesar! We Who Are About to Die Salute You* (fig. 47) is a perfect example of the type of subject made possible by systems based on descriptive geometry. Here the long, curving lines of the amphitheater sweep from the far distance nearly into our space in a continuous arc. At upper left, a mesh canopy inclines over the heads of the athletes, lifting upward as it nears the edge of the canvas. Curved subjects and inclined planes were traditionally among the most vexing perspective problems. Descriptive geometry offered artists a way to plot any point in space with equal ease, regardless of its relationship to the picture plane. As Eakins' instructor and role model, Gérôme provided an influential example in such disciplined use of perspective.

Perspective Process in the Rowing Pictures

Shortly after Eakins' return to Philadelphia in 1870, he began to paint rowers on the Schuylkill River, a project that synthesized the elements of his prior training and reflected an idiosyncratic and ambitious new approach to plotting space.

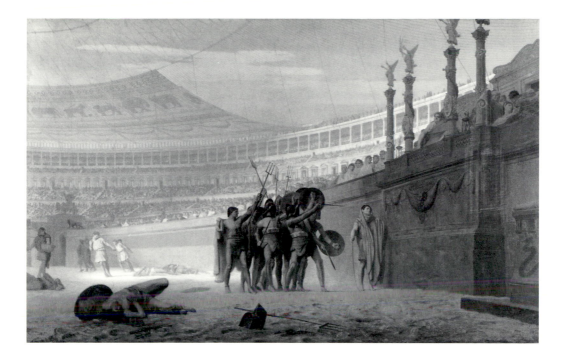

47
Jean-Léon Gérôme, *Hail Caesar! We Who Are About to Die Salute You*
(Ave Caesar! Morituri te salutant), 1859. Oil on canvas, 36 ½ x 57 ¼ in.
(92.7 x 145.4 cm). Yale University Art Gallery, New Haven; Gift of
C. Ruxton Love, Jr., B.A. 1925.

The most well-studied of Eakins' perspective drawings are his designs for *The Pair-Oared Shell* of 1872 (fig. 19).[10] These include a line drawing that outlines the boat and a pier behind it (fig. 20) and a second study that incorporates watercolor and plots reflections in the water based on the angle of the sun (fig. 21). Eakins typically divided the components of the painting in this manner and also drew ground plans and cross-section views, as we shall see below.

Both perspective drawings for *The Pair-Oared Shell* are structured by an underlying foreshortened grid, which was Eakins' first step in plotting the space of his pictures on paper. The foreshortened grid was a traditional Albertian starting point; descriptive geometry and mechanical drawing entered the process later on. The numbers given to each horizontal in the grid represent the increasing distance (in feet) between that register of space and the viewer. The first number on fig. 20 at bottom center—16—positions Eakins at 16 feet from the nearest edge of the represented space. In between the artist and this represented space lies the picture plane. The distance from Eakins to the picture plane is the important "distance from picture," in this case 6 feet, that determines the rate at which the 1-foot wide horizontal registers diminish as they recede into the distance.[11]

The diagonal lines intersecting these horizontals are drawn from regular intervals on the bottom edge of the sheet, with each representing 1 foot of space parallel to the surface of the picture. All these diagonals converge at the viewpoint (also known as the eyepoint, point of sight, or vanishing point), which lies in the center of the composition on the horizon line, and represents the position of the viewer's eye in relation to the scene.

The height of the horizon line was an important choice that could give the effect of a bird's-eye, worm's-eye, or straight-ahead view. Eakins often chose to place his horizon line near the middle of his perspectives, as he does here, providing a straightforward view of his subjects. There are also many instances in Eakins' career where he dramatically manipulated the height of the horizon line to achieve bold effects.[12]

Eakins almost always noted the height of the horizon line and "distance from picture" on his perspectives. These dimensions, along with the artist's carefully calculated reflections and refractions based on the angle of the sun, have encouraged scholars to reconstruct his position as artist and viewer and the time of day depicted. Theodor Siegl, for example, estimated that Eakins' view of *The Pair-Oared Shell* placed him 30½ feet away from the boat at 7:20 p.m. in early June or mid-July.[13]

Once Eakins had foreshortened the space of his scene, he proceeded to plot the coordinates of his objects into it, as though he were a cartographer mapping topographical features onto a grid of latitudes and longitudes. For example, in his study of reflections for *The Pair-Oared Shell* (fig. 21), he noted the following coordinates near the upper margin, left of center:

top John's head from	16 ft to 25 ft reflection		
Barney	17 ft to 25 " "		
Side of boat from	28	37	"
centre oar at outrigger	23	32 "	
Top shirt John	19	28	
Top corner oar	25 ½	29	
Centre of cloud	36		

and below:

Port outrigger reflection from 34 to 44	
Starboard "	33 to 40

In his *Perspective Studies for John Biglin in a Single Scull* (fig. 31), Eakins noted similar measured dimensions in French, signifying his continuing sense of connection with Gérôme and Paris:

Limité des reflets dans les vagues		
haut de la chemise	24 . . .	
. . . tête	22 ~	
genou	28 ~	17
point d'appuis de l'aviron	29	18
haut de la boute du canot	32 ½	21 [14]

In order to determine these coordinates, Eakins had to know the exact measurements of his subjects, a practice considered unnecessary by most American teachers of artistic perspective, who trained the eye to judge distances and dimensions proportionally. Eakins used several methods to ensure that his fastidious measurements of boats, rowers, and distances were translated accurately into his picture.

At the left of the first perspective study for *The Pair-Oared Shell* (fig. 20) are three pyramid-shaped meshes of diagonal lines. The first of these on the left was used as an internal projection of the distance point that determined the scale of foreshortening to a refined degree. Similar fine meshes of lines drawn to the viewpoint could also be used to facilitate extremely precise measurements. Eakins described their use in his treatise:

A foot though is a rather coarse measure for fine things, so we had better divide up some of the square feet into inches.

Let us take the foot on the 24 ft. line from 0 to 1 left, and divide it into 12 equal parts to represent inches, and run lines from the divisions up to the point of sight. This gives us the apparent size of inches at all distances from the eye.

Again draw diagonals across these feet to be able to measure inches forwards from the eye as well as sideways.[15]

Later in his treatise, Eakins advised students on the creation of a "diagonal scale" with which to measure tenths and hundredths of inches.[16] A diagonal scale is evident at center in his second study for *The Pair-Oared Shell* (fig. 21). Both these methods again reveal a fidelity to the minute dimensions of subjects more in keeping with drawings by engineers than with artists' studies. Although Eakins' system was based on a traditional foreshortened grid, rather than on descriptive geometry, his detail and precision in measurement were a departure from traditional "artistic" and modern notions of perspective.

Eakins' perspective treatise reveals why he chose a system so much more meticulous than the norm. Assigning his students the problem of putting a round-topped table into perspective, he advised:

The sketch you make of anything to be put in perspective should always be figured by measures of the principal parts, and to choose the principal parts we must follow the mind of the cabinet maker who constructed it. He wished a table 29 inches high & 30 wide with 3 legs spreading 13 inches from the centre to give it just that much steadiness.[17]

The advice to "follow the mind of the cabinet maker" clearly signals the lingering influences of Eakins' training in mechanical drawing.

Plan and Cross-Section for Oarsmen on the Schuykill (fig. 43) and *Perspective and Plan for The Schreiber Brothers* (fig. 39) are further reminders of Eakins' training as a mechanical draftsman and demonstrate the influence of descriptive geometry on his methods. These preparatory sheets include ground plans of the shells as viewed from above. Such plans, as we have seen, were an important element of descriptive geometry and mechanical drawing. Eakins strongly advocated this type of study:

A ground plan is a map of anything looking down on it, drawn to any convenient scale, and should almost always be drawn on paper before putting things into perspective.[18]

One can see in the studies for both *Oarsmen on the Schuylkill* and *The Schreiber Brothers* how measurements recorded in notations were then plotted on the gridded ground plan. In the study for *Oarsmen,* the ground plan was skewed to represent the oblique angle of the boat to the picture plane.

Eakins may have been rigorous in his perspectival plotting, but he was also practical and efficient. Rather than use a system based entirely on descriptive geometry, as Gérôme's draftsman might have done, he plotted the coordinates resulting from his plan into a foreshortened grid. This system combined perspective's ability to give the "looks of the thing" using just one view with the precise measurements of mechanical drawing that made construction possible. Reflections, waves, and objects all could be measured and plotted into the space of the grid.

Further evidence of Eakins' efficiency and preference for directness is his avoidance of complex spatial contrivances such as Gérôme designed in *Hail Caesar!*[19] Even when he chose difficult problems, as, for example, in his sailing pictures, he trusted his system to accommodate forms tilted in several planes:

You now readily perceive that by a series of . . . measurements, we could point by point construct a perspective drawing of anything which we could measure.

You can see too how to overcome the difficulty of drawing a slanting post, which does not come directly under our universal perspective rule.

We would measure its top point first, how far off from the eye, how far to the right or left of our central plane, & then put it in perspective. Then we would measure the bottom point in the same way, and construct it; and having the picture of these two points of the slanting post, we would draw a line from one to the other for the picture of the post.[20]

Later in his treatise, Eakins also demonstrated a method of circumscribing curved lines and forms within boxes, so that these typically vexing subjects also could be transferred easily onto the perspective grid.[21] A good example of this technique is found in the study of oars in the *Perspective Drawing for The Biglin Brothers Turning the Stake* (fig. 29). Eakins' combination of perspective styles, traditional and mechanical, was more efficient than descriptive geometry, for it obviated the need for a ground plan below. Moreover, it was more quantifiable, appealing to Eakins' instinct for creating drawings that could serve as blueprints for their subjects.

Art and Science in Perspective Drawings for the Rowing Series

Eakins' particular combination of artistic and scientific interests yielded enigmatic results in all aspects of his career. Despite Eakins' fidelity to the dimensions of his subjects, neither his perspective drawings nor his final pictures are painted versions of a literally "realistic" point of view. Rather, the aesthetics of pictorial design competed with the artist's desire for measurable accuracy throughout the compositional process.

As we saw in the drawings for *The Pair-Oared Shell*, Eakins almost always inscribed the height of the horizon line and distance from the picture on his sheet. These dimensions determined the scale of foreshortening in his overall spatial composition. If someone was meant to be seen at 50 feet away from a high vantage point, that person would appear smaller and in a "flatter" space than if seen at 12 feet straight ahead.

The specifity of the dimensions recorded in Eakins' drawings implies that they are exact representations of his position as a viewer of the scene he presents, as Theodor Siegl assumed. This is not the case, however. In plotting the space of *The Pair-Oared Shell* and other boating scenes, including *The Champion Single Sculls* (fig. 4), Eakins manipulated the dimensions of

the eye's "distance from picture" so that the boats loom larger within the composition than they could when seen from the artist's actual position on the shoreline.[22] He writes:

To fix the distance [from the picture to the eye] you consider how large you want one of your important objects to be in the picture: if you want it life size in the picture, your drawing must be distant from the eye as far as that object. If you wish any object to be in the picture half as big as real, you must place your picture plane at half the distance from the eye of that object; if quarter as big, quarter the way & so on.[23]

As this statement demonstrates, the sizes of objects in the picture are manipulated for aesthetic purposes simply by moving a fictionalized picture plane, rather than by relocating the actual eye.

Altering the distance of the picture plane from the subject easily allowed Eakins to enlarge or reduce the scale of his figures. If he was 30 feet from an object, and presumed the picture plane to be at 3 feet from his eye, the objects would be 30:1 divided by 3:1, equaling a ratio of 10:1. A boat in the scene would be one-tenth its actual size. If Eakins decided that the boat was too large, he could fictionally move the picture plane to 2 feet away and render the boat at one-fifteenth its actual size, and so on.

Eakins' use of this technique had a substantial impact on the pictorial effects of his pictures, even if they remained, according to his system, faithful to the reality of his subjects.[24] In Eakins' system, we become "close-up" viewers of the scene, while the ratios determining the rate at which things become smaller in the distance are calculated for a much more distant eyepoint, based on where Eakins might actually have stood. In analyzing *The Pair-Oared Shell*, Theodor Siegl noted

A strange flattening of the . . . perspective drawing [and] the final painting. The space is compressed; the boat and the pier look flatter and closer together than one would expect, much as in a photograph taken with a telephoto lens. The reason is that Eakins placed his point of distance (the vanishing point for the diagonals) unusually far away. Traditionally, the implied space of the vanishing point is at a distance from the center of the painting equal to the width of the canvas. In The Pair-Oared Shell, *however, the implied distance of the vanishing point is about twice as great, with the result that the painting appears condensed, as if it were the center of a much larger composition.[25]*

Clearly, Eakins gave priority to composition, rather than to a strict record of his actual visual experience. He also felt free to crop or extend the margins of his images after his numerical calculations were completed, as we see in his drawings and three paintings of the Biglin brothers and in *John Biglin in a Single Scull* (figs. 19–22, 25, 26, 29–34).[26]

Linear Perspective in the Finished Pictures

By the time Eakins completed his perspective drawings, he knew a great deal about his subjects and the spatial interrelationships he intended to depict. *Perspective Studies for John Biglin in a Single Scull* (fig. 31) is nearly twice as large as the finished watercolor (fig. 32), indicating the importance of Eakins' mathematical preparations. After completing his perspectives, however, Eakins dramatically switched gears from a linear to a painterly mode. Having incised his perspectival notations onto the blank painting ground, he then scumbled, washed, brushed, and glazed paint over them until they were no more than a faint substructure. Elements such as focus, tone, and hue, which contribute to spatial composition, were often boldly disunited from the underlying linear scheme. In *The Champion Single Sculls,* for example, improbable strokes of bright red and white in a canoe and steamer at the middle of the painting provide both greater tonal contrast and more intense hue than one would expect to see in the background of a perspectival painting; the bridge above is painted with much greater clarity than the landscape elements and water yards in front of it. Large, gestural, and sparkling white clouds appear to sit directly on the surface of the canvas.

Had Eakins merely colored between the lines of his perspectives and followed all the "rules" of spatial composition, his works would not hold the same fascination for us. The tensions between his linear and painterly modes have been seen in many lights, but always as embodying a set of dualistic impulses: American vs. French, science vs. art, rationalism vs. passion, writing vs. drawing, realism vs. Impressionism.[27] Even Eakins' perspective drawings for the rowing series, long taken as manifestations of a purely mathematical agenda, demonstrate the shifting balances which make his work so exhilarating.

Thomas Eakins Under the Microscope:
A Technical Study of the Rowing Paintings

CHRISTINA CURRIE

The gathering together of all of the rowing paintings, related drawings, watercolors, and oil studies gives us a unique opportunity for an in-depth comparative study of Eakins' oil paintings and invites inquiry into the processes he used to create them. *The Biglin Brothers Turning the Stake* (fig. 26), the largest and most ambitious painting in the series, served as the starting point for this study. Through analysis by microscope and x-radiography, we are now able to identify many of the individual steps, not always visible to the naked eye, that Eakins employed to convey a powerful sense of observed reality. What these steps reveal is an artist preoccupied with perspective and measurement.

Eakins absorbed the idea of extensive preparation from his teacher Jean-Léon Gérôme, with whom he studied in Paris from 1866 to 1869.[1] Gerome used drawings, oil studies, and photography to gather information for his compositions, sometimes employing draftsmen for perspective and architectural details. His influence can be seen in Eakins' analytical approach to the rowing paintings.

Although no complete sequence of preparatory work for any single rowing painting survives, from the considerable extant material we can reasonably speculate on the procedures Eakins followed.[2] He began with rough on-the-spot pencil drawings, such as the small architectural sketch of the Girard Avenue Bridge (fig. 14) for *The Champion Single Sculls* (fig. 4). At the same time, he made oil sketches, establishing composition and color relationships, such as *Sketch of Max Schmitt in a Single Scull* (fig. 42) and *The Oarsmen* (fig. 28). The former is not a study for *The Champion Single Sculls*, but may relate to the second figure, position of the boat, and background for *Oarsmen on the Schuylkill* (fig. 40). *The Oarsmen* can be related in its figural composition to *The Biglin Brothers Turning the Stake* and *The Biglin Brothers Racing* (figs. 26, 22).

Next, Eakins most likely created mechanical drawings of the central elements of the composition, in particular the scull, based on measurements of the actual boat.[3] For example, *Perspective Drawing for The Biglin Brothers Racing* (fig. 25) shows a perspective rendering of

48
Photomicrograph of *The Biglin Brothers Turning the Stake* (fig. 26), showing incised lines.

49
Photomicrograph of *The Biglin Brothers Turning the Stake* (fig. 26), showing prick marks outlining former planned position for John Biglin's right arm.

50
Photomicrograph of *The Biglin Brothers Turning the Stake* (fig. 26), showing drawing lines in scull.

the scull, a side view, the scull's position in the water, and written notations throughout the sheet concerning measurements and shadows. In other sheets drawn to the scale of the paintings, such as the *Perspective Drawing for The Biglin Brothers Turning the Stake*, Eakins focused only on the scull, establishing its placement and rendering precise details of its construction. In other perspective drawings, he brought together rowers and boat (figs. 21, 31).[4]

In a lecture on vanishing points, Eakins explained that using colored inks was the least complicated way to approach complex drawings.[5] In the rowing drawings, he employed blue ink for lines purely concerned with perspective, such as the marks for square footage in the ground and for the horizon line and central vertical line and red ink to enclose complicated projections such as the end of an oar (fig. 21). Finally, he outlined the main forms in pencil, later strengthening them with black ink.

Eakins then transferred his carefully worked out drawings to canvas, an exercise in precision and planning. The canvases he used were finely textured, plainly woven, and commercially primed with a white ground layer.[6] All the rowing paintings examined reveal that Eakins made a series of unusually exact markings either on or scratched into this ground layer. These markings served as guidelines for the positions and contours of boats, oars, waves, and principal figures. Through examination by microscope, x-radiography, and infrared reflectography, we can detect three distinct types of markings: incised lines (fig. 48), prick marks (fig. 49), and drawing lines (fig. 50). Many lines are partially filled with the subsequent paint, which proves that Eakins cut into the dry ground layer before beginning to paint; more markings probably remain hidden beneath thicker paint. Most of the incised lines appear to have been ruled with a sharp metal stylus, possibly through a sheet of transfer paper.[7] They function as horizontal and diagonal grids for important elements in the design as well as for contours and outlines. Eakins also incised short arcs, probably with a compass, to mark off important points.

The Biglin Brothers Turning the Stake (fig. 26) contains the greatest number of preliminary markings, in the form of lines incised into the ground layer prior to painting. The locations of these lines were observed with a microscope and x-radiographs and then plotted on a full-scale tracing of the painting (fig. 51). Eakins' incised lines and compass arcs precisely position all four boats; waves, splashes, and reflections are given similar treatment. A set of lines locates the oar as it hits the water in the lower right corner, and closely grouped, curved vertical lines indicate the reflection of the red-flagged stake at the far left.

A relatively simple series of incised lines was observed with a microscope in *The Biglin Brothers Racing* and again charted on a diagram (figs. 22, 52). Diagonal and horizontal guidelines stretching to the edges of the painting accurately situate the principal boat, the stern of the opposition's boat and the blade of the central oar. Similarly, in *The Champion Single Sculls* (figs. 4, 53) diagonal, incised lines locate Max Schmitt's boat and the wake left by the oars, whereas ripples are indicated with horizontal lines crossed with arcs at relevant points.

51
Diagram plotting locations of preliminary markings
on *The Biglin Brothers Turning the Stake* (fig. 26).

52
Diagram plotting locations of preliminary
markings on *The Biglin Brothers Racing* (fig. 22).

53
Diagram plotting locations of preliminary
markings on *The Champion Single Sculls* (fig. 4).

Horizontal lines position the small boat in the upper left background, the rower's head in the boat at right, and the bridges. In *The Schreiber Brothers* (fig. 35), a broken, incised line runs horizontally along the river bank, and individual incised lines mark the thin wires from the cockpit to the end of the scull.

Visible only under the microscope or in a magnified x-radiograph are tiny prick marks which follow the outlines and contours of the heads, torsos, and clothing of the oarsmen in at least three rowing paintings: *The Biglin Brothers Turning the Stake* (fig. 51), *The Pair-Oared Shell,* and *The Biglin Brothers Racing* (fig. 52).[8] Eakins also used prick marks to delineate the rounded elements of the bridges in *The Champion Single Sculls* (fig. 53).[9] He probably pricked through a preliminary drawing or intermediary tracing onto the canvas, joined these marks in pencil, and reinforced the outlines with a drafting pen or fine brush. The prick marks in *The Biglin Brothers Turning the Stake* (fig. 49) reveal Eakins' decision to change the composition: approximately ½ inch above John Biglin's left arm lies a second line of prick marks, indicating an earlier placement of the arm.[10]

Along with the incised lines and prick marks, Eakins used drawing, probably in graphite, to mark boats, architectural features, and dominant reflections, as well as to provide general compositional guidelines. Partially visible through thin or light paint under the microscope, these markings are based on the perspective drawings. For example, in *The Biglin Brothers Turning the Stake,* there is a vertical line from the fingers of Barney Biglin's right arm to the bottom edge of the canvas, providing the central axis for the arrangement of waves in perspective,[11] and a ruled diagonal line from the right edge to approximately the center of the right side of the boat, which locates the uppermost tip of the scull. These precise notations appear in Eakins' perspective study of the subject (fig. 30).

One additional type of marking has been identified: large, conical pinpricks made at approximately 1-inch intervals along all four edges of *The Biglin Brothers Turning the Stake.* Easily discernable without magnification, these markings do not appear on any of the other rowing paintings and seem unrelated to the preparatory drawings. Most likely, they were caused by the adherence of transfer paper when Eakins created a now lost, full-scale watercolor of the painting or when his pupil Alice Barber made an engraving of it for *Scribner's Monthly* in June 1880. Thus these pinholes record a later process, unrelated to Eakins' preparatory stage.

When the transfer of his preparatory drawings to canvas was complete, Eakins began the painting process. In *The Champion Single Sculls* and *The Biglin Brothers Turning the Stake,* he first subtly modified the white ground color with a translucent toning layer, brown-black in the latter (fig. 54) and pale blue in the former painting.[12] At a microscopic level, the commercially primed ground layers on both these paintings are pitted with tiny rounded craters that are probably burst air bubbles. They impart a slightly textured surface or "tooth" not visible when examining Eakins' other rowing canvases or paintings from the early 1870s.[13] When

Turning the Stake is examined closely, the brown-black modifying layer can be seen on the unpainted edges, wherever the paint is thin and, under magnification, in the tiny burst air bubbles of the ground surface. In paint cross-sections of the sky, the toning appears as a thin, dark, transparent, particle-free layer. Probably with the aid of a template,[14] Eakins avoided brushing dark toning on the area reserved for the boat, giving it a luminous quality in comparison to its surroundings.

The boats and oarsmen in the rowing scenes are thinly painted, with the paint layers following the incised lines exactly, imparting a sense of precision and conviction. But Eakins set these sculls and figures against painterly and less controlled areas, employing techniques ranging from the vigorous use of the palette knife for skies to the delicate application of opaque paint and glazes for the sculls. For example, he achieves an intense, jewel-like effect in *The Schreiber Brothers* (fig. 35): a bright red glaze and pink opaque paint on the oarsmen's caps and a deep red glaze on the shadowed sides of the orange struts are optimized by the cool, dark tones of the pier behind. Of all the rowing paintings, *The Biglin Brothers Turning the Stake* displays the most varied combination of techniques, with x-radiographs revealing Eakins' variations in paint thickness and approach. The thick, flat opaque landscape and spontaneous, multilayered sky contrasts dramatically with the thin water zone containing carefully executed boats and figures.

Eakins conveyed the liquid quality and reflective properties of water by using techniques borrowed from both traditional oil painting and watercolor. In *The Pair-Oared Shell,* he created highlights in the upper central water area by scratching through dry, gray paint with a sharp instrument to expose a white underlayer (fig. 56). Conversely, in *The Champion Single Sculls* and *The Biglin Brothers Turning the Stake,* Eakins employed the watercolor device of reserving portions of the light ground to serve as highlights in the foreground waves.[15] In the upper left and right of the latter painting, he thinned the paint while it was still wet, most likely through rubbing the surface with a turpentine-soaked cloth or brush, achieving a washlike paint layer appropriate for depicting water (fig. 59). He executed the bright reflective surface of the water near the river bank with thin, fluid, vertical brushstrokes, while the lower half of the river is created with thicker, horizontal strokes to suggest movement and surface ripples. To break up the brown reflection of the red-capped rower, he applied a blunt point, probably the end of a brush, to lift strokes of wet paint from the surface of the canvas (fig. 58). He also glazed much of the upper water with a subtle, greenish-yellow color. Muddy, opaque brushstrokes tone down some of the brighter blues in the water, mirroring a similar dulling down of the bright blue paint in the sky.

In contrast to the masterly effects Eakins achieved in the water areas and skies, the river bank in this painting appears dense and lacks luminosity. Indeed, he admitted to Gérôme in 1874 that he was experiencing problems keeping his tones from sliding together into muddiness at

54
Photomicrograph of *The Biglin Brothers Turning
the Stake* (fig. 26), showing toning layer.

56
Detail of right center in *The Pair-Oared Shell*
(fig. 19), showing scratching with a sharp
instrument to expose white underlayer.

55
Detail of the horizon line in *The Pair-Oared Shell*
(fig. 19), showing wet-in-wet strokes.

57
Photomicrograph of the sky, near the horizon, in
The Biglin Brothers Turning the Stake (fig. 26),
showing granular ocher layer.

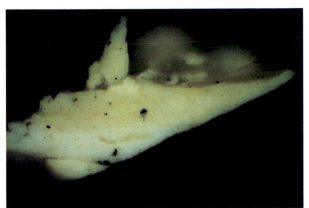

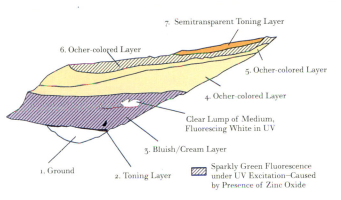

7. Semitransparent Toning Layer

6. Ocher-colored Layer

5. Ocher-colored Layer

4. Ocher-colored Layer

Clear Lump of Medium,
Fluorescing White in UV

3. Bluish/Cream Layer

1. Ground

2. Toning Layer

Sparkly Green Fluorescence
under UV Excitation—Caused
by Presence of Zinc Oxide

58
Detail of reflection in *The Biglin Brothers Turning
the Stake* (fig. 26), showing the use of a blunt point
to lift strokes of wet paint from the surface.

59
Detail of *The Biglin Brothers Turning the
Stake* (fig. 26), showing washlike paint layer.

60
Cross-section of sky from *The Biglin Brothers
Turning the Stake* (fig. 26).

61
Diagram of cross-section of sky from *The Biglin
Brothers Turning the Stake* (fig. 26). Numbers
indicate progression from ground layer to top.

the dark end of the value scale or into weakness around the lights.[16] A cross-section taken from the central area of greenish vegetation in *The Biglin Brothers Turning the Stake* reveals no less than three revisions, a record of Eakins' admitted struggle with tonality and color.

Skies in the rowing paintings are often agitated and thickly painted, providing passages of movement that complement the relative calm of the river. Eakins frequently softened the horizon line between trees and sky with a few wet-in-wet strokes, as in *The Pair-Oared Shell* (fig. 55). He used a palette knife for the upper layers of sky in *The Biglin Brothers Turning the Stake, The Schreiber Brothers,* and the oil study for *John Biglin in a Single Scull* (fig. 34). This technique probably derives from his brief period of study with the French painter Léon Bonnat, whose bold paint application provided an alternative to Gérôme's subordination of surface texture. Eakins also was impressed by Velázquez's expressive approach, for he recorded in his "Spanish notebook" that, like the seventeenth-century master, he found it best to use a palette knife when drawing with color.[17]

Although some of the most exciting brushwork appears in the skies of the rowing paintings, Eakins maintained the focal point of the composition on the subject. He may even have regarded a bright blue sky as a distraction, for most of the rowing paintings have reworked and toned-down skies.[18] A cross-section taken from the sky in *The Biglin Brothers Turning the Stake* reveals a layered structure: first Eakins painted the sky light blue, then he toned it down with a creamy ocher applied thickly with a palette knife (figs. 60, 61). Similarly, in the oil study for *John Biglin in a Single Scull,* the sky is composed of three distinct layers of blue paint from bottom to top: an intense medium blue, a light blue, and a muddy color applied with a palette knife. In the skies depicted in four paintings, *The Biglin Brothers Turning the Stake* (fig. 57), *The Pair-Oared Shell, The Schreiber Brothers,* and *The Biglin Brothers Racing,* Eakins smeared a thin, abraded, granular, ocher-colored layer unevenly over much of the paint surface to reduce the brightness and warm the tonality.[19]

We can gain insight into Eakins' choice of painting materials through pigment and medium analyses. *The Biglin Brothers Turning the Stake* was chosen as a representative rowing painting for limited sampling and non-destructive analysis. The commercially applied white ground layer consists of mostly lead white, with small proportions of iron in the upper regions.[20] Bone black provides the basic component of the brown toning layer.[21] In the body of the painting, cobalt blue was found in the Biglins' head covers and in the blue flag;[22] the pigment vermilion, in the opposing team's head covers and flag.[23] In various parts of the river bank, viridian, an intense transparent green, and cadmium yellow were found.[24] Lead white and zinc white dominate in the sky, with lead-rich layers alternating between zinc/lead-rich bands.[25] Eakins may have purchased a mixture of lead and zinc white, a mixture available on the market in a single paint.[26] Alternatively, he may have carefully layered the two whites in deference to their distinct advantages and disadvantages: zinc white possesses high opacity but becomes brittle on

drying; lead white has advantageous drying properties but low tinting strength. Eakins also may have shared the fear, expressed by late nineteenth-century writers on art, of the possible chemical changes caused by hydrogen sulfide on lead white. Various solutions were proposed, and he may have acted on one that advised artists either to mix or layer lead white with zinc white.[27] Medium analysis was conducted on two minute samples of the sky from *Turning the Stake*. In the upper, creamy ocher layer, the presence of an aged oil, possibly linseed, is suggested, which would be normal for the period. Somewhat more unusual, a natural resin was detected in the lower light blue layer.[28]

The evidence presented here reveals that Eakins, at the beginning of his development as a painter, was already a superb draftsman and master of technical problems. One of the most striking aspects of his process is the novel method of transferring a design from a drawing to the canvas using a combination of incised lines, pinpricks, and drawing lines. Equally noteworthy is his continual search for a balance of tone, color, and texture. Although reworking in the landscapes and skies betrays Eakins' relative inexperience as a painter, he found remarkably innovative solutions for the depiction of water. And he delicately layered paint for the sculls and their crews, enhancing the exquisite detail of his compositions. He relished the technical challenges involved in portraying objects as intricately constructed and finely proportioned as rowing boats. Through his detailed perspective drawings, drawn to the scale of the finished paintings, through compositional studies, watercolors, and oils, Eakins endeavored to create a series of rowing paintings equal in craftsmanship and technical achievement to the boats and the sport he loved.

Painting Victorian Manhood

MARTIN A. BERGER

From the beginning of Thomas Eakins' career in the early 1870s to the present, critics and scholars have consistently remarked on the "manly" nature of the artist's works, but never have the masculine qualities of the paintings been explained. In the nineteenth century, critics saw no need to clarify their assertions, given what they assumed to be sexuality's largely biological determination. For Victorian audiences, the artist's vigorous images of scientists and swimmers (figs. 62, 63), surgeons and boxers (figs. 65, 64) were self-evidently masculine. Yet despite critics' uninterest in interpreting the masculine nature of the artist's work, the very language employed in their discussions offers implicit proof of how masculinity was unconsciously constructed in Victorian society. To read the range of critical commentary over time is to understand that the masculinity of the 1870s was quite different from that of the 1910s.

During the final quarter of the nineteenth century, most critics faulted Eakins' monumental *Gross Clinic* of 1875 (fig. 65) for the violence of its realism. Reviewing the work in 1876, one Philadelphia critic claimed that "the scene is so real that [viewers] might as well go to a dissecting room and have done with it." The painting, the reporter continued, was "a picture that even strong men find difficult to look at long."[1] From the beginning of the twentieth century, however, critics began consistently to interpret the artist's bluntness as a strength. In *A History of American Art* (1901), Sadakichi Hartmann asserted that only Thomas Eakins and Winslow Homer fought against "the lack of rough, manly force, and the prevailing tendency [of American art] to excel in delicacy." Hartmann believed that "nearly every one who looks at . . . [*The Gross Clinic*] . . . exclaims, 'How brutal!' And yet it has only the brutality the subject demands. Our American art is so effeminate at present that it would do no harm to have it inoculated with just some of that brutality."[2] While the graphically violent nature of *The Gross Clinic* was never questioned, critics' understanding of the painting's significance altered over time as society's values evolved. If the painting made strong men ill in the 1870s, by the turn of the century, it had become a cure for effeminacy.

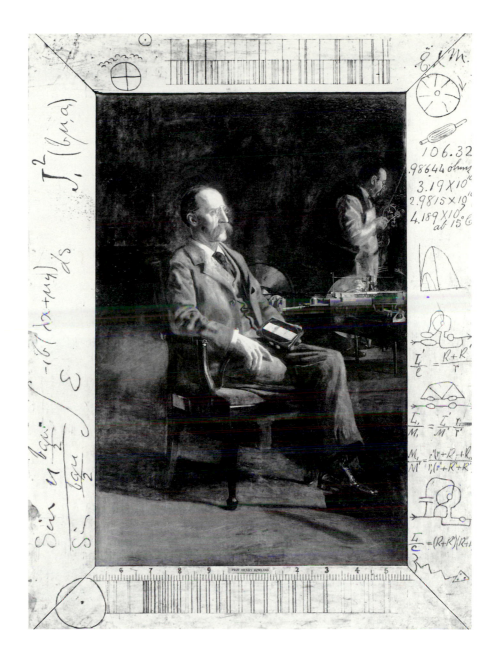

62

Thomas Eakins, *Professor Henry Rowland*, 1891.
Oil on canvas, 82 ½ x 53 ¾ in. (209.6 x 136.5 cm).
Addison Gallery of American Art, Phillips Academy,
Andover, Massachusetts; Gift of Stephen C. Clark.

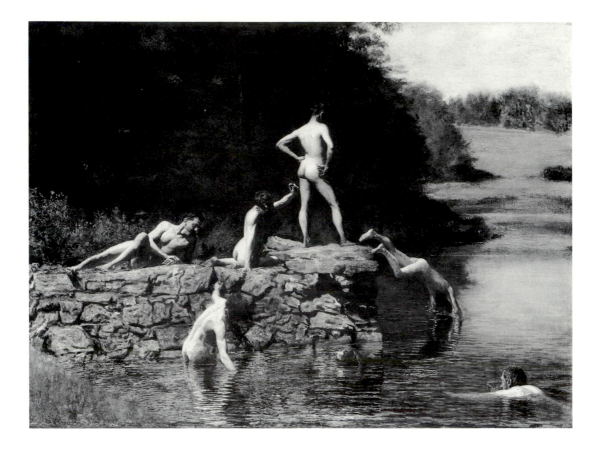

The attention paid by Eakins' contemporaries to masculine themes hardly seems surprising given the observations by modern-day sociologists that gender issues take on special urgency in societies experiencing social unrest. As Carroll Smith-Rosenberg has proposed, people feeling powerless in the face of sweeping social changes "seek through imagery and myth to mitigate their feelings of helplessness by deflecting and partially distorting change and thus bringing it within control of the imagination." Unable to contain or reverse unsettling social conditions, individuals turn inward, reshaping familial and sexual relations over which they retain some control.[3] Questions of sexual identity gained ascendance as American men wrestled with the nation's unraveling social fabric in the aftermath of the Civil War. Reeling under the impact of altered industrial and social orders and concerned by the emerging roles of women and African Americans, Eakins and his contemporaries struggled to define themselves against the new realities of their world.

Not only was Eakins buffeted by lingering national social anxieties, but his understanding of his own masculinity was further complicated by a series of personal failings. In the early 1870s, when he painted the rowing series, he boasted few of the career benchmarks that the period's middle class valued as obvious signs of manhood: he had bought his way out of Civil

64
Thomas Eakins, *Salutat*, 1898. Oil on canvas, 50 ⅛ x 40 in.
(127.3 x 101.6 cm). Addison Gallery of American Art, Phillips Academy,
Andover, Massachusetts; Gift of an anonymous donor.

War service, was unmarried, lived and worked in his parents' home, was engaged in a profes-
sion that had long held effeminate associations, and was unable to earn his own living. Eakins
had, in other words, failed to achieve a number of important "milestones" of manhood.[4]

Of all these failings, a man's inability to support himself would have proved most problematic
for both Eakins and his contemporaries. Whereas middle-class men of the eighteenth century
drew their identity from their families, social positions, and personal achievements, men of
the next century took their social identity largely from their success or failure at work. As one
historian of American manhood has noted, work "lay at the heart of [a Victorian] man's role;
if work was a problem, so was manhood," for manhood was "defined by notions of success
at work."[5]

Eakins' earliest surviving correspondence articulates anxieties he felt in being financially sus-
tained by his father. Letters home from France, where the painter completed his training,
offer painfully detailed accounts of all his expenditures and speak pointedly of his desire for
self-sufficiency. Expressing his "humiliation" in requiring his father's financial support,
Eakins explains that spending his parents' money was his "only great anxiety."[6] In an 1868
letter, Eakins provides his father a typically detailed description of his expenses, despite the

fact that Benjamin Eakins had assured his son that such itemizations were unnecessary. After listing all of his expenditures for the preceding months, Eakins wrote, "Spending your money which came to you from hard work I am touched by the delicacy of [your] not wanting the items but only the sum left, but I will nevertheless continue to give them, as I have always done. . . . I am getting on faster than many of my fellow students and could even now earn a respectable living I think in America painting heads."[7] A later Eakins letter from Paris touched on similar themes: "I will never have to give up painting, for even now I could paint heads good enough to make a living anywhere in America. I hope not to be a drag on you a great while longer . . . all I can do is work."[8]

In each of these letters the artist's progress in the studio is pointedly twinned with his ability to earn a living. Eakins' letters consistently stress his abilities as a competent painter, but they also make a case for the practicality of becoming an artist. Eakins is confident that he is "good enough to make a living anywhere in America"; yet he values self-sufficiency over his chosen profession, for his correspondence also indicates that he understood his obligation to "give up painting" if he was not "good enough to make a living."

Eakins' letters may be read as a reflection of what he thought his father wanted to hear rather than an accurate indication of his own psychological state; after all, the artist was trying to convince his father both of his anxiety about being supported and of his resolve to become successful. However, even if his letters were intended primarily to assuage his father's fears, writing them compelled Eakins to confront his own failings. The letters consistently reminded Eakins that he was unable to attain one of the most powerful standards of middle-class manhood.

Eakins' discomfort over his inability to support himself is crucial for understanding both the artist's masculine standing and the athletic rowers that he began to paint shortly after his return from Europe. In 1870, after nearly four years of artistic training at the École des Beaux-Arts in Paris, Eakins moved back to his parents' house in Philadelphia, where he set up a studio and painted images of family and friends. Unable to sell his work—and thus secure his masculine standing—Eakins might well have desired a symbolic means of sustaining his faltering manhood. Central to an understanding of Eakins' portrayals of rowers are the unconscious strategies by which the artist reframed his masculine position. Eakins reasserted his masculinity by linking himself in his works to uncontestedly masculine professions and by appropriating the male symbols of industrial production. His paintings were "manly" by nineteenth-century standards, precisely because his masculinity was so troubled.[9]

Early in 1871, Eakins produced his first and perhaps most celebrated rowing canvas, *The Champion Single Sculls* (fig. 4). Max Schmitt, a lawyer and amateur oarsman, was for a number of years Philadelphia's single-scull champion. Eakins' painting is dotted with a number of single sculls, a heavy double scull, a steamboat and a train, with three main boats forming a

65
Thomas Eakins, *The Gross Clinic*, 1875.
Oil on canvas, 96 x 78 in. (243.8 x 198.1 cm).
Jefferson Medical College of Thomas
Jefferson University, Philadelphia.

triangle in the center of the canvas. In the foreground rests the scene's protagonist, Max Schmitt, who, allowing his oars to drag in the water, glides slowly to the left of the viewer. Just behind Schmitt, in the middle distance, a single scull is being vigorously propelled toward the background. And running parallel to the railroad bridges in the distance is a red boat rowed by two men, with a third man sitting idly in the craft's stern.

The two scullers closest to the foreground are each lightly attired in contemporary dress—white short-sleeved shirts and dark pants—while the men in the distant red boat wear Quaker garb—long-sleeved tops, with one sporting a tricornered hat (fig. 66). The Quaker costume would have been understood as old-fashioned, even anachronistic, by Eakins' Philadelphia contemporaries, but was nevertheless instantly recognizable.[10] The Quakers' cumbersome craft, developed from the heavy workboats used to haul passengers and cargo across rivers, was the prototype from which modern sculls evolved, but by the 1870s was as obsolete as its rowers' dress. With roots in rowing's utilitarian past, the heavy boat and its crew provide an interesting foil to Schmitt's recreational rowing and his light racing scull.[11] The imaginary line joining the Quakers and Schmitt hints at the history of American rowing, from its commercial beginnings as a means of transportation employed by wage earners to a hobby for the leisure class. Encouraging this development, of course, was the Industrial Revolution, whose visible traces on the canvas are evident in the railroad bridges, the train itself, and the steamboat in the distance.

But the third rower in our triangle may also be pulled into the equation. Dressed in a fashion similar to Schmitt's and also occupying a single scull, he nonetheless pulls vigorously like the rowers in the distant red boat. This recreational sculler is working hard like the Quakers, perhaps training in the hopes of achieving the success of the amateur champion Schmitt. But that imaginary line from the Quakers to Schmitt also points to an evolution from a community in which individuals, supervised by elders, work in conjunction with one another for the common good, to a society in which men strike out on their own for personal fulfillment. Supervised by their coxswain, the Quaker rowers pull together toward the middle of the river, while Schmitt seems to glide along his course independently of outside guidance. Formally distinct, and yet joined to both Schmitt and the Quakers, the middle sculler appears as a sort of transitional figure, metaphorically bridging the gap between older and newer systems of work and success.

That middle sculler is Thomas Eakins. Under his tiny self-portrait, Eakins printed his surname and the year of the painting in neat red letters on the stern of the scull (see frontispiece). As the artist's only signature on the canvas, the inscription signals not only his authorship, but his pictorial presence. But by signing the painting on his scull, Eakins, in effect, names his craft in much the same way that Schmitt's scull is named on its port side with the inscription, "Josie" (fig. 67). In the nineteenth century nearly every rower—amateur and professional—named

Quaker boat from
The Champion Single Sculls, detail of fig. 4.

his scull. Some were christened "Phantom" or "Argonauta," others bore the names of famous political leaders like "Washington" or "Jefferson," while still others were named for their makers. The Biglin brothers, for example, the rowers whom Eakins most often depicted, named one of their sculls "Judge Elliot," after the boatbuilder who designed and built that vessel.[12] By naming his boat after himself, Eakins effectively likens the creation of his painted scull to the boatbuilders' craft.[13]

Such an association has telling implications, given the evolving nature of boatbuilding during the 1860s and 1870s. These decades heralded such technological advances as iron outriggers, swivel oarlocks, sliding seats, and paper hulls. Successful boatbuilders were no longer slavish copyists, constructing stock designs, but instead scientists and even artists. Robert Johnson's *A History of Rowing in America* (1871) echoed the sentiment of scullers and sculling enthusiasts by noting that modern boat builders require "high mathematical knowledge and rare mechanical skill."[14] Another writer, reporting for the "Aquatics" column in the *National Police Gazette*, pointed to a boatbuilder's "artistic skill," which he understood as a talented blend of "mathematical accuracy" and "scientific nicety." This reporter went on to note "that in races of any magnitude [the boatbuilders] come in for a great share of attention."[15] So important were the builders that newspaper and journal reports on rowing regattas almost always named the boats' makers; and so important were the sculls themselves that race reports often listed the precise dimensions of each contestant's scull.[16]

Eakins' metaphoric ties to the boatbuilders, and so to their craft and scientific traditions, were closely linked to the painter's understanding of himself as an artist. Elizabeth Johns was the first to comment on Eakins' desire to forge a link between himself and William Rush, a noted Philadelphia carver active in the late eighteenth and early nineteenth centuries. Referring specifically to the artist's 1877 painting of *William Rush Carving His Allegorical Figure of the Schuylkill River* (fig. 68), Johns notes the parallels that Eakins forged between Rush's progression from a carver of ship ornaments to a creator of high-art statuary and Eakins' professional development from a writer and teacher of ornamental script to a high-art painter.[17]

While Eakins' ties to the crafts have only recently been discussed, scholars have long made reference to the importance of science in the artist's works. In the early 1930s Lloyd Goodrich, commenting on Eakins' studies at Jefferson Medical College, his love of logarithms, and his obsessive reliance on mathematically accurate perspective sketches, called him "a rare combination of artist and scientist." Subsequent studies have rarely neglected to discuss Eakins' complicated relation to the sciences.[18]

Just as *The Champion Single Sculls* suggests a visual link between Eakins and Schmitt, it symbolically couples the painter's practice with that of the respected boatbuilders by selectively associating elements of their professions. For a painter who may have felt inadequate about his manhood, linking himself with successful rowers and esteemed craftsmen was surely fortifying.

67
Max Schmitt in "Josie,"
from *The Champion Single Sculls*, detail of fig. 4.

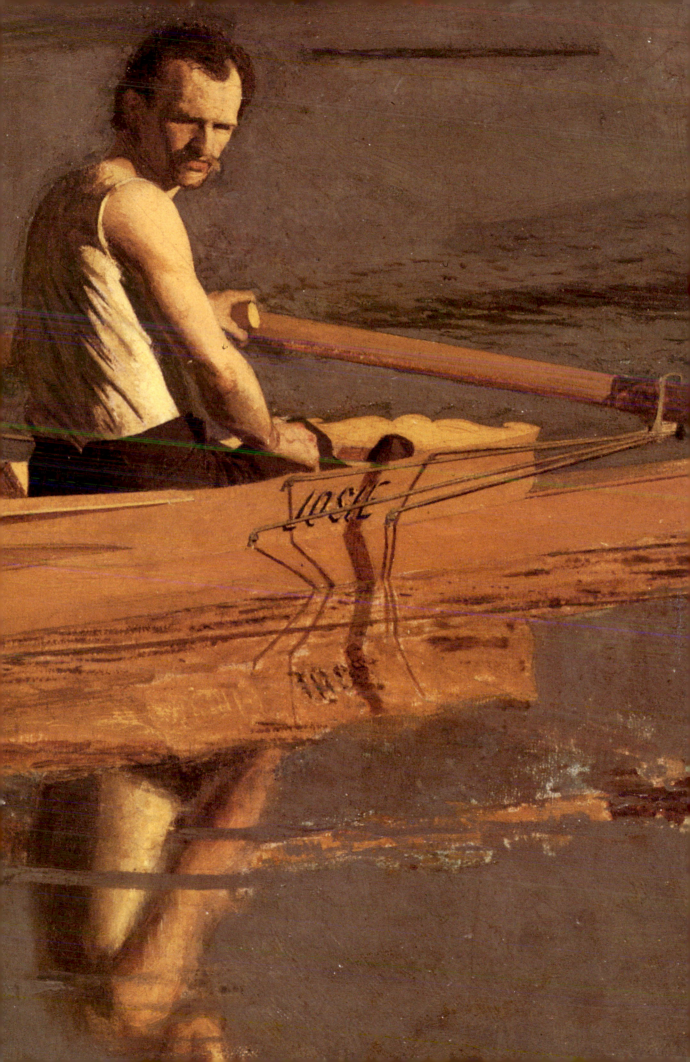

And yet it should be clear that Eakins' ties to the boatbuilders go beyond simple visual link-ages in the paintings, as both painter and boatbuilders are partially responsible for Schmitt's fame. Just as the boatbuilders' project is integral to the rowers' success, so Eakins' painterly work memorializes Schmitt's prowess as a champion sculler. Without Eakins' record of Schmitt's achievement, the rower would certainly be forgotten today. Even the painter's title for the work points to his historical project. By naming the canvas *The Champion Single Sculls*, Eakins alerts us to his commitment to record, thus perpetuating Schmitt's accomplishments as assuredly as did the builder of that race-winning scull.

If Schmitt's portrait allowed Eakins to counter perceptions of his own masculine failings by linking himself to manly pursuits, the artist's three paintings of the Biglin brothers allowed him to negotiate larger cultural inconsistencies inherent in Victorian definitions of work and manhood. Completed shortly after his portrait of Schmitt, this series portrays the popular, pro-fessional pair-oared team of John and Barney Biglin (figs. 19, 22, 26). *The Pair-Oared Shell*, *The Biglin Brothers Racing*, and *The Biglin Brothers Turning the Stake*, produced during 1872–73, loosely portray the brothers' 1872 victory in a famous professional pair-oared race on the Schuylkill River in Philadelphia. The match was arranged after the New York-based Biglins challenged any two men in England to row against them in a five-mile race. While no Englishmen took up the challenge, Henry Coulter and Lewis Cavitt of Pittsburgh offered to meet the Biglins.

In addition to being reported in a dozen Philadelphia papers, the Biglins' race was given extensive coverage by *The New York Times, The Spirit of the Times, The New York Clipper, Turf, Field and Farm*, and *The Aquatic Monthly*.[19] This last journal provided a colorful description of the scene, corresponding closely to Eakins' renderings of the race: "The river presented a pleasant aspect, being dotted over with myriads of small boats, and the handsome barges and shells of several of the clubs comprising the Schuylkill Navy. Two small steam pleasure yachts and the propeller Edith, gaily decked with bunting, as they plied up and down the stream made the scene quite animated. At about 4 o'clock the Biglins made their appear-ance in their boat, the Judge Elliot. . . . The occupants of the boat were dressed in blue flannel half-breeches, close fitting shirts, and wore a blue silk handkerchief about the head."

In the middle distance of *The Biglin Brothers Turning the Stake*, directly above Barney Biglin's head, appears the red-kerchiefed Pittsburgh team, rowing toward the red stake flag marking the midpoint of the race, just as the Biglins round their blue flag. The brothers are in mid-turn, with John reversing his stroke and "backing" as Barney checks the craft's position and pulls forward, thus pivoting the scull around the flag. By rowing in opposite directions, the rowers stay in place, rotating their scull around the stake and into position for the final pull back toward the finish line.

68

Thomas Eakins, *William Rush Carving His Allegorical Figure
of the Schuylkill River*, 1877. Oil on canvas, 20 ⅛ x 26 ½ in.
(51.1 x 67.3 cm). Philadelphia Museum of Art; Gift of Mrs.
Thomas Eakins and Miss Mary Adeline Williams.

Like most of Eakins' extant renderings of rowers, the artist here achieves an illusion of motion by showing the scullers at the conclusion of their strokes. The effect is impressive, yet paradoxical, given that the motion of each brother is used largely to counteract the exertions of the other. Although the ability to pull together is perhaps *the* most crucial skill for successful pair-oared teams, Eakins chose to render the Biglins at the one point in the race during which they must work "against" each other.

The importance of this odd "pivotal" moment was not lost on the painter's contemporaries. Impressed with Eakins' decision to show the brothers pulling in opposite directions, one period critic, reviewing the work for *The American Architect and Building News*, wrote, "It is a very strong drawing, and the moment is cleverly chosen when the stroke [John] backs water and his action is in contrast with that of his mate [Barney]."[20] The dialectical tension established by the brothers' efforts is "clever" because it highlights the disparate components of rowing usually subsumed within an apparently seamless whole. These internal contradictions are also important for the ways in which they dramatize diverse and similarly contained elements of the era's conception of masculinity. In other words, just as the painting draws attention to the apparently contradictory efforts of the rowers, it may also illustrate rarely articulated ideological oppositions coexisting within nineteenth-century manhood.

On the most basic and perhaps conscious level, *The Biglin Brothers Turning the Stake* points to rowing's reliance on both physical and mental skills. As in *The Biglin Brothers Racing*, Barney glances in the viewer's direction, checking the craft's position. If John's shaded head—coupled with his sun-drenched back, legs, and arms—hints at the importance of his physicality, then Barney's sideways glance and the sliver of light along his face might be seen as an allusion to the mental, decision-making skills that he brings to the team. Positioned in the bow, Barney is not only responsible for pulling, like his brother, but would also have controlled the boat's rudder by means of a pair of ropes at his feet. A nineteenth-century essay on rowing reminds us that in pair-oared rowing, "the bow-oar [Barney] steers and directs, whilst the stroke-oar [John] merely pulls steadily and follows the directions of the bow-oar. . . . Let one man steer and direct, the other merely following the directions and not slacking or pulling harder without orders."[21]

Paintings showing the dichotomy between mental and physical tasks, while simultaneously stressing the need for their unity, were common in Eakins' oeuvre. In *Rail Shooting* of 1876 (fig. 69), the black poleman has his knees bent and weight slightly back, steadying the craft, while the white hunter leans forward, taking aim.[22] Whereas the gunman's legs and torso are painted with flat broad strokes that reveal nothing of the body beneath his clothing, the poleman's torso and arms are sculpted with fine brushstrokes, accentuating the musculature. And yet, with light flooding his head, it is the hunter's face that stands out most distinctly from the canvas, while the poleman's is lost in deep shadow. With his darkened face, the poleman is

69
Thomas Eakins, *Rail Shooting*, 1876.
Oil on canvas, 22 ⅛ x 30 ¼ in. (56.2 x 76.8 cm).
Yale University Art Gallery, New Haven;
Bequest of Stephen Carlton Clark, B.A. 1903.

presented largely as a physical construct, while the "bodiless" hunter is signed as intellect by the detailed head from which his shotgun projects. Even as the painting seems to code mental and physical tasks as being exclusively in the domain of whites and blacks, respectively, it points clearly to the importance of teamwork for the hunt's success.[23]

John's and Barney's roles may not be as rigidly defined as those of the hunter and poleman, but they remain visually and historically distinct. Given the Biglins' fame, many contemporary viewers would have understood the physical-mental differentiation of roles based on their knowledge of the rowers' personal lives. According to business directories, during the 1860s and 1870s, John Biglin worked variously as a "mechanic," "laborer," "foreman," "fireman," and "boatman." The year after Eakins painted his 1874 rendering of *John Biglin in a Single Scull*, Biglin's profession was listed as "laborer" in *Goulding's New York City Directory for 1875–1876*. While John was engaged in hard physical labor, Barney was absorbed in predominantly mental work, having won election later in 1872 to his first of several terms in the New York State Assembly.[24] By uniting the brothers, each with their distinctive skills, *The Biglin Brothers Turning the Stake* suggests that success derives from the teamwork that balances the crews' respective mental and physical abilities.

To late twentieth-century viewers, the painting's call for a balancing of mental and physical exertions may seem prosaic, but it is important to consider that such a doctrine was still vigorously discussed in the nineteenth century. Beginning in the first half of that century, and becoming increasingly fashionable toward the 1870s, "self-culture" books counseled Americans to balance the activities of mind and body. In these decades, both mental and physical activity were thought necessary for sound health, just as each could cause breakdowns if taken to extremes. As the author of a popular 1873 book, *The Intellectual Life,* observed: "the excessive exercise of the mental powers is injurious to bodily health, and . . . all intellectual labor proceeds upon a physical basis." In 1874 another writer argued against those who thought that mental activity alone could promote good health, warning that a dearth of exercise would result in "the clogging of the wheels of the internal parts of the fleshy frame, and various shades of stomachic and cerebral discomfort."[25]

But given the differing classes of the brothers, Eakins' images of the Biglins went beyond merely reflecting general, contemporary concerns for the balancing of mental and physical exertions. In industrial America, working-class men were obliged to perform predominantly physical work, while males of the middle and upper classes were engaged solely in labor that physician and scientist S. Weir Mitchell called "brain work." The practices of late nineteenth-century industry circumscribed the decision-making capabilities of laborers while at the same time limiting the physical activities of managers.[26] Given the class divisions of roles, arriving at the mental-physical balance that so many advocates of good health were demanding was difficult. Rowing, however, provided both a site and an activity that could bridge the gap,

offering laborers the opportunity to make choices and command their own bodies, and wealthier participants the chance to gain the physicality they lacked in their daily routines.[27]

Because the tasks of both brothers remain overwhelmingly physical (despite the mental component of Barney's role), the work might also suggest ways in which Eakins and his rowers complement each others' masculine positions. Just as Barney offers mental balance to John's wholly physical tasks, so Eakins' "scientific" artistic practice counterbalances the brothers' athletic profession. Not only would Eakins' masculine standing be improved through his association with the successful racers, but the scullers would solidify *their* positions by being more forcefully linked to Eakins' intellectual art. Artist and athletes, Eakins seems to suggest, ultimately cooperate in a symbiotic relationship, each sharing components of Gilded Age masculine identity that the other seemed to lack.

Despite the balance rowing may have afforded to the lives of middle- and working-class men, it is certainly true that these classes never enjoyed the freedoms of wealthier Americans. While rowing may have granted its adherents the opportunity to command their own physical and mental activities, and while it promoted the appearance of symmetry between the lives of white- and blue-collar workers, rowing did not offer participants control over their alienated labor in the market place. What rowing did provide, however, was a reconciliation of masculine ideologies. In the end, rowing's immense popularity may well have been linked to the very *impossibility* of successfully negotiating the disparate and contradictory demands of Victorian manhood.[28]

If Eakins' choice of subject matter worked by association to link the artist to men and occupations that his society coded as masculine, his realist style augmented his masculine position by dissociating him from various feminine associations. While it is commonly assumed today that nineteenth-century realism was unambiguously regarded as masculine, the realism of the 1870s and 1880s possessed both masculine and feminine resonances. During most of Eakins' lifetime, the artist's perceived ability to "replicate" the real was not understood as a sign of his manhood, for despite the admiration that Victorian critics displayed for manliness, they were quick to point to Eakins' "exactitude" as a fault. In fact, throughout much of the nineteenth century the depiction of the real was thought incompatible with the ideals of high art.

It was not until the early years of the twentieth century that critics routinely coupled Eakins' realism to the perceived masculinity of the artist and his works.[29] For early twentieth-century critics like Hartmann and Goodrich, who lamented the "aesthetic wasteland" of Victorian American art, Eakins' images came as a welcome respite.[30] In describing the work of Robert Vonnoh, one of the American "descendants of impressionism," Hartmann noted that "he painted a number of strong, masculine pictures of gray in gray realism, but later on, becoming a fashionable portraitist, he entered the variegated fields of impressionism" (fig. 70).[31] For many twentieth-century critics, Eakins' works were in polar opposition to the paintings of the

American Impressionists. As canvases by artists such as John Sloan, George Luks (fig. 71), and George Bellows (fig. 72) were interpreted by early twentieth-century audiences as masculine, Eakins' works were retrospectively accorded the same masculine label because of the obvious debts—in subject matter and at times in handling—that the younger generation's paintings clearly owed Eakins. Consequently, while European Impressionism is traditionally understood as fostering the modernist impulses of the twentieth century, American Impressionism was viewed as largely derivative. In America modernism traces its roots back to the nineteenth century through the Social Realists at the turn of the century and the realists before them. Within the cultural context of modernism, Eakins' realist paintings were both an antidote to the effeminacy of Impressionism and the foundation from which modernism emerged.[32] Yet once Eakins' works were linked to modernism, the historically specific ideologies of nineteenth-century manhood were subsumed under those of the new century. The realism of Victorian America became uniquely masculine only in the twentieth century with the rise of a new ethos that saw the experience of the real as an end unto itself.[33]

When the rowing series was painted during the first half of the 1870s, realism possessed feminine associations because of its extreme reliance on detail. In an 1868 letter to his father, Eakins makes clear his understanding of detail as a feminine attribute by favorably contrasting what he took to be the rough "head work" of oil sketches with the detailed "ladies' work" of finished canvases.[34] And yet, if realism possessed clear feminine associations, it also allowed him to distance himself from such unwanted ties. Eakins' painting technique, with its smooth brushstrokes, naturalistic colors, and attention to detail, permitted the artist to downplay his participation in the creation of his scenes without subverting his style.[35] By presenting his canvases as if they were "real" and unmediated by his artistry, Eakins upheld the tenets of realism, as he distanced himself from his chosen style. Ironically, the very mimetic precision of Eakins' realistic canvases, a precision that the artist understood as feminine, allowed him to pull back metaphorically from his work.

Rowing, like nineteenth-century realism, was not exclusively masculine: Victorian women, for example, demonstrated (and were encouraged to demonstrate) as much interest in the sport as men (figs. 7, 9). Late nineteenth-century periodicals make it clear that women regularly made up half the audiences for popular sculling matches, and editorials routinely promoted women's participation in athletics.[36] While it was enough for women simply to take part in sports, men were expected to excel. Given the close links between period conceptions of masculinity and success, Eakins' unremarkable participation in sports did not significantly enhance his manhood. An 1867 editorial on the champion St. John rowers articulated the era's dominant criteria for recognizing masculinity when it stated: "If men are to be judged by their deeds and performances, then the St. John rowers are assuredly entitled to all the fame and reputation

70
Robert Vonnoh, *In Flanders Field—Where Soldiers Sleep and Poppies Grow*, 1890. Oil on canvas,
58 x 104 in. (147.3 x 264.2 cm). The Butler Institute of American Art, Youngstown, Ohio.

71
George Luks, *Holiday on the Hudson*, c. 1912. Oil on canvas, 30 x 36 ⅛ in. (76.2 x 91.8 cm).
The Cleveland Museum of Art; Hinman B. Hurlbut Collection.

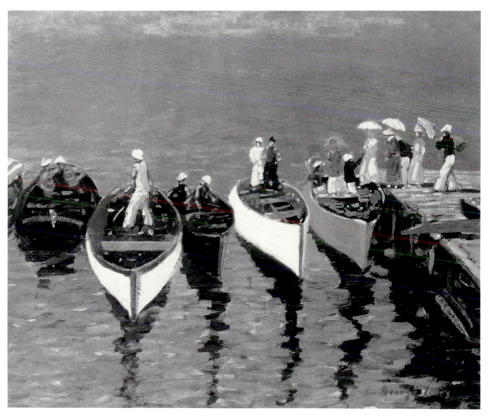

that they now enjoy; as *success* [emphasis original], which is naturally the world's only crite-
rion to judge from, has been theirs to a wonderful degree."[37]

The meaning of success as a win-lose proposition, however, was undergoing a subtle alteration
in the early years of the 1870s; success was coming to mean more than simply a man's accom-
plishments in his profession. During these years the practices of work and their ties to indus-
trialization—whether those practices led to success or not—were coming increasingly to be
understood as manly. Illustrating this transformation is Eakins' 1874 painting of John Biglin,
who was also one of America's most successful *single*-scull racers. The firmly locked wrists and
rigid arms evident in *John Biglin in a Single Scull* (fig. 34) attest to the rower's physicality as
well as allude to his mechanical nature.[38] Biglin's left arm meets the oar at an acute angle,
redirecting the oar's diagonal thrust toward his chest. The sharp angular meeting of oar and
arm is echoed by the angle at which the rower's calf meets his thigh and by the pairs of iron
outriggers meeting at the oarlock. Visually, Biglin seems but one part of the machine that he
propels. As one 1872 sporting editorial aptly noted, Biglin is a "tough, sinewy specimen of
human mechanism."[39] Late Victorian journal and book descriptions of rowers described them
variously as "machines," "watch springs," and "pistons."[40] One author even likened rowers to
steam engines, maintaining that to be successful "the fire-grate and chimneys of the human
engine must be kept clear and in perfect working order." So taken was the author with this
metaphor that he referred to sweat almost exclusively as "steam."[41]

The visual and literary descriptions of "Biglin-as-machine" are directly tied to the rise of pro-
ductivism in nineteenth-century American culture. Widely accepted in the later years of the
century, productivism held that the shared processes of production linked machines, workers,
and natural forces.[42] Intrigued by productivism and what he calls "machine culture," Mark
Seltzer claims that the increasingly blurred boundaries in Victorian literary descriptions of the
users, makers, and managers of machines was a peculiar problem of the later nineteenth cen-
tury. Drawing on the work of historian Perry Miller and others, Seltzer argues that beginning
at mid-century, the association "of steam power and generation . . . [was] part of a larger cele-
bration of technology by which Americans viewed the machine, and especially the steam
engine . . . as a replacement for the human body." For Seltzer machine culture is interesting
not so much for its equation of human and mechanical productions as for its tendency to natu-
ralize and elevate the machine over the body.[43]

On one level, Eakins' rowing paintings can be seen to embody the pervading machine culture
that Seltzer detected in literary works of the late nineteenth century. In light of the written
and visual records coupling rowers to "pistons" and "steam engines," and given nineteenth-
century rhetoric on the generative power of industrial machinery, Biglin's image can be read-
ily understood as an emblem of productivity. Certainly Biglin—as a sign for production—

72
George Bellows, *Both Members of This Club,* 1909. Oil on canvas, 45 ¼ x 63 ⅛ in. (114.9 x 160.3 cm).
National Gallery of Art, Washington, D.C.; Chester Dale Collection.

was of particular interest to a man whose own artistic "productions" were so infrequently purchased.

But in a more specific sense, the painting's linkages to machines and to generative production also helped Eakins forge ties between his artistic practice and the masculine domain of industrial America. The American home, which early in the nineteenth century had been the site of production as well as consumption, became toward the middle and later parts of the century associated almost exclusively with consumption. As men left their homes in increasingly large numbers, entering the industrial economy as paid workers (skilled and unskilled laborers as well as clerks and managers), the site of production shifted from home to factory. Left increasingly with childcare and household work alone, women became closely associated with consumption, while their husbands, laboring largely in offices and factories, were connected with production.[44] Given this growing bifurcation between female (consuming) and male (producing) cultures in late nineteenth-century middle-class America, Eakins might well have unconsciously desired to appropriate the masculinized symbols of production by allying himself closely with male traditions of work and distancing himself from labor that was gendered female. By associating himself with the innovative boatbuilders, the famous rowers who

produced victories, and the industrial machinery of production, Eakins metaphorically strengthened his links to the male world.

On another, secondary level, the canvases' associations with machines and production construct ties between the spheres of work and leisure. To viewers, the rowing canvases may have helped legitimate emerging recreational culture, given the ambivalence with which Americans of the era regarded leisure pursuits.[45] As Daniel Rogers has argued, the American ethos that valued work above all else began to decay in the 1850s, evolving by the 1870s into an ideal that advocated a balance of work and leisure. Beginning in the 1870s, leisure came to be viewed not as mere idleness or indolence but rather as an antidote to the excesses of Gilded Age labor practices. In the early 1870s, *The Christian Reader* contended that Americans now had "the duty of play."[46]

Such standard late nineteenth-century admonitions were echoed by Eakins' friend, the Philadelphia physician S. Weir Mitchell. Ministering predominantly to Philadelphia's wealthy, Mitchell built on the neurasthenia theories of George M. Beard and developed his own "rest cure" for those afflicted by nervousness. In contrast with the Victorian "self-culture" tracts that frequently sought to encourage the integration of intellectual and physical labors at work, Mitchell's doctrine tacitly accepts the impossibility of joining mental and manual tasks in the modern, middle-class work place. In *Wear and Tear, or Hints for the Overworked* (1871), Mitchell acknowledges the class-based divisions of labor and seeks instead to balance mental work with physical play. In an era when the interconnections between the mind and body were only beginning to be understood, Mitchell assured his patients that "nothing is now more sure in hygienic science than that a proper alternation of physical and mental labor is best fitted to insure a lifetime of wholesome and rigorous intellectual exertion."[47]

Such cultural prescriptions would have been welcomed by Eakins, as they initiated a shift in how society calculated male identity. The societal evaluations that saw mental exertion (work) alone as unwise, even reckless, and physical activity (sports) as beneficial, heralded a middle-class standard of manhood in which one's masculinity was not predicated on work alone. By advocating the value of men's participation in physical activities that were not directly job-related, the period's writers effectively articulated a reevaluation of manhood. This evolving rhetoric, which sought to balance work with leisure and mental with physical activity, opened the door to a conception of masculinity that was not predicated on traditional notions of success alone.

If industrial America of the 1870s had failed the working classes through its deflationary crises, low wages, unemployment, seasonal work, cyclical recessions, loss of economic independence, and dangerous working conditions, rowing—as a true meritocracy with its codified

rules and tangible rewards for success—must have held out an appealing promise to the working classes. Being tied to a machine for ten hours a day on a factory floor was clearly not the utopian vision of modernity that laborers had envisioned; rowing's working-class popularity may therefore have been closely allied with its metaphoric ability to make good on the potentialities of the Protestant work ethic and industrialism. During the last century the image of a successful rower wedded to a machine by choice, for pleasure, obviously held appeal for workers grown weary of the broken promises of industrialism.

For the wealthy, the rowing paintings offered confirmation of what prosperous Americans wanted to believe: that their success was attained solely through skill and determination. In a vague, non-threatening manner, the paintings optimistically suggested to the affluent that middle- and working-class men could also advance themselves if they were willing to work hard enough. As a group that was increasingly conditioned to value recreation, wealthy Americans may have appreciated that Eakins' rowers presented an alternate means of "production," one that bridged the gap between brain work and leisurely sports, creating a transitional space between the strict work ethic of the early part of the century and the ethos of leisure at the century's close.

For both Eakins and his contemporaries, the rowing paintings offered specific but varying metaphoric strategies for negotiating the complicated and at times contradictory demands of Victorian manhood. The subtle negotiations effected in the rowing canvases allowed Eakins to recast his masculinity and so downplay his unstable position, not by reinventing the meaning of Victorian manhood, but by selectively associating himself with masculine elements of Gilded Age culture. Pushing at the borders of period masculine ideologies, Eakins' paintings worked to legitimate more expansive definitions of "the masculine" in late nineteenth-century American culture.

Notes to the Essays

A key to manuscript collections cited and references abbreviated by author's name and date of publication can be found in the Selected Bibliography, p. 135.

Cooper (pp. 12–23)

1 Elizabeth Johns, "Drawing Instruction at Central High School and Its Impact on Thomas Eakins," *Winterthur Portfolio* 15 (Summer 1980), p. 144.

2 Milroy 1986, p. 63.

3 Goodrich 1982, I, p. 17.

4 Milroy 1986, p. 26.

5 Weinberg 1984, p. 5. For the teaching procedures at the École des Beaux-Arts, see pp. 5–33.

6 Thomas Eakins to Benjamin Eakins, October 26–27, 1866, PAFA; Foster and Liebold 1989, pp. 197–203. See also pp. 48–51 for Eakins' "Siege of the École."

7 The Americans admitted with Eakins were Conrad Diehl, Earl Shinn, Howard Roberts, and Frederick A. Bridgman; Foster and Liebold 1989, p. 48.

8 According to Foster and Leibold 1989, p. 42, there are 124 Eakins letters from Europe (including transcripts and fragments) dating from the fall of 1866 to the spring of 1870. The largest number are to Benjamin Eakins.

9 Milroy 1986, p. 24.

10 Thomas Eakins to Benjamin Eakins, May 31, 1867, PMA.

11 Milroy 1986, pp. 143–46.

12 Ibid., p. 116. In particular, Knoedler's in New York showed Gérôme's paintings before placing many of them in private collections.

13 Foster, forthcoming. Also Gerald M. Ackerman, "Thomas Eakins and His Parisian Masters Gérôme and Bonnat," *Gazette des Beaux-Arts* 73 (April 1969), p. 240; Weinberg 1984, p. 41.

14 For a discussion of Taine and his tenure at the École, see Milroy 1986, pp. 232–43.

15 See Thomas Eakins to Benjamin Eakins, March 6, 1868, PAFA, Foster and Liebold 1989, pp. 206–08. For Spencer's writings published in the United States and their impact on American art philosophy of the period, see Milroy 1986, pp. 229–39.

16 Ibid., pp. 112–13.

17 Ibid., p. 51.

18 Weinberg 1984, p. 23.

19 Quoted in Goodrich 1982, I, p. 23.

20 Weinberg 1984, p. 37.

21 September 20, 1867, PAFA, quoted in Weinberg 1984, p. 37, and Goodrich 1982, I, p. 25.

22 Quoted in Goodrich 1982, pp. 26–27.

23 Ibid., p. 27.

24 Several of Eakins' acquaintances were already members of Bonnat's atelier, including Edwin Blashfield, Eugene Poole, and Milne Ramsay. For Bonnat's teaching methods, see Milroy 1986, pp. 254–60.

25 Thomas Eakins to Benjamin Eakins, March 6, 1868, PAFA, Foster and Liebold 1989, pp. 206–08.

26 Ibid.

27 Thomas Eakins to Benjamin Eakins, "Autumn" 1869, PMA, quoted in Milroy 1986, p. 262.

28 Thomas Eakins to Benjamin Eakins, December 2, 1869, PAFA, Foster and Liebold 1989, pp. 210–12; and February 23 or 24, 1868, PAFA.

29 Thomas Eakins to Benjamin Eakins, October 29, 1868, PAFA, Foster and Liebold 1989, pp. 208–09.

30 Thomas Eakins to Benjamin Eakins, November 5, 1869, PAFA, Foster and Liebold 1989, p. 210; and November 29, 1869, PMA.

31 Thomas Eakins to Benjamin Eakins, December 2, 1869, PAFA, Foster and Liebold 1989, pp. 210–12.

32 Hendricks 1974, p. 70, identified the original title of the painting as *The Champion Single Sculls*—the title under which Eakins exhibited it. Johns 1983, p. 19 n. 2, points out that since the painting honors one champion, the title should read *The Champion, Single Sculls*, but Eakins regularly omitted commas. For a detailed description of the painting, see Natalie Spassky, *American Paintings in The Metropolitan Museum of Art*, II (New York: The Metropolitan Museum of Art, 1985), pp. 588–94.

33 See note 13.

Cooper (pp. 24–78)

1 Thomas Eakins to Caroline Eakins, October 8, 1866. PAFA.

2 Thomas Eakins to Frances Eakins, November 13, 1867, and "Good Friday," 1868, AAA.

3 Thomas E. Weil, Jr., "Rowing: A Historical Overview of the First Modern Sport," in *Reflections on a Tradition*, exh. cat. (Washington, D.C.: Georgetown University Fine Arts Gallery, 1990), n.p.; revised and reprinted in *American Rower's Almanac 1996* (Washington, D.C.: American Rower's Almanac, Inc., 1996), pp. 3–8.

4 Doggett provided in his will for the winner to receive an orange coat and a silver arm badge engraved "Liberty." The contest has been held continuously since its inception. See Thomas C. Mendenhall, *A Short History of American Rowing* (Boston: Charles River Books, 1980), p. 5.

5 By the early 1870s, Americans had purchased approximately two thousand boats, and twelve thousand people had joined boating clubs; see *Turf, Field and Farm*, March 22, 1872, p. 185. By 1873, there were 289 organized boat clubs in twenty-five states. The culminating event for American rowing was the inclusion of rowing as one of the two sports—the other was marksmanship—represented at the 1876 Centennial Exposition in Philadelphia.

6 "If some of our fashionable women would practice a little with the oar when they are killing time during the Summer months out in the country, it would be a good thing for them. Rowing is splendid exercise, and a lady can easily learn to pull her own boat and take care of herself on water. Our fashionable women stand sadly in need of just such healthy exercise; it will give them strength, improve digestion, expand the chest, bring color to the cheeks and brightness to the eyes; and then the idlers will not return to the city in the Autumn days like faded flowers. . . . If women will take to the oars in July and August instead of to talking scandal and reading sensational novels, we feel confident in saying that they will greatly improve their physical and mental conditions, and will make more conquests in masculine ranks than they now make. Man can not resist admiring woman when she is at exercise in the boat no more than he can resist admiring her when she sits like a queen in the saddle"; *Turf, Field and Farm*, July 12, 1872, p. 24.

7 *The New York Clipper*, June 29, 1867, p. 92, quoted in Johns 1983, p. 36.

8 Thomas Eakins to Caroline Eakins, June 28, 1867, PAFA. [From the time of Schmitt's first single scull championship in 1867 to the time Eakins returned to Philadelphia in July 1870, the celebrated oarsman lost the title, won it back, and then lost it again. Of the race in June 1869, Eakins wrote to his sister Frances, "I'm looking out for news of Max's race. . . . I will be real sorry if he dont win this time for it will break his heart if he dont and it is an ambition that dont wrong others." After learning of Schmitt's victory he wrote, "I am glad he beat & you give him my congratulations next time you see him." Thomas Eakins to Benjamin Eakins and Frances Eakins, 2 July 1869, PAFA; Thomas Eakins to Frances Eakins, 8 July 1869, AAA. The race is recorded in Frederick J. Engelhardt, *The American Rowing Almanac and Oarsman's Pocket Companion* (New York: Engelhardt and Bruce, 1873), pp. 117–18.

9 Toney Frazier, "Whitman, Eakins and the Athletic Figure in American Art," in *Aethlon: The Journal of Sport Literature* 6 (Spring 1989), p. 79.

10 Charles A. Peverelly, *The Book of American Pastimes*, 2nd ed. (New York: The American News Company, 1868), pp. 116–17. For a modern discussion of the cult of the strenuous life in late nineteenth-century America, see David E. Shi, *Facing Facts: Realism in American Thought and Culture, 1850–1920* (New York: Oxford University Press, 1995), pp. 212–22.

11 Thomas Eakins to Benjamin Eakins, March 6, 1868, PAFA, Foster and Liebold 1989, pp. 206–08.

12 Johns 1983, chap. 2. This remains the most complete and subtle analysis of the painting.

13 Johns 1983, p. 37 n. 42, cites reports of the race in Engelhardt, *The American Rowing Almanac*, p. 121; *Philadelphia Evening Bulletin*, October 6, 1870; *The New York Clipper*, October 15, 1870, p. 220; *The Spirit of the Times: A Chronicle of the Turf, Field, Sports and Stage*, October 15, 1870, p. 135; and Louis Heiland, *History of the Schuylkill Navy of Philadelphia* (Philadelphia: Drake Press, 1938), p. 134.

14 Thomas Eakins to Benjamin Eakins, March 6, 1868, PAFA.

15 David Farmer, *Rowing/Olympics*, exh. cat. (Santa Barbara: University Art Museum, University of California, Santa Barbara, 1984), pp. 11, 15; Richard A. Glendon and Richard J. Glendon, *Rowing* (Philadelphia: J.B. Lippincott, 1923), chap. 9, "Sculling."

16 *Philadelphia Evening Bulletin*, April 27, 1871.

17 *Philadelphia Inquirer*, April 27, 1871.

18 Goodrich 1982, I, pp. 76–79.

19 In addition to numerous preliminary works that are lost, at least two oil sketches of rowers were overpainted by the artist and are known to us through x-rays of *Sketch of the Gross Clinic* and the *Portrait of J. Harry Lewis* (both Philadelphia Museum of Art); see Siegl 1978, p. 54. Eakins also executed a portrait of the champion rower Joshua Ward that was destroyed in a fire at Ward's Hotel; see Irene Ward Norsen, *Ward Brothers Champions of the World* (New York: Vintage Press, 1958), p. 52.

20 *The Aquatic Monthly and Nautical Review* 1 (June 1872), p. 57.

21 Ibid., p. 56.

22 There were six Biglin brothers (*New York Herald*, April 23, 1886, p. 9), four of whom rowed competitively—John, Bernard, Philip, and James. I am greatly indebted to William Lanouette, who is at

work on a book about the Biglin brothers and professional rowing, for generously sharing his information with me, and for his careful reading of the manuscript.

23 *Philadelphia Press*, May 21, 1872, quoted in Jane E. Allen and Roger B. Allen, *Flashing Oars*, exh. cat. (Philadelphia: Philadelphia Maritime Museum, 1985), no. 154.

24 *The New York Clipper*, June 1, 1872, p. 68. Barney Biglin was born in Cambria County, Pennsylvania, on September 4, 1840, the son of John and Eleanor Biglin. In later life, Barney was a businessman, member of the New York State Assembly, and founder of a freight-forwarding company; he died on May 11, 1924 (*The New York Times*, May 12, 1924, p. 17).

25 See *Goulding's New York City Directory for 1875–1876*. (New York: Lawrence G. Goulding, 1875). John Biglin was born on January 30, 1844, in Cambria County, Pennsylvania, and died on April 19, 1886.

26 *The New York Times*, April 23, 1886, p. 8.

27 *Turf, Field and Farm*, May 24, 1872, p. 335; *The New York Clipper*, June 1, 1872, p. 68.

28 *Turf, Field and Farm*, May 24, 1872, p. 335. The sliding seat had two advantages: it enabled the oarsman to increase the length of time his oar was in the water and thus propel the boat farther in single stroke, and, unlike fixed-seat rowing, where the stroke was largely taken by the back and arms, the sliding seat allowed the oarsman to harness more of his leg muscles; see Mendenhall, *A Short History of American Rowing*, p. 10. The sliding seat had been introduced into general use in the late 1860s by the American sculler John C. Babcock, although others, including Walter Brown (fig. 8), also claimed credit for developing this important innovation. Initially, there was considerable discussion among rowers as to its advantages, and periodicals such as *Turf, Field and Farm* kept readers up-to-date on the division between "the sliders" and "anti-sliders." By 1872, virtually every shell had slides in some form: movable seats that traveled in grooves, or on wheels and runners, or "the smooth board, well slushed with tallow, on which the oarsman, his trunks reinforced with leather, moved"; Samuel Crowther and Arthur Ruhl, *Rowing and Track Athletics* (New York: The Macmillan Company, 1905), p. 42; see also pp. 237–40.

29 *Philadelphia Press*, May 21, 1872, quoted in Hendricks 1974, p. 74.

30 *Philadelphia Press*, May 21, 1872, quoted in Allen and Allen, *Flashing Oars*, no. 154.

31 Eakins' record book 2, p. 14, PAFA, records the painting as *The Biglens* [*sic*] *under the Bridge* and *The Biglens* [*sic*] *Practicing*. However, when the painting was exhibited for the first time in 1879 at the National Academy of Design in New York it was titled *The Pair-Oared Shell*.

32 See Theodor Siegl's excellent analysis of *The Pair-Oared Shell* in *Philadelphia: Three Centuries of American Art*, exh. cat. (Philadelphia: Philadelphia Museum of Art, 1976), pp. 393–94.

33 Bregler, Eakins' lifelong friend and pupil, analyzed the palette with the colors still on it that Eakins left at his death; see Charles Bregler, "Eakins' Permanent Palette," *The Art Digest* 15 (November 18, 1940), p. 4.

34 For a full analysis of Eakins' perspective drawings, see Amy Werbel's essay, pp. 79–89.

35 Quoted in Bregler, March 1931, p. 383.

36 Siegl, *Philadelphia: Three Centuries*, pp. 391–93; Siegl 1978, pp. 54–56. For an expanded discussion of Eakins' formulations of scale, ratio, and distance, see Foster, forthcoming.

37 Sewell 1982, pp. 17–18.

38 "Reflections in the Water," in "Miscellaneous Notes," in Eakins' unpublished drawing manual, PMA.

39 *Philadelphia Evening Telegraph*, April 6, 1881; *New York Herald*, April 28, 1879, p. 5; S.R. Koehler, *The American Art Review* 2, part 2 (1881), p. 122; *The New York Times*, April 20, 1879, p. 10.

40 *Turf, Field and Farm*, May 24, 1872, p. 335.

41 *The Aquatic Monthly and Nautical Review* 1 (June 1872), pp. 56–58. The race was given prominent coverage in numerous publications. For example, *The New York Times*, May 21, 1872, placed its report in the center of the front page above the fold.

42 See note 40 above.

43 *The Biglin Brothers Racing* can now be dated to 1872 based on a description of it as one of three Eakins rowing scenes hanging in the New York office of the weekly periodical *Turf, Field and Farm*: "One picture shows them ready for the word go, with Barney's cunning eye over his left shoulder." The other two scenes were *The Pair-Oared Shell* and a "water color of John in a single shell"; *Turf, Field and Farm*, October 25, 1872, p. 266.

44 I am deeply grateful to Thomas E. Weil, Jr., for his analysis of the various rowing strokes used by each of Eakins' scullers and oarsmen. My discussion of the paintings has been immeasurably enhanced by his generous willingness to share his extraordinary knowledge of the sport. In addition to the works cited in note 2 above, Mr. Weil is the author of *Rowing: The First Modern Sport*, exh. cat. (Mystic Harbor, Connecticut: Mystic Seaport Museum, 1996).

45 Notebook VI, "Talks to Class," undated notes in Susan Macdowell Eakins' hand, PAFA. See also Bregler, March 1931, p. 384.

46 Foster, forthcoming.

47 M.G. van Rensselaer, "The Philadelphia Exhibition—II," *The American Architect and Building News* 8 (December 25, 1880), p. 303. Eakins' record books (1 and 2, nos. 41 and 35, respectively), PMA, list the painting as "Biglen [*sic*] Brothers turning Stake-boat." Eakins' student Alice Barber did an engraving of the painting for *Scribner's Monthly Illustrated Magazine* 20 (June 1880), p. 165, which was erroneously captioned "On the Harlem."

48 Observers from the rowing community have differed as to what precisely John Biglin appears to be doing from his position as stroke on the starboard side. One authority has suggested that the oarsman is backing water, a normal role for the rower on the inside of the turn—a view supported primarily by the position of Biglin's left wrist; Thomas C. Mendenhall, "The Rowing Art of Thomas Eakins," *Rowing USA* (April-May 1983), p. 14. Others, however, have pointed to elements of the image which could be inconsistent with what would otherwise be the natural interpretation, such as the position of his right wrist, which seems as or more typical of a "pulling" stroke than a "backing" one. These experts have argued that the professional Biglins would not have checked the forward progress of the boat at this moment in a race. This suggests that the stroke may have come forward on his slide to allow the bowman better reach, and may be applying some light pressure ("touching it up") by pulling with his right arm, perhaps to move the shell away from the stake. Some of these authorities point to the apparent cavity in the water on the bow side of John Biglin's blade and to the water flowing over the blade, away from the viewer, as even stronger evidence of a pulling stroke, but at least one observer maintains that the image shows water flowing over the blade toward the viewer, which would be supportive of the "backing" or "holding" view. As each of these propositions runs into one or more contrary indicators, it raises the question of whether Eakins may have erroneously combined inconsistent elements of different movements in depicting John Biglin's activity. Letters to the author from Thomas E. Weil, Jr., January 12, 1996; David H. Vogel, head coach, men's heavyweight crew, Yale University, and president, United States Rowing Association, January 23, 1996. Interviews with Anthony P. Johnson, varsity crew coach, Georgetown University, pair-oar world champion, 1967, silver medal, 1968 Olympics, March 24 and 25, 1996; William Lanouette, March 26, 1996.

49 "It is rather curious that gentlemen amateurs and gentlemen's sons will persist in rowing with nude bodies. Why do they do it? It is certainly not because there is any advantage in rowing without a shirt. It is very seldom that we see even a professional crew on the water without being decently covered, and in the majority of regattas it would hardly be permitted. . . . The Biglins were never seen on the water without being decently clad, and yet when the question of rowing with or without shirts was brought up in the Convention of the Rowing Association of American Colleges there was a large majority in favor of rowing with the upper body nude. This is merely a boyish freak. . . . not even a common waterman would be guilty of such immodesty," *Turf, Field and Farm,* April 23, 1875, p. 281. For further mention of Coulter's and Cavitt's rowing costume, see *The Aquatic Monthly and Nautical Review* 1 (June 1872), p. 58, and *The New York Times,* May 21, 1872, p. 1. Modes of dress have long bespoken social class. Perhaps because rowing had become so egalitarian, some rowers believed the only way to mark a more elite status was to appear bare to the waist, possibly a way of associating themselves with the partially garbed athletes of the ancient world.

50 Quoted in Bregler, March 1931, p. 385.

51 [Earl Shinn], "Notes," *The Nation,* March 12, 1874, p. 172.

52 "Fine Arts, The Water Color Exhibition," *The New York Tribune,* February 14, 1874, p. 7.

53 Ibid. Paper boats, praised for their lightness, were all the rage in the early 1870s. They were made in pressed layers and waterproofed with shellac. See *The Annual Illustrated Catalogue and Oarsman's Manual for 1871* (Troy, New York: Waters, Balch and Co., Patent Paper Boat Builders, 1871).

54 See note 43 above.

55 Jean-Léon Gérôme to Thomas Eakins, May 10, 1873, transcribed in Goodrich 1982, I, pp. 113–14. After leaving France in June 1870, Eakins exchanged letters with Gérôme on several occasions. Most of these letters have disappeared and are known only through copies. About 1930, Eakins' widow, Susan Macdowell Eakins, showed Goodrich two original letters from Gérôme, now lost, the 1873 letter just cited and another from 1874 (see note 56 below). Goodrich's published texts and translations are based on his personal transcriptions of French originals.

56 Jean-Léon Gérôme to Thomas Eakins, September 18, 1874, transcribed in Goodrich 1982, I, p. 116.

57 Eakins' record book 2, p. 59, PAFA. The entry may be in Susan Macdowell Eakins' hand.

58 For further discussion of the Biglin watercolor and its replica in relation to the perspective drawing and oil study, and an analysis of Eakins' reputation in the 1870s as a watercolorist, see Foster, forthcoming.

59 Eakins' friend, the revolutionary photographer Eadweard Muybridge, would later include two plates

of a rower on a rowing machine in his famous *Animal Locomotion* publication.

60 Thomas Eakins to Earl Shinn, March 26, 1875, FHL, quoted in Goodrich 1982, I, p. 121.

61 The identification of the painting as *The Schreiber Brothers* was made by Eakins' widow, Susan Macdowell Eakins. In addition to the photograph of Max Schmitt (fig. 13), photos of Eakins' father, Benjamin, and his sister Caroline inscribed or stamped "Schreiber and Sons" are in the Archives of the Pennsylvania Academy of the Fine Arts; inscribed Schreiber photos of dogs and horses are in the Charles Bregler Collection at the Pennsylvania Academy. In a letter to Kathrin Crowell, August 19, 1874, PAFA, Eakins mentions going to Gloucester with Hans Schreiber; see also Foster and Leibold 1989, no. 20, p. 273, for a letter of November 22, 1929 from Susan Eakins, in which she mentions photos of animals by Henry Schreiber.

62 See note 60 above.

63 Foster, forthcoming.

64 For Eakins' preparation of the canvas, see Christina Currie's essay, pp. 92–93.

65 See note 60 above.

66 Thomas Eakins to Earl Shinn, undated letter, FHL, quoted in Goodrich 1982, I, pp. 121–22.

67 The crew first competed in the Annual Regatta on June 18, 1874. Although they won the first trial heat on June 5 "to the intense delight of all Philadelphia," they lost the final trial to the Argonauta Rowing Association. They had been in training for two months or so, and the regatta was their first attempt in a four-oared shell race. Their race against the Quaker City Rowing Club was their first win. See *The Aquatic Monthly and Nautical Review* 4 (July 1874), pp. 11–13, and *Turf, Field and Farm*, October 2, 1874, p. 252. The painting hung in the sun porch of the Pennsylvania Barge Club until 1929, probably a gift from the artist.

68 Hendricks 1974, p. 75, was the first to identify the rower as Schmitt and to suggest a date of 1874 for the painting.

69 Foster, forthcoming.

70 Whitman to the journalist Horace L. Traubel, quoted in F.O. Matthiessen, *American Renaissance* (London: Oxford University Press, 1941; reprint 1974), p. 604.

Werbel (pp. 79–89)

1 Theodor Siegl has made these analyses for *Perspective Drawing for The Pair-Oared Shell* (fig. 20); see *Philadelphia: Three Centuries of American Art*, exh. cat. (Philadelphia: Philadelphia Museum of Art,

1976), pp. 391–93. For an extended discussion of Eakins' perspectival and mechanical drawings, see Foster, forthcoming.

2 "[Thirty-Ninth through Forty-Third] Annual Reports of the Controllers of the Public Schools of the First District of Pennsylvania," Philadelphia, 1858–61.

3 The substance of Central's curriculum in linear perspective is unclear. We do know, however, that Eakins scored well on a difficult examination in perspective shortly after graduation from Central, indicating that he had achieved a high level of competence in this discipline. For an excellent discussion of this examination, see Elizabeth Johns, "Drawing Instruction at Central High School and Its Impact on Thomas Eakins," *Winterthur Portfolio* 15 (Summer 1980), pp. 139–49.

4 Cornu was a French civil engineer whose textbook was translated by Central High School's first principal, Alexander Dallas Bache; see A. Cornu, *Course of Linear Drawing Applied to the Drawing of Machinery* (Philadelphia: J. Dobson, 1842).

5 Thomas Eakins, "Linear Perspective," unpublished lecture, p. 34, based on Eakins' perspective lectures at the Pennsylvania Academy of the Fine Arts in the early 1880s, PMA (which also has a typed transcript). Darrel Sewell, curator of American art at the Philadelphia Museum of Art, kindly allowed me to study the manuscript over a period of several weeks.

6 Martin Kemp, *The Science of Art: Optical Themes in Western Art from Brunelleschi to Seurat* (New Haven: Yale University Press, 1990), p. 224.

7 Marianne Marcussen, "L'évolution de la perspective linéaire au XIXe siècle en France," *Hafnia: Copenhagen Papers in the History of Art* 7 (1980), pp. 51–73.

8 Perspective played a limited formal role in the curriculum of the École des Beaux-Arts in the 1860s, largely because it was considered a prerequisite for study. Students wishing to fully matriculate were required to pass a four-hour examination in perspective. Although admitted to the École, Eakins never formally matriculated, and there is no evidence that he took this examination. If he attended the optional weekly lectures on perspective, he never mentioned it. For examinations at the École, see H. Barbara Weinberg, *The Lure of Paris* (New York: Abbeville Press, 1991), p. 16.

9 Kathleen A. Foster, in Wilmerding 1993, p. 69, writes that Gérôme "probably would have hired a draughtsman to prepare his perspective schemes."

10 For an excellent recent discussion of this series, see Foster, in Wilmerding 1993, pp. 68–70.

11 I wish to extend sincere thanks to Kathleen Foster for clarifying this point in editorial comments.

12 As, for example, in *Baby at Play* (National Gallery of Art, Washington, D.C.); see Jules David Prown, "Thomas Eakins' *Baby at Play*," *Studies in the History of Art* 18 (1984), pp. 121–27.

13 Siegl, *Philadelphia: Three Centuries*, pp. 391–93.

14 "Boundaries of the reflections in the waves

height of the shirt	24 . . .	
. . . head	22 ~	
knee	28 ~	17
fulcrum of the oar	29	18
height of the tip of the shell	32 ½	21"

15 Eakins, "Linear Perspective," p. 11.

16 Ibid., pp. 19–20.

17 Ibid., p. 17.

18 Ibid., p. 13.

19 Although Eakins never attempted the complex combination of oblique, tilted, and curving forms in *Hail Caesar!*, he by no means chose an easy route in his own work. As Kathleen Foster writes (in Wilmerding 1993, p. 70): "No two paintings in the series (aside from watercolor replicas) had the same eye level, or the same figure scale, the same angle of recession for the shell, or the same ratio of viewing distance (from the spectator to the painting) to object distance (from the spectator to the figures)."

20 Eakins, "Linear Perspective," p. 7.

21 Ibid., p. 32. This method appears in Peale's *Graphics*, as well as in numerous other nineteenth-century drawing manuals.

22 Johns 1983, p. 20, notes that in *The Champion Single Sculls*, Eakins "pulled the bridges considerably closer to the viewer than they appear in actuality."

23 Eakins, "Linear Perspective," p. 5.

24 I avoid judging Eakins' system as "correct" or "incorrect" because such judgment assumes that there is only one correct linear perspective system. Nothing could be further from the truth. From the time of Alberti, artists have relied far more on idiosyncratic methods such as Eakins' than on theoretical treatises (many of which disagree in any event). The sciences of perceptual psychology and optics further demonstrate the inability of linear perspective to ever "correctly" describe vision. Eakins' drawings and paintings are better evaluated against the laws of perspective he recounts in his own text.

25 Siegl, *Philadelphia: Three Centuries*, pp. 392–93.

26 In a letter of 1875, Eakins noted that he preferred his painting of *The Schreiber Brothers* (fig. 35) to the Biglin pictures, which he found "wanting in distance & some other qualities." He might have been referring here to compositional changes made after the perspective drawings were completed. Thomas Eakins to Earl Shinn, March 26, 1875, FHL; quoted in Goodrich 1982, I, p. 121.

27 H. Barbara Weinberg, Michael Fried, and Kathleen Foster have all put forth powerful models for explaining these tensions.

Currie (pp. 90–101)

I am grateful to the National Endowment for the Arts and the Andrew L. Mellon Foundation for financial support during these studies. I also thank the NASA Lewis Research Center in Cleveland for its collaboration, in particular James Smith, senior research scientist at the Analytical Science Branch of the Materials and Structures Division and William Waters. My thanks to Bruce Robertson, professor of art history at the University of California, Santa Barbara, formerly curator of American painting at The Cleveland Museum of Art, and my colleagues there for support and advice: Marcia Steele, Kenneth Bé, Bruce Christman, Rainer Richter, Virginia Krumholtz, Judith de Vere, Evan Turner, and the photographic department. I also thank Stanton Thomas for help with editing. Many colleagues in other museums made paintings available for examination and/or spent time discussing observations: in particular, Mark Bockrath, head painting conservator, Pennsylvania Academy of the Fine Arts; Kevin Avery, curator of American paintings, and Dorothy Mahon, conservator of paintings, The Metropolitan Museum of Art; Anne Hoenigswald, conservator of paintings, National Gallery of Art; Mark Tucker, head painting conservator, Philadelphia Museum of Art; Mark Aronson, chief paintings conservator, Yale University Art Gallery; Frank Gettens, curator, Hirshhorn Museum and Sculpture Garden; Rita Albertson, painting conservator, Museum of Fine Arts, Boston. I owe special thanks to Robin Jaffee Frank, assistant curator of American paintings and sculpture at the Yale University Art Gallery, for her editorial suggestions. Finally, I would like to thank Helen Cooper, The Holcombe T. Green Curator of American Paintings and Sculpture at Yale, for her advice and encouragement with this essay.

1 Perspective lines and detailed underdrawing for forms have been detected in Gérôme's work: an underdrawn perspective framework visible with the naked eye in *The Tulip Watch*, 1882 (Walters Art Gallery, Baltimore); infrared reflectography revealed detailed underdrawing in *Lion on the Watch*, c. 1885 (The Cleveland Museum of Art).

2 Bregler, March 1931, p. 384.

3 A surviving box of drafting tools originally belonging to Eakins and probably dating back to his school days contains instruments necessary for these types of drawings: dividers, compasses, ruling pens, and a lettering pen; see Rosenzweig 1977, p. 223.

4 For a full discussion of the perspective drawings, see Amy Werbel's essay (pp. 79–89).

The only two extant drawings for *The Biglin Brothers Turning the Stake* were formerly owned by Charles Bregler (figs. 29, 30). His correspondence with Henry Sayles Francis, formerly curator of paintings at The Cleveland Museum of Art, offers tantalizing clues regarding other drawings, now lost, for the painting. In a letter dated March 22, 1942, Bregler wrote: "Eakins made accurate drawings of the ground plan of the boat, etc. But it was impossible to save them, the paper being in a state of decay. These are the only two drawings that remain that he made for this painting." In a letter to Francis dated March 30, 1943, Bregler described the boat drawings on drafting paper he had discovered twenty-five years earlier, including the large perspective drawing for this painting: "They were rolled up and were in an old trunk. When I tried to unroll them, they crumbled to pieces—and was only successful in saving a few. To me they are rare documents as they so fully give a very graphic picture of Eakins' methods, and the minute study of every detail—made from measurements of the boat." Both letters are in The Cleveland Museum of Art, Registrar files.

5 "[T]o avoid complications, it is as well in all extended drawings to use three different inks, a blue ink for instance for the square feet marks in the ground plan and from the picture of these square feet in the perspective plan, for the horizon, and middle one; in short for all the purely perspective scale parts; secondly a red ink for axes of construction, or simpler figures enclosing the complex ones not sought directly: and finally black ink for the finished outlines"; Thomas Eakins, "Vanishing Points," unpublished lecture, c. 1884, PMA.

6 Many of his canvases came from Janetzky and Company, one of the best art materials suppliers in Philadelphia. The company's label appears on the backs of *Oarsmen on the Schuylkill*, *The Biglin Brothers Turning the Stake*, and *The Champion Single Sculls*.

7 Goodrich 1933, p. 42, relates that a detailed perspective drawing would be drawn to the same scale as the canvas and transferred to canvas with transfer paper. Incised markings can also be seen in *Sailboats Racing*, 1874 (Philadelphia Museum of Art) and *Starting Out After Rail*, 1874 (Museum of Fine Arts, Boston).

8 The dark brown "toning" layer and accumulated layers of dirt and varnish probably account for the dark appearance of the prick marks through the microscope.

9 The tiny dots around the bridges appeared black when observed under the microscope. It is assumed that they are prick marks, as in *The Biglin Brothers Turning the Stake*, but no complete x-radiograph exists for verification.

10 Alternatively, this line of prick marks may indicate an error made during Eakins' transfer process.

11 A vertical center line is frequently observed in Eakins' work, not only in oil paintings, but also in drawings and watercolors. It can be seen with the naked eye in *The Meadows, Gloucester*, c. 1882 (Philadelphia Museum of Art) in the green area of the foreground, and in *Sailing*, c. 1875 (Philadelphia Museum of Art) in the foreground, middle ground, and just above the horizon for approximately 1 inch.

12 It was not determined if Eakins used a toning layer on the grounds of the other rowing paintings; however, colored toning layers are common in his work. They have been detected on many of his paintings at the Philadelphia Museum of Art; Theodor Siegl, various drafts of his 1978 catalogue, kindly lent by Evan Turner, former director, The Cleveland Museum of Art. Many oil sketches on canvas and primed paper from the Bregler Collection at the Pennsylvania Academy of the Fine Arts also have brown toning layers; see Mark F. Bockrath, Virginia N. Naude, and Debbie Hess Norris, "Thomas Eakins, Painter, Sculptor, Photographer," *Journal of the American Institute for Conservation* 31 (1992), pp. 51–64.

13 This "tooth" was not visible on Eakins' other sculling canvases or on other paintings from the early 1870s examined with the microscope: *The Pair-Oared Shell*, *The Biglin Brothers Racing*, *The Schreiber Brothers*, *Starting Out After Rail*, and *Sailboats Racing*. *Oarsmen on the Schuylkill* was not examined by the author.

14 I am grateful to Bruce Robertson for suggesting this possibility.

15 I noted Eakins' technique of reserving prearranged spaces for separate parts of the design when examining his watercolor *John Biglin in a Single Scull* (fig. 33).

16 Foster and Leibold 1989, p. 62.

17 Homer 1992, pp. 48–49.

18 For other examples in Eakins' painting of reworking a blue sky with a palette knife to tone it down, see Siegl 1978, pp. 89–90, 93.

19 Whether this represents Eakins' uppermost layer or the remains of early restoration remains an unresolved question.

20 Sky cross-section analyzed by x-ray dot mapping and EDX analysis. Analysis carried out by James Smith at NASA Lewis Research Center. Analysis performed on a JEOL 840-A electron microscope. The experimental conditions were presented in a paper by Christina Currie and James Smith, "*The Biglin Brothers Turning the Stake-Boat* by Thomas Eakins: A Technical Study Reveals Surprising Techniques," at the 1994 meeting of the American Institute for Conservation of Historic and Artistic Works, Nashville.

21 Calcium, phosphorus, and oxygen found by x-ray dot mapping and EDX analysis suggest the presence of bone black.

22 Cobalt detected by x-ray fluorescence spectroscopy conducted by Bruce Christman, head of conservation at The Cleveland Museum of Art. A Kevex 0975 A Energy Dispersive X-Ray Fluorescence Spectrometer was used. Most analyses were conducted using 50KV, 3.3 Ma excitation conditions with a mixed barium carbonate and strontium carbonate secondary target. Occasionally a single target of either barium or strontium carbonate was used. In most cases an approximately 4 mm area of the painting was examined using a 6 mm collimator on the x-ray tube and a 2 mm collimator on the detector.

23 Mercury, characteristic of vermilion, was detected by x-ray fluorescence spectroscopy.

24 Chromium detected by x-ray fluorescence spectroscopy, presence of viridian confirmed by polarizing microscopy. Cadmium detected by x-ray fluorescence spectroscopy.

25 X-ray dot mapping and EDX analysis were used.

26 For example, Windsor and Newton's "New White," which was listed in the company's catalogue for 1849. I am grateful to Leslie Carlyle for sending me this information from her unpublished Ph.D. dissertation, "A Critical Analysis of Artists' Handbooks, Manuals and Treatises on Oil Painting Published in Britain Between 1800–1900: With Reference to Selected Eighteenth Century Sources" (London: Courtauld Institute of Art, University of London, 1991).

27 Ibid.

28 The presence of a natural resin is further suggested by examination of the sky cross-section under ultraviolet excitation: transparent areas of medium within the light blue layer fluoresce white, a known characteristic of natural resins. This discovery confirms the experience of conservators cleaning Eakins' work, who have observed that his paint can be highly sensitive to their usual solvents for removing discolored varnish and have blamed the problem on his "resinous" paint mixtures. Hilaire Hiler, *Notes on the Technique of Painting* (New York: Oxford University Press, 1934), p. 166, notes, "Girardot said that this medium gave paintings 'the solidity of flint.' The Duroziez oil is prepared by the firm of Duroziez of Paris, and is now known by the trade name of Oliesse." It is possible that Eakins was attempting to reconstitute an oil resin similar to that used by Gérôme, whose painting medium is said to have been composed of four parts oil copal varnish mixed with Duroziez oil and three parts rectified oil of spike or turpentine.

Berger (pp. 102–23)

This essay develops ideas first discussed in a chapter of my dissertation, "Determining Manhood: Constructions of Sexuality in the Art of Thomas Eakins," Ph.D. diss. (New Haven: Yale University, 1995). An earlier version appears in Berger 1994.

1 "The Society of American Artists Second Annual Exhibition," *New York Daily Tribune*, March 22, 1879.

2 Sadakichi Hartmann, *A History of American Art* (Boston: L.C. Page & Company, 1901), I, pp. 192, 200–03.

3 Carroll Smith-Rosenberg, *Disorderly Conduct: Visions of Gender in Victorian America* (New York: Alfred A. Knopf, 1985), p. 90.

4 Joseph F. Kett, *Rites of Passage: Adolescence in America, 1790 to the Present* (New York: Basic Books, 1977), pp. 31, 144, lists some of the cultural markers indicating the attainment of manhood: marriage, leaving home for good, joining a church, or entering a profession. For views of veterans as masculine, see E. Anthony Rotundo, "Body and Soul: Changing Ideals of American Middle-Class Manhood, 1770–1920," *Journal of Social History* 16 (Summer 1983), p. 28; George M. Fredrickson, *The Inner Civil War: Northern Intellectuals and the Crisis of the Union* (New York: Harper & Row, 1968), pp. 175–76. For the Civil War service of Eakins' high school classmates, see Frank H. Taylor, *Philadelphia in the Civil War, 1861–1865* (Philadelphia: The City of Philadelphia, 1913), p. 300; Nicholas H. Maguire, "Contribution of the Central High School of Philadelphia to the War," pamphlet, 1864. For the importance of work, see E. Anthony Rotundo, *American Manhood: Transformations in Masculinity from the Revolution to the Modern Era* (New York: Basic Books, 1993), pp. 167–69, 178–93; Robert L. Griswold, *Fatherhood in America: A History* (New York: Basic Books, 1993), pp. 13–14.

5 Rotundo, *American Manhood*, pp. 191, 178.

6 Foster and Leibold 1989, pp. 45, 128; Goodrich 1982, I, p. 36, Thomas Eakins to Benjamin Eakins, September 20, 1867, PAFA.

7 Thomas Eakins to Benjamin Eakins, March 17, 1868, PAFA.

8 Thomas Eakins to Benjamin Eakins, June 24, 1869, PAFA. For other evidence of Eakins' unease in accepting his parents' support, see his letters addressed to his father, November [1867], his mother and aunt Eliza, November 1867, PAFA.

9 For other discussions of the rowing paintings in the context of masculinity, see Berger 1994, pp. 1–17; Bryan Jay Wolf, *The Invention of Seeing* (New Haven: Yale University Press), forthcoming.

10 As early as 1862, the English visitor Anthony Trollope noted that traditionally attired Quakers were becoming a rarity in Philadelphia; see Anthony Trollope, *North America* (1862), Robert Mason, ed. (Aylesbury, England: Penguin Books, 1968), p. 151.

11 Johns 1983, pp. 20, 39. Johns was the first art historian to identify the rowers' dress.

12 *The Aquatic Monthly and Nautical Review* 1 (June 1872), p. 57.

13 Both Elizabeth Johns and Michael Fried have discussed Eakins' complicated relation to craft traditions; see Johns 1983, pp. 83–91, 95–102, 104-14, and Fried 1987, pp. 19–20. Perhaps not coincidentally, Eakins traded one of his early boating scenes, *Starting Out After Rail* (1874) to James C. Wignall, a Philadelphia shipbuilder, for a boat; see Hendricks 1974, p. 327.

14 Robert B. Johnson, *A History of Rowing in America* (Milwaukee: Corbitt & Johnson, 1871), p. 250.

15 *National Police Gazette*, April 6, 1867, p. 3.

16 *The Aquatic Monthly and Nautical Review* 1 (April 1873), pp. 830–33, offered a long article on the most prominent American boatbuilders, which included a list of every boat the builders had produced during the preceding year along with their buyers' names. Some regattas even embroidered the winning scull's name onto the trophy flags, instead of recording the name of the winner. *The Baltimore American*, October 22, 1872, stated that "The New York Rowing Club was awarded the silk flag with the Maryland coat of arms, and the blue pennant, on which is to be emblazoned the name of the winning boat and the date of the race, which were the prizes for the victors in the first race"; quoted in *The Aquatic Monthly and Nautical Review* 1 (November 1872), p. 486.

17 Johns 1983, pp. 100–01. Fried 1987, pp. 19–20, does not believe that Eakins held Johns' distinctions between "high" and "low" art. He argues that *William Rush* illustrates the artist's desire to show the continuity between artisanship and high art.

Claiming that the designs and carvings for ship ornamentation, evident in Rush's studio, must be read contiguously with the artist's allegorical sculpture, Fried posits that modern-day scholars' divisions between "craft" and "artistic" traditions were not as rigidly held by Eakins. Whether one accepts Johns' hierarchical interpretation of the work or Fried's progression theory, both explications support the suggestion of a link between the artist/craftsman boatbuilders and Eakins the painter.

18 Goodrich 1982, I, pp. xiii, 98; Lifton 1987, pp. 247–74, especially 247; Johns 1983, pp. 53–55.

19 *The New York Times*, May 21, 1872, p. 1; *The Spirit of the Times: A Chronicle of the Turf, Field, Sports and the Stage*, May 25, 1872, p. 228; *Turf, Field and Farm*, May 24, 1872, p. 335; *The New York Clipper*, June 1, 1872, p. 68; *The Aquatic Monthly and Nautical Review* 1 (June 1872), pp. 56–58.

20 M.G. van Rensselaer, "The Philadelphia Exhibition—II," *The American Architect and Building News* 8 (December 25, 1880), p. 303.

21 Reverend J.G. Wood, *Athletic Sports and Recreations for Boys* (London and New York: George Routledge and Sons, 1871), p. 238.

22 Kathleen A. Foster, Indiana University Art Museum, Bloomington, in a paper delivered at Yale University in October 1995, identifed the African-American poleman as David Wright. Lloyd Goodrich (1933, p. 169, no. 104) titled the painting *Will Schuster and Blackman Going Shooting*—a title unknown in Eakins' lifetime.

23 Interestingly enough, in Eakins' c. 1874 painting of *The Artist and His Father Hunting Reed Birds* (Virginia Museum of Fine Arts, Richmond), Eakins himself assumes the poleman's marginalized position. Eakins rotated the stern of the skiff away from the picture plane, placing his image behind that of the main protagonist.

24 *Goulding's New York City Directory for 1875–1876* (New York: Lawrence G. Goulding, 1875), p. 97; *Turf, Field and Farm*, November 15, 1872, p. 314; *The New York Times*, May 12, 1924, p. 17; *The New York Herald Tribune*, May 12, 1924, p. 11. We know that Eakins perceived mechanics and boatmen to be of a distinct social class, for in a letter to his mother (October 8, 1866, PAFA) he wrote that "the quays of the Seine are always full of people weekdays as well as Sundays fishing. Some seem to be poor people, mechanics or boatmen. Many however are well dressed people some with sporting costume."

25 Philip Gilbert Hamerton, *The Intellectual Life* (Boston: Roberts Brothers, 1873), p. 5. Hamerton's book went through numerous editions into the early decades of the twentieth century. The second quota-

tion is from John Stuart Blackie, *On Self-Culture: Intellectual, Physical, and Moral* (New York: Scribner, Armstrong, and Company, 1874), p. 58. While some Americans had argued much earlier in the century that spiritual and physical health were intertwined, the concept became widely embraced only in the 1870s and 1880s. For examples of early advocates, see Harvey Green's introduction to Kathryn Grover, ed. *Fitness in American Culture: Images of Health, Sport, and the Body, 1830–1940* (Amherst: The University of Massachusetts Press, 1989), pp. 7–8; for other nineteenth-century discussions on the value of balancing the physical and mental, see Johnson, *A History of Rowing in America*, pp. 11–23, and Blackie, *On Self-Culture*, p. 58. For a twentieth-century explication of this phenomenon, see Burton J. Bledstein, *The Culture of Professionalism: The Middle Class and the Development of Higher Education in America* (New York: W.W. Norton & Company, 1978), pp. 254–58.

26 Harry Brod, "Themes and Theses of Men's Studies," in Harry Brod, ed., *The Making of Masculinities: The New Men's Studies* (Boston: Allen and Unwin, 1987), p. 14.

27 The different class standing of the brothers is also a sign of the broad appeal which the sport held for both middle- and working-class Americans. For a discussion of nineteenth-century American rowing as an activity transcending class divisions, see Thomas C. Mendenhall, *A Short History of American Rowing* (Boston: Charles River Books, 1980), p. 23.

28 Despite my claims for sport's ability to offer metaphoric balance to men's lives, I remain aware of the scathing critiques many observers have leveled against sports. For example, the Frankfurt School theorist Theodor Adorno, *Prisms*, Samuel and Shierry Weber, trans. (Letchworth, England: Garden City Press, 1967), p. 81, contended that "modern sports . . . seek to restore to the body some of the functions of which the machine has deprived it. But they do so only in order to train men all the more inexorably to serve the machine." In language almost as dark, historian Donald Mrozek, *Sport and American Mentality* (Knoxville: University of Tennessee Press, 1983), p. 11, calls sports "the religious ritual of the machine age—sacrifice without purpose, performance without magic, obsolescence without compensation, and value without meaning." For a nineteenth-century critique of sports, see Thorstein Veblen, *The Theory of the Leisure Class* (1899; New York: Penguin Books, 1979), pp. 254–59.

29 For period criticism of Eakins' exacting realism, see William C. Brownell, "The Younger Painters of America: First Paper," *Scribner's Monthly Illustrated Magazine* 20 (May 1880), p. 13; S.R. Koehler, "Second Annual Exhibition of the Philadelphia Society of Artists," *The American Art Review* 2, part 1 (1881), p. 110; [Earl Shinn], "The Pennsylvania Academy Exhibition," *The Art Amateur* 4 (May 1881), p. 115; "The American Artists Supplementary Exhibition," *The Art Amateur* 7 (June 1882), p. 2.

30 Goodrich 1933, p. 154.

31 Hartmann, *A History of American Art*, II, p. 242. Robert W. Vonnoh was a Hartford-born painter who taught at the Pennsylvania Academy of the Fine Arts from 1891 to 1896.

32 See, for example, Wayne Craven, *American Art: History and Culture* (Madison, Wisconsin: Brown & Benchmark Publishers, 1994); Jules David Prown, *American Art from Its Beginnings to the Armory Show* (New York: Rizzoli International Publications, 1980); John Wilmerding, *American Art* (New York: Penguin Books, 1976).

33 For discussions of the shifting masculine paradigm in late nineteenth- and early twentieth-century American art, see Marianne Doezema, *George Bellows and Urban America* (New Haven: Yale University Press, 1992), pp. 58, 68–71, 94, and Rebecca Zurier, "Real Life, Real Art, Real Men: Gendering Realism at the Turn of the Century," paper delivered at the College Art Association Conference, Baltimore, 1991.

34 Thomas Eakins to Benjamin Eakins, October 29, 1868, PAFA: "Gérôme tells us every day that finish is nothing that head work is all & that if we stopped to finish our studies we could not learn to be painters in a hundred life times & he calls finish needle work & embroidery & ladies' work to deride us"; Foster and Leibold 1989, pp. 208–09. After visiting Eakins' studio in Paris during the summer of 1868 with their father, Fanny Eakins wrote that her brother "had not yet finished any of his paintings (that is lady's work, he says) and of course they are rough looking, but they are very strong and all the positions are fine and the drawing good"; quoted in Goodrich 1933, p. 24. For an explication of Western painting that sees detail (and nineteenth-century realism) as gendered female, see Naomi Schor, *Reading in Detail: Aesthetics and the Feminine* (New York: Methuen, 1987), especially pp. 4, 42–47. For a discussion of the masculine (and feminine) resonances of nineteenth-century realism, see David E. Shi, *Facing Facts: Realism in American Thought and Culture, 1850–1920* (New York: Oxford University Press, 1995), pp. 7–9, 34–36.

35 The dominant assumption in Eakins scholarship is that the artist traps a "real" moment in paint. See, for example, Donelson F. Hoopes, *Eakins' Watercolors* (New York: Watson-Guptill Publications, 1971), p. 12, who asserts that Eakins' paintings capture the "truth"; Siegl 1978, pp. 54–56, who establishes the exact time of day portrayed in *The Pair-Oared Shell;*

Gordon Hendricks, *Thomas Eakins: His Photographic Works* (Philadelphia: Pennsylvania Academy of the Fine Arts, 1969), p. 13, who comments that Eakins created many of his canvases by copying "brush stroke by brush stroke, from a photograph."

36 *The New York Clipper*, for example, is filled with references to large crowds of women who attended sculling matches. See the "Aquatics" column in the following issues: April 30, 1859, p. 15; July 21, 1866, p. 114; July 13, 1867, p. 106; July 15, 1871, p. 117. For articles insisting on the importance of women attending and appreciating rowing races and other sporting events, see *The New York Clipper*, May 14, 1859, p. 28; *Turf, Field and Farm*, April 11, 1873, p. 236. For a reference to rowing as an appropriate sport for women to participate in, see Johnson, *A History of Rowing in America*, p. 23. Judging from the many red parasols and dresses of the figures on the riverbanks in Eakins' *The Biglin Brothers Turning the Stake* and *The Biglin Brothers Racing*, the painter clearly recognized the sport's appeal to women.

37 *National Police Gazette*, June 15, 1867, p. 3. See also John William Carleton, *Walker's Manly Exercises* (Philadelphia: John W. Moore, 1856), p. 18.

38 Jules D. Prown, Paul Mellon Professor of American and British Art, Yale University, has long lectured on the mechanical "springlike" qualities of *John Biglin in a Single Scull*.

39 *The New York Clipper*, September 7, 1872, p. 178.

40 *The Spirit of the Times: A Chronicle of the Turf, Field, Sports and the Stage*, May 25, 1872, p. 225; and November 30, 1872, pp. 247, 251.

41 William Wood, *Manual of Physical Exercises* (New York: Harper & Brothers, 1870), p. 105; see also p. 104. For other examples of rowers likened to machines, see Walter Bradford Woodgate, *Oars and Sculls, and How to Use Them* (London: George Bell & Sons, 1875), pp. 2, 135; Blackie, *On Self-Culture*, p. 75; *The Spirit of the Times*, November 30, 1872, p. 247.

42 Anson Rabinbach, *The Human Motor: Energy, Fatigue, and the Origins of Modernity* (Berkeley: University of California Press, 1992), p. 3.

43 Mark Seltzer, *Bodies and Machines* (New York and London: Routledge, 1992), pp. 27, 28. For a historical examination of machine culture and productivism, see Rabinbach, *The Human Motor*. For the aesthetics of machinery, see John F. Kasson, *Civilizing the Machine: Technology and Republican Values in America, 1776–1900* (New York: Grossman Publishers, 1976), pp. 139–80.

44 Mary P. Ryan, *Womanhood in America: From Colonial Times to the Present* (New York: New Viewpoints, 1975), pp. 139, 144; Griswold, *Fatherhood in America*, pp. 13–14; Nancy Chodorow, *The Reproduction of Mothering: Psychoanalysis and the Sociology of Gender* (Berkeley: University of California Press, 1978), pp. 4–6, 10, 178–80; Rotundo, "Body and Soul," p. 30; Michael S. Kimmel, "The Contemporary 'Crisis' of Masculinity in Historical Perspective," in Brod, *The Making of Masculinities*, pp. 137–53, especially 141–43.

45 An exhibition record of the rowing works in Eakins' lifetime is given on pp. 136–39.

46 Daniel T. Rogers, *The Work Ethic in Industrial America, 1850–1920* (Chicago: University of Chicago Press, 1979), p. 102, pp. 94–124, especially 103–08.

47 S. Weir Mitchell, *Wear and Tear, or Hints for the Overworked* (Philadelphia: J.B. Lippincott & Co., 1871), p. 19. For additional information on Mitchell as well as an interesting account of the affinities between Mitchell and Eakins, see Lifton 1987, pp. 247–74.

Selected Bibliography

Berger 1994
Berger, Martin A. "Negotiating Victorian Manhood: Thomas Eakins and the Rowing Works." *Masculinities* 2 (Fall 1994), pp. 1–17.

Bregler, March 1931
Bregler, Charles. "Thomas Eakins as a Teacher." *Arts* 17 (March 1931), pp. 376–86.

Bregler, October 1931
Bregler, Charles. "Thomas Eakins as a Teacher." *Arts* 18 (October 1931), pp. 27–42.

Foster, forthcoming
Foster, Kathleen A. *Thomas Eakins Rediscovered.* New Haven: Yale University Press, forthcoming.

Foster and Leibold 1989
Foster, Kathleen A., and Cheryl Leibold. *Writing About Eakins: The Manuscripts in Charles Bregler's Thomas Eakins Collection.* Philadelphia: University of Pennsylvania Press for the Pennsylvania Academy of the Fine Arts, 1989. Includes an inventory of Eakins' letters at PAFA; a number are reproduced in full.

Fried 1987
Fried, Michael. *Realism, Writing, Disfiguration: Thomas Eakins and Stephen Crane.* Chicago and London: University of Chicago Press, 1987.

Goodrich 1933
Goodrich, Lloyd. *Thomas Eakins: His Life and Work.* New York: Whitney Museum of American Art, 1933.

Goodrich 1982
Goodrich, Lloyd. *Thomas Eakins.* 2 vols. Cambridge, Massachusetts, and London: Harvard University Press for the National Gallery of Art, 1982.

Hendricks 1974
Hendricks, Gordon. *The Life and Work of Thomas Eakins.* New York: Grossman Publishers, 1974.

Homer 1992
Homer, William Innes. *Thomas Eakins: His Life and Art.* New York: Abbeville Press, 1992.

Johns 1983
Johns, Elizabeth. *Thomas Eakins: The Heroism of Modern Life.* Princeton: Princeton University Press, 1983.

Lifton 1987
Lifton, Norma. "Thomas Eakins and S. Weir Mitchell: Images and Cures in the Late Nineteenth Century." In Mary Mathews Gedo, ed. *Psychoanalytic Perspectives on Art.* Hillsdale, New Jersey, and London: The Analytic Press, 1987.

Milroy 1986
Milroy, Elizabeth C. "Thomas Eakins' Artistic Training, 1860–1870." Ph.D. diss. Philadelphia: University of Pennsylvania, 1986.

Rosenzweig 1977
Rosenzweig, Phyllis D. *The Thomas Eakins Collection of the Hirshhorn Museum and Sculpture Garden.* Washington, D.C.: Smithsonian Institution Press, 1977.

Sewell 1982
Sewell, Darrel. *Thomas Eakins: Artist of Philadelphia.* Exhibition catalogue. Philadelphia: Philadelphia Museum of Art, 1982.

Siegl 1978
Siegl, Theodor. *The Thomas Eakins Collection.* Philadelphia: Philadelphia Museum of Art, 1978.

Weinberg 1984
Weinberg, H. Barbara. *The American Pupils of Jean-Léon Gérôme,* Fort Worth: Amon Carter Museum, 1984.

Wilmerding 1993
Wilmerding, John, ed. *Thomas Eakins and the Heart of American Life.* Exhibition catalogue. London: National Portrait Gallery, 1993.

Wilson 1987
Wilson, Rob. "Sculling to the Over-Soul: Louis Simpson, American Transcendentalism, and Thomas Eakins's *Max Schmitt in a Single Scull,*" *American Quarterly* 39 (Fall 1987), pp. 410–30.

Manuscript Collections

AAA
Archives of American Art, Smithsonian Institution, Washington, D.C.

FHL
Friends Historical Library of Swarthmore College; Richard Tapper Cadbury Collection

PAFA
Pennsylvania Academy of the Fine Arts, Philadelphia; Charles Bregler's Thomas Eakins Collection

PMA
Philadelphia Museum of Art; Thomas Eakins Archives, Department of American Art

Works in the Exhibition

Dimensions are given in inches followed by centimeters; height precedes width.

Each entry includes a record of the exhibitions of the work within Eakins' lifetime, as well as in the memorial exhibitions organized after his death in 1916. The titles assigned by Eakins or by others to his works have varied considerably, even during the artist's life. Thus, it is sometimes difficult to establish exactly which works were included in a specific exhibition. The titles given in the exhibition record retain the peculiarities of spelling and capitalization found in Eakins' notebooks, exhibition catalogues, contemporary reviews, and Lloyd Goodrich's papers (PMA).

The Champion Single Sculls, 1871 (fig. 4)
Oil on canvas
32 ¼ x 46 ¼ (81.9 x 117.5)
The Metropolitan Museum of Art, New York;
 Purchase, The Alfred N. Punnett Endowment Fund
 and George D. Pratt Gift, 1934
PROVENANCE: Max Schmitt (sitter), Philadelphia;
 Mrs. Louise S.M. Nache (sitter's widow), until 1930;
 Mrs. Thomas Eakins, Philadelphia, 1930–33;
 (Babcock Galleries, New York, 1930–31); (Milch
 Galleries, New York, 1934)
EXHIBITIONS: Philadelphia, Union League of
 Philadelphia, 1871, as *The Champion Single Sculls*

Sketch of Girard Avenue Bridge, c. 1871 (fig. 14)
Verso: *Sketch of an oar* (fig. 15)
Pencil on paper
4 ⅛ x 6 ⅞ (10.5 x 17.5)
Hirshhorn Museum and Sculpture Garden,
 Smithsonian Institution, Washington, D.C.; Gift of
 Joseph H. Hirshhorn, 1966
INSCRIPTIONS (verso): *left oar looking out to the
 blade;* letters S and P at l.l., erased
PROVENANCE: Charles Bregler, Philadelphia; Joseph
 Katz, Baltimore; (M. Knoedler & Co., New York, 1961);
 Joseph H. Hirshhorn, New York, 1966

The Pair-Oared Shell, 1872 (fig. 19)
Oil on canvas
24 x 36 (61 x 91.4)
Signed and dated on verso, c.r.: *EAKINS/1872*
Philadelphia Museum of Art; Gift of Mrs. Thomas
 Eakins and Miss Mary Adeline Williams
PROVENANCE: Mrs. Thomas Eakins, Philadelphia;
 Charles Bregler, Philadelphia
EXHIBITIONS: New York, Thomas's Saloon at the
 Lotos Club, 1877(?), as *Biglens under the bridge
 (Biglens Practising)*; Long Branch, New Jersey,

unspecified venue, summer 1878, as *Biglens under the
bridge (Biglens Practising)*; New York, National
Academy of Design, "54th Annual Exhibition," April
1–May 31, 1879, as *A Pair-oared Shell*; Chicago, Art
Hall, "Inter-State Industrial Exposition of Chicago,"
September 8–October 23, 1880, as *Biglens Practising*;
Philadelphia, Pennsylvania Academy of the Fine
Arts, "52nd Annual Exhibition," April 4–May 29,
1881, as *Biglen brothers practising*; Denver, National
Mining and Industrial Exposition, "1st Annual
Exhibition," August 1–September 30, 1882, as *Biglens
under the bridge (Biglens Practising)*; Washington,
D.C., United States Capitol, "National Exposition for
the Benefit of the Garfield Monument Fund,"
November 25–December 3, 1882, as *Biglens under the
bridge (Biglens Practising)*; Boston, New England
Manufacturers' and Mechanics' Institute, "New
England Industrial Exhibition," September 5–
November 3, 1883, as *The Biglens Practising*; possibly
included in Philadelphia, Earle's Galleries, one-artist
exhibition, opened May 11, 1896; Philadelphia,
Faculty Club, University of Pennsylvania, opened
February 16, 1901, as *Biglin Brothers, the centennial
oarsmen, rowing under Columbia Bridge*;
Philadelphia, Pennsylvania Academy of the Fine
Arts, "111th Annual Exhibition," February 6–March
26, 1916, perhaps the work exhibited as *Pair-oared
Shell* but cited in Thomas Eakins' notebooks separately from other citations for this painting; St. Louis,
City Art Museum, "11th Annual Exhibition of
Selected Paintings by American Artists," September
3–October 29, 1916, perhaps the work exhibited as
Pair-Oared Shell but cited in Thomas Eakins' notebooks separately from other citations for this painting;
New York, The Metropolitan Museum of Art,
"Loan Exhibition of the Works of Thomas Eakins,"
November 5–December 3, 1917, as *Pair-oared Shell*;
Philadelphia, Pennsylvania Academy of the Fine
Arts, "Memorial Exhibition of the Works of the Late
Thomas Eakins," December 23, 1917–January 13,
1918, as *Pair-Oared Shell*

Perspective Drawing for The Pair-Oared Shell,
c. 1872 (fig. 20)
Pencil, ink, and wash on paper
31 1/16 x 47 ⅛ (78.9 x 119.7)
Philadelphia Museum of Art; Purchased with the
 Thomas Skelton Harrison Fund
INSCRIPTIONS: in pencil, l. and c., numbered grids;
 r., calculations; various dimensions on bridge pier
PROVENANCE: Mrs. Thomas Eakins, Philadelphia,
 until 1930; Charles Bregler, Philadelphia, until 1944

Perspective Drawing for The Pair-Oared Shell,
c. 1872 (fig. 21)
Pencil, ink, and watercolor on paper
31 ¹³/₁₆ x 47 ⁹/₁₆ (80.8 x 120.8)
Philadelphia Museum of Art; Purchased with the
Thomas Skelton Harrison Fund
INSCRIPTIONS: in pencil, l. of c., lines numbered *1–5*;
r. of c., *1–15*; parallel lines numbered *16–64*; in black
ink over pencil, l., *96 340 42/ 340 ft. reflection of trees
on near side of wave/ 200 ft. off side of a man hidden
by wave itself*; in pencil, u.l., upside-down, *top John's
head from 16 ft to 25 ft reflection/ Barney 17 ft to 25 " "/
Side of boat from 28 37 "/ centre oar at outrigger 23
32"/ Top shirt John 19 28/ Top corner oar 25½ 29/
Centre of cloud 36*; in black ink over pencil, l. of c.,
*Port outrigger reflection from 34 to 44/ Starboard "
33 to 40*
PROVENANCE: Mrs. Thomas Eakins, Philadelphia,
until 1930; Charles Bregler, Philadelphia, until 1944

The Biglin Brothers Racing, 1872 (fig. 22)
Oil on canvas
24 ⅛ x 36 ⅛ (61.3 x 91.8)
National Gallery of Art, Washington, D.C.; Gift of Mr.
and Mrs. Cornelius Vanderbilt Whitney, 1953
PROVENANCE: Mrs. Thomas Eakins, Philadelphia,
1916; (E. A. Milch & Co., New York, 1933); Whitney
Museum of American Art, New York, 1933–50; (M.
Knoedler & Co., New York, February 18–April 19,
1950); Mr. and Mrs. Cornelius Vanderbilt Whitney,
1950–53
EXHIBITIONS: Philadelphia, Pennsylvania Academy
of the Fine Arts, "Memorial Exhibition of the
Works of the Late Thomas Eakins," December 23,
1917–January 13, 1918, as *Biglen Brothers Ready to
Start Race*

Bridge Study, c. 1872 (fig. 24)
Pencil on paper
8 ¹/₁₆ x 5 ¹⁵/₁₆ (20.5 x 15.1)
Pennsylvania Academy of the Fine Arts, Philadelphia;
Charles Bregler's Thomas Eakins Collection,
Purchased with the partial support of the Pew
Memorial Trust and the John S. Phillips Fund
INSCRIPTIONS: in pencil, l.l., upside-down, *W.S.W.*;
c., *width straight/ across/ 9 yds*; u.c., *87 2 89 ft/ 29 yds
2 ft*
PROVENANCE: Mrs. Thomas Eakins, Philadelphia,
1917–38; Charles Bregler, Philadelphia, 1939–58;
Mary Bregler, Philadelphia, 1959–85

*Perspective Drawing for The Biglin Brothers
Racing,* 1872 (fig. 25)
Ink, colored ink, pencil, and watercolor wash on paper
31 ⅞ x 47 ⅝ (81 x 121)

Hirshhorn Museum and Sculpture Garden,
Smithsonian Institution, Washington, D.C.; Gift of
Joseph H. Hirshhorn, 1966
PROVENANCE: Charles Bregler, Philadelphia; Joseph
Katz, Baltimore; (M. Knoedler & Co., New York, 1961);
Joseph H. Hirshhorn, New York, 1966
Exhibited only in Washington and New Haven

The Biglin Brothers Turning the Stake, 1873
(in Eakins' record books as "Biglen Brothers turning
Stake-boat") (fig. 26)
Oil on canvas
40 x 59 ½ (101.6 x 151.1)
Signed and dated l.l.: *EAKINS 73*
The Cleveland Museum of Art; Hinman B. Hurlbut
Collection
PROVENANCE: Mrs. Thomas Eakins, Philadelphia,
until 1927
EXHIBITIONS: Long Branch, New Jersey, unspecified
venue, summer 1878, as *Biglen Brothers turning the
Stake-boat*; Boston, Massachusetts Charitable
Mechanics' Association, "13th Exhibition,"
September 2–November 2, 1878, as *Turning the Stake*;
Philadelphia, Philadelphia Society of Artists, "2nd
Annual Exhibition," November 1–December 6, 1880,
as *Turning the Stake, A pair oared Race*; St. Louis, Art
Hall, "21st St. Louis Fair," October 3–8, 1881, as
Turning the Stake-Boat; Denver, National Mining and
Industrial Exposition, "1st Annual Exhibition,"
August 1–September 30, 1882, as *Biglen Brothers
turning the Stake-boat*; New York, The Metropolitan
Museum of Art, "Loan Exhibition of the Works of
Thomas Eakins," November 5–December 3, 1917, as
The Biglen Brothers Turning the Stake-Boat

The Oarsmen, c. 1873 (fig. 28)
Oil on canvas
14 x 18 (35.6 x 45.7)
Portland Art Museum, Oregon; Mrs. Blanche Hersey
Hogue Bequest
PROVENANCE: The Portland Art Association, until
1927; Mrs. Blanche Hersey Hogue, 1927–54
EXHIBITIONS: Philadelphia, Pennsylvania Academy
of the Fine Arts, "Memorial Exhibition of the Works
of the Late Thomas Eakins," December 23,
1917–January 13, 1918, possibly work exhibited as
Professional Oarsmen (Sketch)

*Perspective Drawing for The Biglin Brothers
Turning the Stake,* c. 1873 (fig. 29)
Pen and colored ink, pencil, and ink wash on paper
31 ⅞ x 47 ¹¹/₁₆ (81 x 121.1)
Hirshhorn Museum and Sculpture Garden,
Smithsonian Institution, Washington, D.C.; Gift of
Joseph H. Hirshhorn, 1966

PROVENANCE: Mrs. Thomas Eakins, Philadelphia;
Charles Bregler, Philadelphia; Joseph Katz, Baltimore;
(M. Knoedler & Co., New York, 1961); Joseph H.
Hirshhorn, New York, 1966
EXHIBITIONS: Cincinnati, "Seventh Cincinnati
Industrial Exposition," September 10-October 11,
1879, as *A Pair-oared Race*

*Perspective Drawing for The Biglin Brothers
Turning the Stake*, c. 1873 (fig. 30)
Pencil and brown wash on paper
13 ¹⁵⁄₁₆ x 17 (35.4 x 43.2)
The Cleveland Museum of Art; Mr. and Mrs. William
H. Marlatt Fund
PROVENANCE: Charles Bregler, Philadelphia, 1942

*Perspective Studies for John Biglin in a Single
Scull*, c. 1873 (fig. 31)
Pencil, ink, and wash on two sheets of paper joined
together
27 ⅜ x 45 ³⁄₁₆ (69.6 x 114.8) (sight)
Signed near center: *Eakins*
Museum of Fine Arts, Boston; Gift of Cornelius V.
Whitney
INSCRIPTIONS: in pen and pencil, u.c. and pasted to r.,
in French, *Limité des reflets dans les vagues/ haut de
la chemise 24 . . . / . . . tête 22 ~/ genou 28 ~ 17/ point
d'appuis de l'aviron 29 18/ haut de la boute du canot
32½ 21*
PROVENANCE: Mrs. Thomas Eakins, Philadelphia;
Charles Bregler, Philadelphia; (Milch Galleries, New
York); Whitney Museum of American Art, New York,
1933– c. 1950; (M. Knoedler & Co., New York);
Cornelius V. Whitney

John Biglin in a Single Scull, 1873 (fig. 32)
Watercolor on paper
16 ⅞ x 23 ¹⁵⁄₁₆ (42.9 x 60.8) irregular
Signed and dated l.r.: *EAKINS/1873*
Paul Mellon Collection, Upperville, Virginia
PROVENANCE: Jean-Léon Gérôme, Cannes la Bocca;
Dr. Picot; Mr. Teissier; Mme. DuFrene, Cannes la
Bocca; Hedouard Perrier; Claire Perrier, his daughter;
by descent through the family; (Christie's, May 23,
1990)
EXHIBITIONS: New York, American Society of
Painters in Water Color, "7th Annual Exhibition,"
February 1874, as *John Biglin, of N.Y., the Sculler*
Exhibited only in Washington and New Haven

John Biglin in a Single Scull, c. 1873 (fig. 33)
Watercolor on paper
19 ¹⁵⁄₁₆ x 24 ⅞ (50.6 x 63.2)
The Metropolitan Museum of Art, New York; Fletcher
Fund, 1924

PROVENANCE: Mrs. Thomas Eakins, Philadelphia,
1916–24
EXHIBITIONS: Philadelphia, Pennsylvania Academy
of the Fine Arts, "A Collection of Water-Color
Drawings, Loaned to the Pennsylvania Academy of
the Fine Arts," December 3, 1877–January 12, 1878,
probably watercolor exhibited as *John Biglen*;
Cincinnati, "7th Cincinnati Industrial Exposition,"
September 10–October 11, 1879, possibly work exhib-
ited as *The Single Sculler*; New York, The
Metropolitan Museum of Art, "Loan Exhibition of
the Works of Thomas Eakins," November
5–December 3, 1917, as *John Biglen in a Single Scull*;
Philadelphia, Pennsylvania Academy of the Fine
Arts, "Memorial Exhibition of the Works of the Late
Thomas Eakins," December 23, 1917–January 13,
1918, probably work exhibited as *John Biglen in a
Single Scull (Water Color)*
Exhibited only in Cleveland

John Biglin in a Single Scull, 1874 (fig. 34)
Oil on canvas
24 ⅜ x 16 (61.9 x 40.6)
Signed and dated on verso: *Eakins 1874*
Yale University Art Gallery, New Haven; Whitney
Collections of Sporting Art, given in memory of
Harry Payne Whitney, B.A. 1894, and Payne Whitney,
B.A. 1898, by Francis P. Garvan, B.A. 1897, M.A.
(Hon.) 1922
PROVENANCE: Mrs. Thomas Eakins, Philadelphia;
(Babcock Galleries, New York); Col. Henry Penn
Burke, Philadelphia, c. 1928; (Macbeth Galleries,
New York); Francis P. Garvan, New York, 1932
EXHIBITIONS: New York, American Art Association,
"2nd Annual Exhibition of Sketches and Studies,"
opened October 19, 1883, possibly work exhibited as
Study of a Man Rowing; Philadelphia, Pennsylvania
Academy of the Fine Arts, "Memorial Exhibition of
the Works of the Late Thomas Eakins," December
23, 1917–January 13, 1918, as *John Biglen, Single Scull*

The Schreiber Brothers (*The Oarsmen*), 1874
(fig. 35)
Oil on canvas
15 x 22 (38.1 x 55.9)
Signed r.c.: *EAKINS 1874*
Yale University Art Gallery, New Haven; John Hay
Whitney, B.A. 1926, M.A. (Hon.) 1956, Collection
PROVENANCE: Ernest L. Parker; (New York art
market); John Hay Whitney

Perspective Study of Rowers for The Schreiber
 Brothers, c. 1874 (fig. 37)
Pencil on paper
14 ¹⁄₁₆ x 17 ¹⁄₁₆ (35.7 x 43.3)
Pennsylvania Academy of the Fine Arts, Philadelphia;
 Charles Bregler's Thomas Eakins Collection,
 Purchased with the partial support of the Pew
 Memorial Trust and the John S. Phillips Fund
INSCRIPTIONS: in pencil, u.l., *Picture 5 ft 72 figures/*
 Horizon 6[?] ft/ 60:5:72 in./ 90:5/ [?]"/ 120"; l.l. to l.r.,
 numbered grids, *1–8, 60–113*
PROVENANCE: Mrs. Thomas Eakins, Philadelphia,
 1917–38; Charles Bregler, Philadelphia, 1939–58;
 Mary Bregler, Philadelphia, 1959–85

Perspective Study of Bridge Pier and Water
 for The Schreiber Brothers, c. 1874 (fig. 38)
Pencil on paper
13 ¹⁵⁄₁₆ x 17 (35.4 x 43.2)
Pennsylvania Academy of the Fine Arts, Philadelphia;
 Charles Bregler's Thomas Eakins Collection,
 Purchased with the partial support of the Pew
 Memorial Trust and the John S. Phillips Fund
INSCRIPTIONS: in pencil, u.l., *Tableau 5 pieds 60: 5: 48/*
 L horizon 4 pieds/ Le bord lointain 700 pieds/ 700: 5:
 48/ [arithmetical notations]; l.c. numbered grids, *1–8,*
 40–60; l.r. on pier, *pier*; c.l. on pier, numbering of
 courses of stone; pinholes throughout design
Verso: perspective grid with arithmetical notations
 throughout
PROVENANCE: Mrs. Thomas Eakins, Philadelphia,
 1917–38; Charles Bregler, Philadelphia, 1939–58;
 Mary Bregler, Philadelphia, 1959–85

Perspective and Plan for The Schreiber Brothers,
 1874 (fig. 39)
Pen, black, red and blue ink and pencil on paper
28 ¼ x 47 ⅝ (71.8 x 121)
Pennsylvania Academy of the Fine Arts, Philadelphia;
 Gift of Charles Bregler
INSCRIPTIONS: in pencil, l.r., *EAKINS 1874*; u.l.,
 horizon 4 ft/ Tableau 5 ft/ reflection angle of bridge
 34–45/ [Dog?] head 38–46/ Trees 40–60/ Billy's head
 62 1/2 + 83/ Wave 4 [ft?] x 1/16 in/ slope of wave[?]
 102[?]; u.r. on plan numbered grid, *10–0–10; 59–92*
PROVENANCE: Mrs. Thomas Eakins, Philadelphia,
 1917–38; Charles Bregler, Philadelphia, 1939–49

Oarsmen on the Schuylkill (formerly *Pennsylvania*
 Barge Four), c. 1874 (fig. 40)
Oil on canvas
27 ⅝ x 48 ¼ (70.2 x 122.6)
Private collection; courtesy Hirschl and Adler Galleries,
 New York

PROVENANCE: Pennsylvania Barge Club,
 Philadelphia; (Griscom Galleries, 1930); The
 Brooklyn Museum, New York

Sketch of Max Schmitt in a Single Scull
 (formerly *Oarsman in a Single Scull, Sketch*),
 c. 1874 (fig. 42)
Oil on canvas
10 x 14 ½ (25.4 x 36.8)
Philadelphia Museum of Art; Gift of Mrs. Thomas
 Eakins and Miss Mary Adeline Williams
PROVENANCE: Mrs. Thomas Eakins and Mary
 Adeline Williams, Philadelphia

Plan and Cross-Section for Oarsmen on the
 Schuylkill, c. 1874 (fig. 43)
Pencil and ink on paper
47 ⅝ x 31 ⅝ (121 x 80.3) irregular
Pennsylvania Academy of the Fine Arts, Philadelphia;
 Charles Bregler's Thomas Eakins Collection,
 Purchased with the partial support of the Pew
 Memorial Trust and the John S. Phillips Fund
INSCRIPTIONS: in pencil, u.l., *The Biglin Shell/ length*
 35 ft./ cockpit/ amidships 15 in./ flare 19 in./ centre of
 boat to centre of outrigger 27 in./ outrigger 6 ¼ inches
 high above seat,/ oars 12 ft long./ 3 ft 6 oar from end to
 the button.; numbered grids, *27–68, 11–0–16* and arith-
 metical notations throughout
Verso: l.r., *4 oared shell Schmitt* [illegible]/ *& pair oared*
 the Biglons [crossed out]
PROVENANCE: Mrs. Thomas Eakins, Philadelphia,
 1917–38; Charles Bregler, Philadelphia, 1939–58;
 Mary Bregler, Philadelphia, 1959–85

Perspective Study for Oarsmen on the Schuylkill,
 c. 1874 (fig. 44)
Pencil, ink, and watercolor on paper
26 ¾ x 47 ⁹⁄₁₆ (67.9 x 120.8)
Pennsylvania Academy of the Fine Arts, Philadelphia;
 Charles Bregler's Thomas Eakins Collection,
 Purchased with the partial support of the Pew
 Memorial Trust and the John S. Phillips Fund
INSCRIPTIONS: in ink over pencil, u.r., *distance of*
 picture 6 ft./ 7 becomes 1/ at the stroke./ eye 36 inches
 above water., in pencil, *stroke 42 ft off/ Seat 3 in high/*
 44; numbered grid, *23–3000* throughout; pinholes
 throughout
Verso: in pencil, l.l., *4 oared shell/ perspective of*; c.r.,
 Biglin/ Brothers
PROVENANCE: Mrs. Thomas Eakins, Philadelphia,
 1917–38; Charles Bregler, Philadelphia, 1939–58;
 Mary Bregler, Philadelphia, 1959–85

Edited by Sheila Schwartz

Designed and typeset by Greer Allen and Ken Scaglia

Printed by Hull Printing Co.

Bound by Acme Bookbinding